PRACTICAL PORTRAIT PAINTING

FRANK SLATER

PRACTICAL PORTRAIT PAINTING

FRANK SLATER

DOVER PUBLICATIONS, INC.
New York

This Dover edition, first published in 1989, is an unabridged, slightly corrected republication of the work originally published in 1949 by Seeley, Service & Co., Ltd., London, and published in the United States by Charles Scribner's Sons, New York. For this edition, several obvious typographical errors have been silently corrected, and some page references added to the Index where clearly appropriate. In addition, many plates have been moved from their original positions to others (with the page references in "Illustrations and Acknowledgments" amended accordingly), and four plates that were originally in color ("The History of a Portrait" C–F) are here reprinted in black and white.

Manufactured in the United States of America
Dover Publications, Inc., 31 East 2nd Street, Mineola, N.Y. 11501

Library of Congress Cataloging-in-Publication Data

Slater, Frank.
 Practical portrait painting / Frank Slater.
 p. cm.
 Reprint. Originally published: New York, Scribner's.
 ISBN 0-486-26133-6
 1. Portrait painting—Technique. I. Title.
ND1302.S58 1989
751.45'42—dc20
 89-17235
 CIP

TO

MARY

CONTENTS

ILLUSTRATIONS AND ACKNOWLEDGMENTS

PLATES

Illustrations and Acknowledgments

Illustrations and Acknowledgments

Illustrations and Acknowledgments

TEXT DIAGRAMS

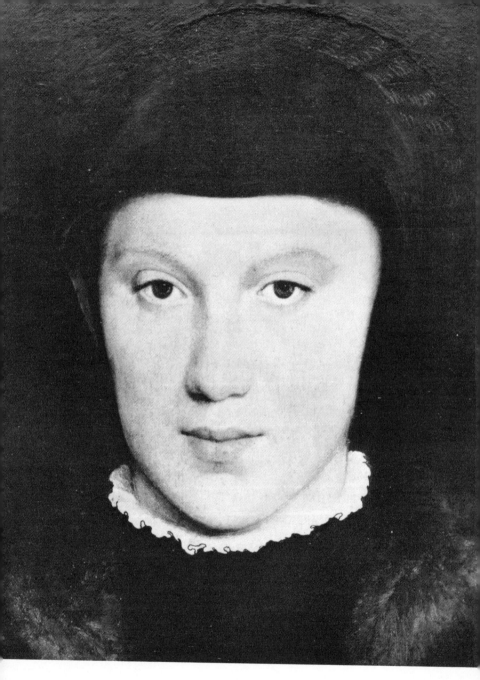

Plate 1 THE DUCHESS OF MILAN (detail) *Hans Holbein*

This beautiful work shews Holbein at his greatest. Smooth, subtle and intellectual—a masterpiece of selection.

National Gallery

I

INTRODUCTION

I HAVE great faith in the importance of portrait painting. I believe it to be valuable as an art, as a contribution to social life, and as an historical record.

This book sets out to analyse the basic principles of a good portrait, and to give a detailed account of different techniques for pencil, charcoal and painting in oils.

It is based on over twenty years' experience as a portrait painter and its aim is to be essentially practical. All painters have to struggle many years before they can express themselves freely. That is as it should be. But much time and heartbreak can be avoided if certain fundamentals are fully grasped at the outset. I believe it is possible to find your particular form of self-expression only after a sound technical training. There is no short cut to becoming a good portrait painter; but many pitfalls may be avoided by learning from someone else's proved experience.

What are the necessary qualifications for success in this exacting profession? First of all you should have an unquenchable desire to paint portraits, coupled with a certain gift, or flair, for doing so. Without that gift I believe it to be impossible. The initial talent *must* be there—it cannot be acquired.

But once the seed exists, however small, it can be cultivated by hard work and enthusiasm.

Then you should have an interest in your fellow creatures, in their minds, their characters, and their behaviour. When you are painting a portrait you are not just painting a head and a set of features. *You are re-creating life.* It is no use merely trying to copy, or imitate, what is in front of you. It is not sufficient to make an

interesting picture or work out a harmony of form and colour. I would say that the first essential of a good portrait is to portray the true character of the sitter, and to make it vital, human, and convincing. The greatest portrait painters have always combined a penetrating understanding of character with their other powers. Holbein, Rembrandt, Velasquez, and Goya, all painted uncompromising records of human beings as well as works of the highest artistic value.

Let us settle once and for all what we mean by the word "likeness". It is very important that this word should be defined, because it will occur many times in the course of this book. If a portrait is a good likeness it means, clearly, that it looks like the sitter. But to the inexperienced observer a portrait may appear a good likeness, and yet in fact be poorly painted, weak in drawing, feeble in colour and superficial in characterization. Conversely, a portrait may be beautifully painted, subtle in colour, delicately modelled and a fine work of art—and yet not a very good likeness. So although a good portrait *should* be a good likeness, it is only one of many essentials, and not enough in itself.

In actual fact, the likeness depends on the correct relationship between the features and reasonable accurate observation and drawing. But that is not enough. The painter must search for every human subtlety, and try to find out just what makes this particular individual entirely different from everyone else. That is the fascinating part of the job—everyone is utterly different. There may be a similarity now and again in structure or type, but the essence, the peculiar personality of every human being, is unique, and a good likeness should catch that unique quality.

A portrait painter must be a psychologist and something of a mind-reader; he must be receptive to other people's moods; he must try to penetrate the complex characters of men and women; he should understand children. He must be able to talk easily to all kinds of people, and make them lose any feeling of shyness or self-consciousness. If he fails to do these things, his portraits may seem cold and lifeless—a collection of waxworks.

The men and women who belonged to the Court of Henry

Introduction

VIII live for us to-day because Holbein drew them over four hundred years ago. We know the merchants and rabbis of seventeenth-century Holland, the Grandees of Spain and the family of Charles I, because Rembrandt, Velasquez and Van Dyck were great portrait painters.

No new developments and modern trends can in any way lessen the importance of the work of the past. Nevertheless, most of these great masters lived before the Impressionists had made valuable discoveries about the treatment of light and atmosphere, before Cézanne made his intellectual analysis of colour, form and recession, and Picasso opened up new worlds for the artist to conquer.

These developments must all have their effect on the contemporary painter, for no one can be uninfluenced by the period in which he lives. The portrait painter, no less than any other artist, must be fully aware of new discoveries, and make use of any that can help him on the road to self-expression.

This book is an attempt to give the student something to hold on to, while he is still struggling to find himself. Although no text-book can be a substitute for a sound training at one of the established art schools, it is not always possible for everyone to have this advantage. While writing, I particularly have those in mind who are trying to learn by themselves, and wish to compare their own problems with someone else's.

First of all we shall see what can be learnt from the past. I do not care for the phrase "Old Masters". There have been great painters in every epoch, and they have all been individuals, with their own particular gifts. By lumping them together with the phrase "Old Masters", we tend to think of them as too remote and inhuman. When we study their lives and work, we discover that each had to struggle with his own problems, even as you and I, and that hard work and self-criticism played almost as much part in their success as natural genius.

Of course, many of them seem to have acquired a mastery over their medium at a very early age—but you must not forget that it was usual in those days for the talented youngster to be an appren-

tice in the studio of a practising painter, and learn his craft while still very young. This was an admirable scheme which unfortunately seems impracticable to-day. So when you see paintings by Velasquez done at the age of twenty, you must remember that he had already been studying for eight years.

Before you can expect to start work as a professional portrait painter at least four or five years of training are necessary. After that, if you have friends or relatives who believe in your talents and are willing to sit, you may pick up some commissions, which in turn will lead to others. It is not likely that you will make a living from these to begin with, and it may be necessary to supplement your income in other ways—such as working for magazines, newspapers or advertising.

During the years of study you should have a complete training in drawing and painting from life. You are likely to find, however, that it may still take some time before you are completely master of your medium. There are always new problems to solve, fresh experiments to be made. The surest way to improve is by learning from your own mistakes, by severe self-criticism, and the analysis of your failures and successes.

I have always wanted to paint portraits. I started as a child, drawing my friends and relations. At school I drew from the antique, and learnt water-colour painting. At seventeen I worked for a few months at the Central School of Arts and Crafts, and studied life drawing under Ernest Jackson. He was a first-class teacher, but I was still a little too young to understand all he said. I can well remember how it felt to be so desperately keen and so abysmally ignorant. I had no idea what the word "form" meant, I had a good sense of proportion, and could imitate the outward appearance of things. My facility for rapid sketching increased, unhampered by any real understanding of what I was drawing. This enabled me, during the next two years, while undertaking entirely different work, to make some free and expressive sketches.

At nineteen I was eventually permitted to study seriously, and went to the Polytechnic School in Regent Street. After a year of life drawing I began to paint in oils. Then followed two and a

half years at the Royal Academy schools. Charles Sims, R.A., taught painting, assisted by visiting Royal Academicians. Ernest Jackson taught drawing. This time his methods were a revelation to me. I grasped for the first time what drawing really meant. I discovered it to be an intense intellectual exercise. I learnt that it was not just copying, but re-creating.

Sims was a fine critic, too, and I learnt much that was useful in the handling of my medium. But it was Walter Sickert who taught me the real meaning of painting. The story of his period of teaching at the schools is well worth repeating, and I shall tell it in due course when I deal fully with the technique of painting.

While still at the Royal Academy schools I started to earn a living by drawing portraits of well-known people for magazines and periodicals.

This was excellent practise, and taught me to work quickly and accurately. Soon afterwards I went to America, where I obtained a great deal of work of this kind. During a stay of eighteen months I drew several hundred portraits, as well as painting a number of commissions.

But I realized how much there was still to learn before I could call myself a painter. It took several more years before I worked out a technique that suited me, and since then I have tried unceasingly to perfect it. There are as many good techniques as there are good artists, but there are a thousand bad ways of painting. If I can describe one or two good methods completely, it may prove helpful to those who are still uncertain of themselves.

The principles of good drawing are more simply stated. Naturally, the artist will eventually express himself in line and form as characteristically as in his own handwriting; but I believe there are certain fundamentals that are constant in all fine draughtsmanship. I learnt what these were from Ernest Jackson.

I acquired a technique that gave me confidence to do my job in a workmanlike manner. I have taught this technique to others, and have been amazed how rapidly their work has improved.

I shall describe it in detail in the chapter devoted to drawing. It is not possible to teach anyone how to become a fine artist, but a sound technical basis *can* be acquired, and every artist should have a solid foundation of good drawing.

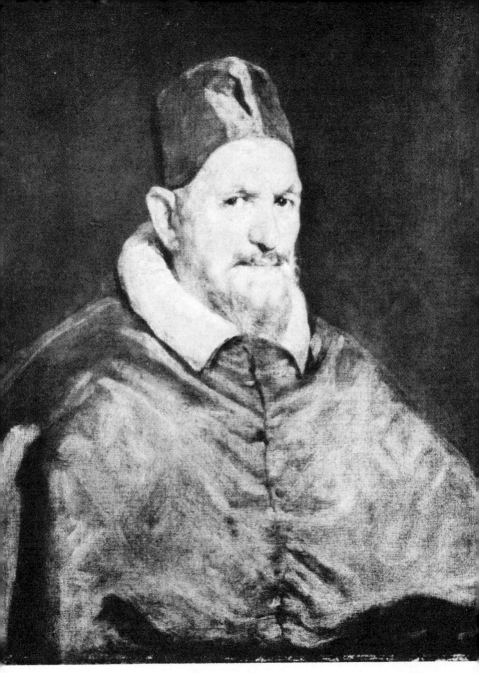

Plate 2 POPE INNOCENT X *Velasquez*

Velasquez has never been surpassed as a painter of portraits rich in character and beautiful in colour. This is certainly one of the strongest in characterization. We are shewn the man as he was, worldly, shrewd, powerful and cruel, but not without humour. He might be a modern dictator.

Victoria and Albert Museum

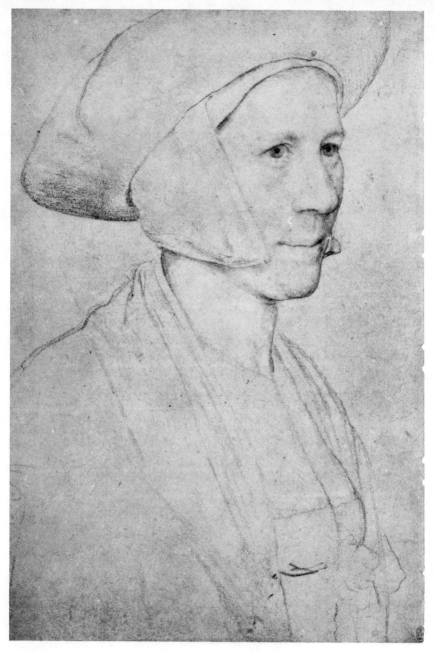

Plate 3 PORTRAIT OF A LADY UNKNOWN *Hans Holbein*

A beautiful and delicate portrait by a great draughtsman. Note the economy of means, the subtlety of the line and the modelling. What a sensible-looking woman she appears to have been—very much like the British housewife of to-day—and yet she lived over four hundred years ago. Holbein's men and women never date, because he had a deep understanding of human beings.

Windsor Castle

II

PORTRAIT DRAWINGS

Holbein to John

Before attempting to describe different methods of drawing and painting a portrait, I should like to discuss the work of a few great portrait painters of the past. If you are among the fortunate who have the opportunity of paying frequent visits to the great public galleries, there is at your disposal an endless source of inspiration in studying the work of the masters. In spite of the high standard of most colour reproductions, no print can be more than a reminder of the original after you have seen the actual painting in all its beauty of colour and texture.

Drawings can be amazingly well reproduced, and students should collect as many books of reproductions as possible. There are some splendid editions containing the work of most of the great masters at very reasonable prices.

I do not claim to be an authority on the history of portrait painting. I have been too busy painting to become an historian. There is a number of books available if you wish to study the history of art and the biographies of the great painters.

What I propose to do is to discuss the work of portrait painters who have appealed to me personally, and show what I have been able to gain from studying their work.

Each individual will have his own preferences, and some of the greatest masters may not appeal to everyone.

I am fortunate in having lived most of my life in London, so that the National Gallery, the Tate, the Wallace Collection, the British Museum and the Victoria and Albert Museum are part of my accustomed background.

For over thirty years I have paid regular visits to these wonderful collections, and I am as familiar with the paintings as if they belonged to me, which in a sense they do.

I have visited the Louvre, the Prado, the galleries of Florence, Rome and Venice. I know the Metropolitan Museum in New York, the collections in Munich and Vienna. At every gallery I have concentrated particularly on the portraits.

I have followed the work of contemporary artists, both at the smaller galleries and at the annual exhibitions.

I mention these facts to show that from the vast number of portraits I have seen, certain artists and individual pictures have attracted me more than others, and it is about these that I wish to write, not as a critic or historian, but as someone who has learnt much from them. If I mention the work of artists whom I have found meretricious or pretentious, that is because I feel something can be gained by studying their faults and so trying to avoid them.

To begin with drawings, the first master who, to my mind, reaches a standard of perfection that has seldom been surpassed, is Hans Holbein.

He seems to have all the necessary qualities of the great portrait draughtsman. He selects the essential characteristics in a face with unerring instinct, stresses individual idiosyncracies without exaggeration, and understands the basic humanity of each sitter so well that his portraits might have been drawn yesterday of the next-door neighbours.

You have only to compare his work with that of his British contemporaries to notice the world of difference between his genius and their rather rigid and limited talents.

His technique is not so simple as it might at first appear. If you study the original drawings at Windsor Castle, you will notice that what may seem a firm, continuous line, consists of a number of delicate touches, building up to the appearance of firmness. Each touch searches more closely for the truth. The modelling of the whole head is extremely subtle. The sitter is usually placed in a flat simple light, without strong contrasts of shadow. This

allows the features to be revealed by delicate bits of drawing. Holbein makes little use of light and shade, and is never searching for dramatic effects. He models the head with the utmost reticence, and yet misses nothing. His stressed accents are his only concession to drama, and in the selection of these he is a supreme master.

Looking at one of these portrait drawings, it is not always easy to discern the subtly modelled structure of form that exists just beneath the accentuated features. Observe, too, how delicately he follows the line between the lips, the curve of the eyelids, and edge of a cheekbone. These accents will certainly have been stressed at the last, and so are perfectly related to one another. He has also invented a beautifully decorative method of interpreting the accessories, the collars, jewels and fur. The hair, too, receives characteristic treatment, which nevertheless merges with the whole drawing.

Holbein's artistic austerity appeals to me tremendously. He achieves the highest rank as an artist without conceding one iota to easy popularity. There is no bravura, no flourish, no facile virtuosity. Every drawing is a masterpiece of careful selection of essentials, combined with a warm feeling for the human being he is portraying.

Holbein reached the peak of his own form of expression—Leonardo da Vinci stands alone on his own summit of genius.

His drawings are the ultimate classics of draughtsmanship, and no one, before or since, has studied the form and beauty of the human countenance with such extreme delicacy and understanding. In addition to his love of sheer beauty, Leonardo possessed what amounted to a morbid interest in the evil, cruelty and degradation that could be portrayed in the human face, and his studies of hideous and repulsive features are unique.

His technique, using the sensitive line and the natural movement of the wrist to model with his chalk or pencil, has remained the foundation of all traditional drawing, and Augustus John employs a similar method to-day.

No student can afford to be without the beautiful edition of Leonardo's works which has been recently published.

Rembrandt's etchings and pen-and-ink drawings are miracles of exquisite draughtsmanship. The combination of strength of conception with delicacy of technique is remarkable.

The drawings of Rubens are richly rewarding to study. His warmth and liveliness, the full roundness of his form, the use of sanguine with black and white chalk, are all characteristic. His portrait drawings are more vivid in expression than Holbein's, and more convincing, purely as portraits, than Leonardo's. If he is not quite on their plane as an artist, his technique is worthy of careful study.

Amongst the early French draughtsmen, Clouet is one of the finest masters, comparable to Holbein, although perhaps not quite as convincing.

Watteau's drawings are in the great tradition, exquisite in their charm and delicacy, but having considerable force, and going deeper than many of his contemporaries.

Ingres's portrait drawings represent a certain kind of perfection that has never been excelled. Specializing in small pencil portraits, he was able to draw a head only an inch or two in size, which completely captured the essential character. I strongly recommend students to study these drawings: for classic purity of conception, for delicacy and for finesse they have seldom been surpassed.

Another French genius, the integrity of whose work never fails to give me delight, is Degas. Although not primarily a portraitist, he drew many portraits which have the same convincing humanity that illuminates Holbein's drawings, combined with a Gallic charm that concedes nothing to artificiality or prettiness.

Coming closer to the present time, the portrait drawings of Sargent are so completely satisfying, purely as likenesses, that people are inclined to take his technical ability for granted.

No one admires Sargent's particular abilities more than I do, and yet at the same time I am fully aware of his failings. People either praise him without reserve, or dislike his work intensely. As a practising artist, I am enormously impressed with his charcoal drawings. They are convincing, boldly handled, and often

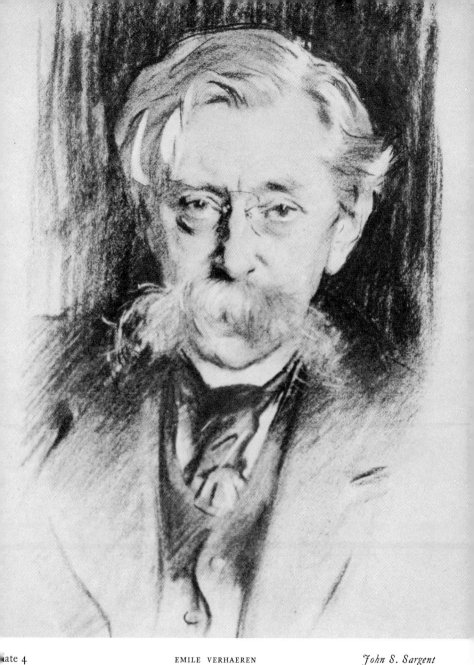

EMILE VERHAEREN *John S. Sargent*

characteristic example of Sargent's charcoal technique. He has caught the surface likeness, cleverly
sing his medium with a variety of accent, tone and texture. The drawing has the liveliness of a
apshot, and with some of a snapshot's lack of selection. Compared with the Holbein, it seems to
ave too many unimportant and accidental details, in the hair and moustache for example. All the
me it has a realistic quality which is very effective.

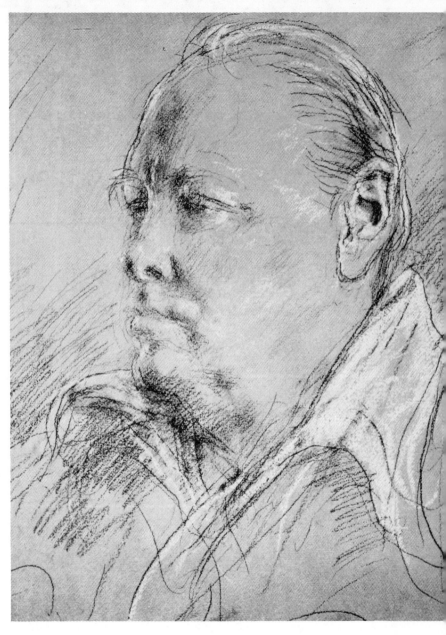

Plate 5 THE RIGHT HONOURABLE WINSTON SPENCER CHURCHILL *Augustus Jo*
When a great artist draws a great man we can expect something exciting, and here it is. Notice t
searching rhythmic line, the apparently casual scribbles that suggest the subtle modelling and t
use made of the white chalk. This drawing has style *and is a fine example of John's master*
draughtsmanship. Collection of Ronald Strauss, Esq.

very fine in conception. Many of them, however, seem, on closer inspection, to be more like paintings in monochrome, too concerned with the values and lacking in selection and subtlety. They are perfect representations of the surface appearance, but they lack the search for character and form of Holbein's portraits, the subtle modelling of Leonardo's, the integrity of Ingres, and the wit of Degas. Sargent was the portrait painter supreme of the materialistic, luxurious world of the Edwardian period, and as a recorder of his times he was perfectly endowed. But his drawings lack the sensitiveness and delicacy of the great masters.

Two of his younger contemporaries, Orpen and John, showed far greater powers of true draughtsmanship. Augustus John is the only living artist I propose to discuss at any length in this book. He seems to me to be the only portrait painter now working who merits the word genius. Orpen, had he lived, might also be at the height of his powers to-day. His drawings, carried out mostly in pencil, follow the traditional technique of the great masters, but have a charm of wit and observation entirely personal. He had the enviable gift of knowing just how much weight a drawing could carry, never laboured a sketch, and never carried a drawing a touch beyond what was required. His graceful line and subtle modelling should be studied by all who wish to draw in pencil. I should never advise anyone to study Sargent with a view to carrying on his style. It needs Sargent's virtuosity to bring it off, otherwise it is heavy and uninteresting. Orpen's technique, however, is a perfect model to any student.

Finally, Augustus John. I consider him by far the greatest living draughtsman. He seems to me both to follow the great tradition and at the same time to have an original, creative mind. His best drawings compare favourably with any of the past. He is, indeed, a romantic artist, searching for the tender and the graceful, and yet with such forcefulness and passion, that his work is never sentimental. As he has matured, his drawings have become more and more selective, and his treatment increasingly personal. He is able to express the form and rhythm of hair, for instance, by a few apparently arbitrary waving lines, and seems to

create the feeling of softness and roundness of a cheek by a smudged accent. This comes as the result of years of searching for the subtleties of form, and his absolute knowledge of what he is interpreting. His early drawings are far more carefully worked out, and he has arrived at his present style through long study, as well as through his natural genius.

So, to me, it seems that the great tradition runs from Holbein and Leonardo, through Rubens, Watteau, Ingres and Degas to Augustus John to-day. Picasso, who began drawing in this same manner—his early work is very much influenced by Degas—has broken completely away, and is still exploring new fields of expression. But I am sure he would be the last to deny the value of having studied in the traditional style, and that a knowledge of sound drawing has always been of service to him, even in his most violent and experimental moods.

III

PORTRAIT PAINTING BEFORE THE
IMPRESSIONISTS

Whatever style of drawing you use, and whatever medium you employ, drawing must, by its very nature, remain a convention. Colour is eliminated, tone values ignored. The artist selects from Nature just what is necessary to re-create the form and interpret the character of the sitter. His technique consists of transposing the facts before him into another sphere, and for this purpose he uses a set of conventions. If his drawings seem representational, it is because we are accustomed to the conventions employed. The only kind of drawing that aims at a photographic realism is the heavy charcoal portrait, using full tone values, with high-lights picked out and half-tones rubbed in, such as Sargent made at one period. This kind of portrait is definitely outside the great tradition of draughtsmanship, which is not concerned with tone values, but with form alone.

When it comes to painting in oils, there is no doubt that an extraordinary degree of realism can be obtained. The power it can have to create an illusion of reality is sometimes uncanny in its effect.

This facility to imitate Nature is exciting, but when used without discretion, it can also be very dangerous. Most fine artists have had this power, but have used it with restraint, for they have realized that the creating of an illusion is not their primary aim. It may, in fact, not be their aim at all.

This may sound contradictory at first—for, after all, a portrait is supposed to be a likeness of a person as close to Nature as possible.

You must realize, however, that the painter's business is to transfer to the canvas an interpretation, in terms of colour and form, of what is before him. If he has an exceptionally good eye for tone values, the illusion of reality will be very pronounced. But this power may be possessed by inferior artists, and many of the greatest painters have not been interested in making use of it. Although a portrait should be representational, it should not try to compete with Nature. It need not—indeed it should not— "jump out of the frame"; it should always remain a picture, behind it.

Rembrandt, undoubtedly the greatest magician of them all, never tried to *imitate* Nature; his men and women have a life of their own, built up organically from within. Velasquez seems to be closer to actual Nature, but his paintings still remain interpretations, and make no concession to photographic realism.

So, although one of the aims of a portrait may be exact representation, it is not one of the basic essentials. The artist's selective and interpretative powers must predominate over the merely imitative ones.

A portrait painted in oils is, in its way, as much a convention as one in black and white, and if this is kept in mind you may avoid many pitfalls.

With the development of the craft of oil painting, and up till the time of the invention of photography, it was natural for most painters to be interested, to some degree, in how far they could actually create this illusion of Nature, which oil painting undoubtedly has the power to give.

It fascinated a great genius like Leonardo, but because he was an artist of the first rank, he never let it interfere with his creative gifts as an original artist.

Rubens and Van Dyck were great realists, in addition to being very fine artists. So were Raeburn and Lawrence. Finally, Ingres brought too great a concentration on realism to its logical conclusion, and his paintings show that, taken beyond a certain limit, it can defeat its own ends. However much we may admire the amazing craftsmanship of Ingres's painting, his men and women

seem cold and lifeless. A tightly-painted portrait, however exquisite the form and modelling, will lack the vitality of one freely handled. The more loosely and boldly a portrait is painted, the more life it possesses. Rembrandt and Velasquez, in their prime, painted with the greatest possible freedom.

The earlier masters were naturally not as free, in this respect, as the later ones. Holbein, supreme draughtsman and artist, used a painting convention of smooth finish that does not give the same vitality to his sitters that we see in the portraits of the later masters. "The Duchess of Milan" remains one of the world's masterpieces, but the craft of painting was to develop further, and even a genius like Holbein could not escape from his own period.

Treatment and interpretation remain the important qualities of the fine artist, and an ability to imitate the outward appearance of Nature is only one weapon in the painter's armoury.

Among the great portrait painters of the Italian Renaissance—and it was a period when portrait painters flourished—Titian towers above them all.

Moroni, Bronzino, Andrea del Sarto, Raphael and many others produced wonderful portraits, but for sheer nobility of conception, richness of technique and monumental design, Titian stands alone. His superb "Man with a glove" is surely one of the great portraits of the world. When looking at this masterpiece, although it is easy to admire its positive qualities, you should also notice how much it has avoided every possible error. It represents a handsome man, but there is no attempt to flatter, it is extremely simple in design, but not empty. The pose is graceful, but completely natural; the light accents of the cuffs and hand are placed to perfection, to lighten the dark mass of the clothes, but their disposition seems in no way contrived. It is representational, but not burdened with detail, or tight in handling. It does not leap out of the canvas, but is nevertheless utterly convincing in its realism. A very great portrait indeed.

The names of Rembrandt and Velasquez may occur many times in this book. A whole literature has been written about

them. No book about portraiture can fail to mention their names over and over again.

Rembrandt undoubtedly went further and deeper into the art of painting human beings than any other artist. I can only beg every student to study his work unceasingly. If Titian's portraits are magnificent, so were his aristocratic sitters, attired in their splendid clothes. Rembrandt painted the rich and noble as well as the humble and the poor, and all his work is imbued with magnificence. Every artist should take the opportunity to study his paintings in the original, and keep a book of reproductions constantly by him. They are an endless source of inspiration, and a reminder of the heights to which genius can rise.

Velasquez seems closer to our times in his actual technique and handling of paint. Many consider him the first modern painter; modern in that he seems to come closer to our ideas of representation. If you compare his early work with his later you will see how a facility for completely "finished" realism gave way to a much looser handling, almost impressionistic in its breadth, freedom and atmospheric treatment of colour. Velasquez has never been surpassed as a painter of portraits, rich in character, beautiful in colour and sumptuous in design.

El Greco, too, is a genius of unique qualities. His completely original style, with a tendency to elongate the forms, make his work immediately recognizable. He is an example of an artist of great individuality, who imposed his own temperament on every portrait he painted, and yet gave a completely satisfying rendering of the sitters. In the opinion of some critics, his work has an original quality that places it even higher than that of Velasquez.

Naturally, all artists impose their own temperament to a greater or lesser degree on their portraits, and none more than Franz Hals, who makes all his sitters seem friendly, contented human beings. No doubt the people who came to Hals to be painted felt warmly disposed towards him, and they radiate good humour. Yet there is nothing forced about their smiles. His free handling and bold brushwork make you feel that the faces are mobile and

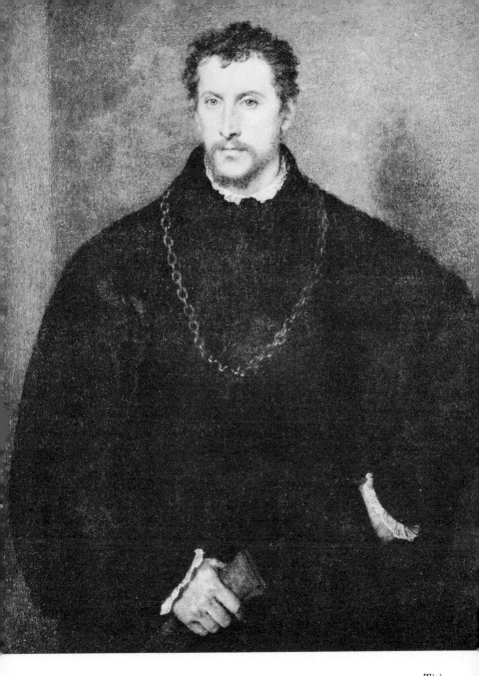

Plate 6 MAN WITH A GLOVE *Titian*

A very great portrait. It has distinction, grace and delicacy combined with a feeling of power in a simple, massive design.

Pitti Palace, Florence

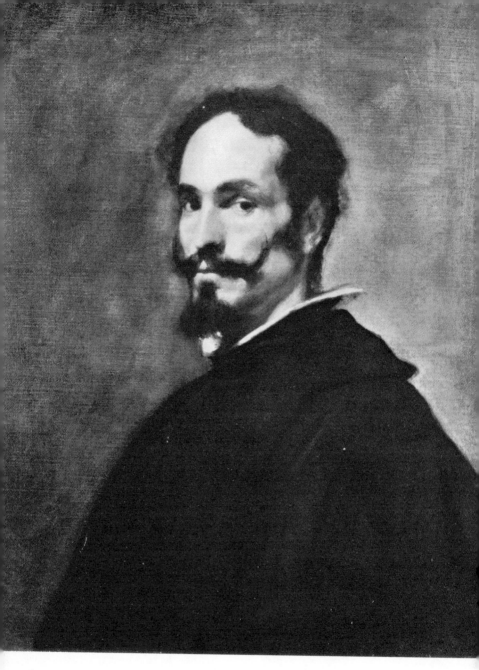

Plate 7 PORTRAIT OF A MAN WITH A BEARD *Velasquez*

A fine dramatic study. Notice the beautiful simplicity of the pattern made by the darks and how the light plays over the head. Velasquez always painted with great breadth of style, emphasizing the essentials with the born painter's intuition.

Victoria and Albert Museum

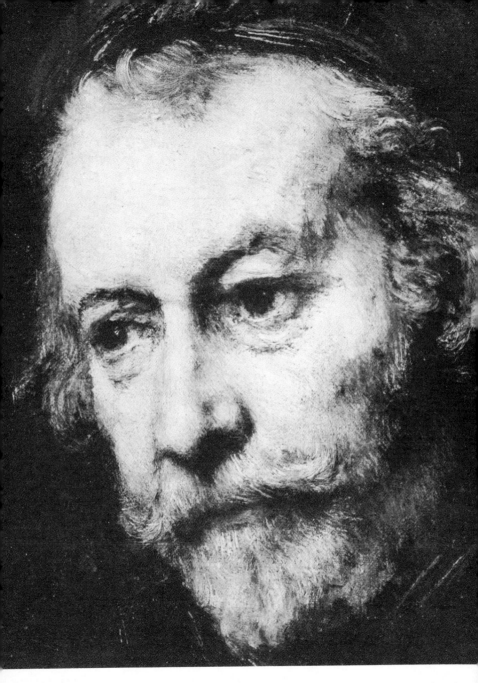

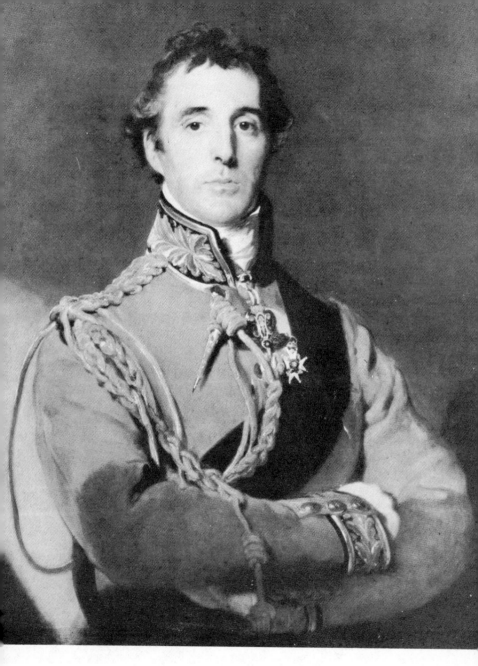

Plate 9 THE DUKE OF WELLINGTON *Sir Thomas Lawrence*

Lawrence knew all the tricks of the born portrait painter. Here is the successful general in glowing
uniform and all the glamour of recent victory, painted by the most successful artist of the day. It is
a brilliant piece of work.

Victoria and Albert Museum

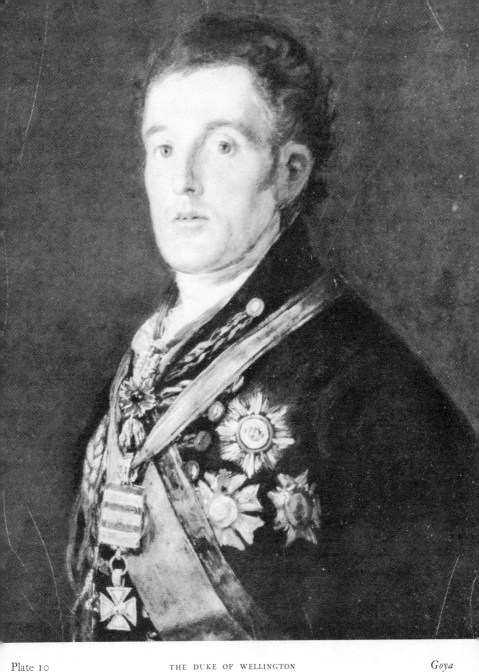

Plate 10 THE DUKE OF WELLINGTON *Goya*

Compare this portrait with the one by Lawrence. What a completely different interpretation! Does it tell us more of the truth about the man? Lawrence's portrait has a more immediate appeal, but perhaps Goya's goes deeper. It is not so flattering but it has a certain finality that puts it above the Lawrence as a work of art.

National Portrait Gallery

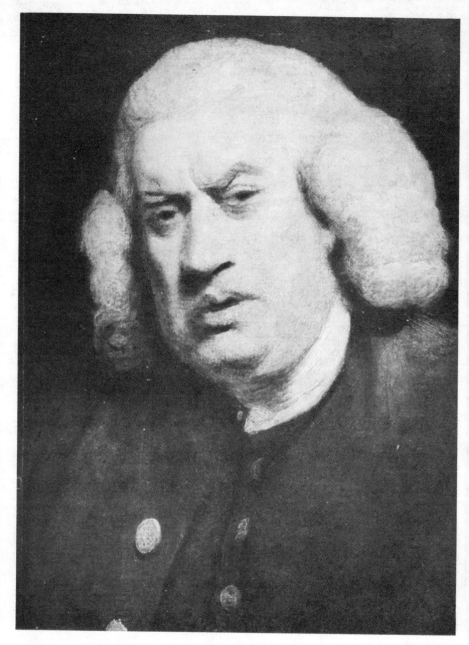

Plate 11 DR. JOHNSON *Sir Joshua Reynolds*

A fine example of Reynolds's bold handling of a dramatic theme. Notice the massive sculptural treatment of the head. The character is ruthlessly brought out by the broad treatment and elimination of detail. To compare this portrait with the Gainsborough on the following page is manifestly unfair to Gainsborough, but the comparison is extremely interesting.

Tate Gallery

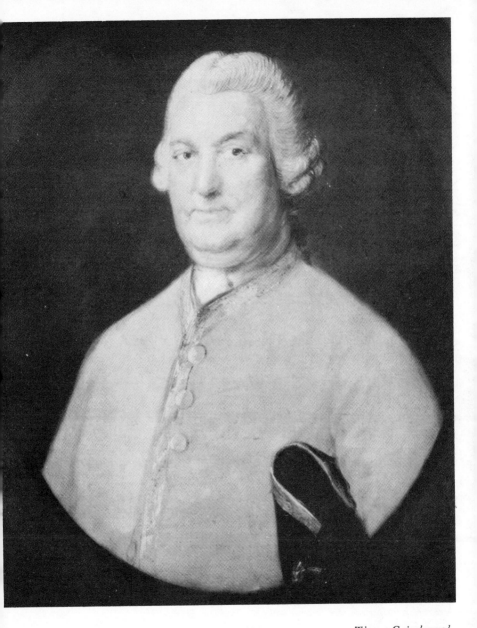

Plate 12 STRINGER LAWRENCE *Thomas Gainsborough*

This appears to have been one of Gainsborough's less successful portraits Compared with the Reynolds it seems thin and lacking in character. It is always interesting to see the lesser works of the acknowledged Masters and to know that they had their comparative failures. In this picture simplicity becomes emptiness and the lightness of touch seems rather flimsy.

National Portrait Gallery

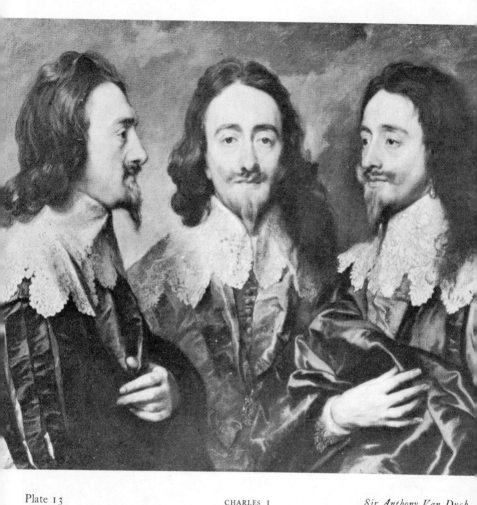

Plate 13 CHARLES I *Sir Anthony Van Dyck*

This distinguished triple portrait tells us all we want to know of the appearance and character of Charles I. Apart from the finely painted heads, notice the intricate pattern of the interwoven triangles round the collars and the beards and repeated in the background. This work was carried out for the benefit of a sculptor, so that he could study the head from every angle.

Windsor Castle

have not been frozen into artificial grins. Their smiles are spontaneous and natural.

If he did not search so deeply into the depths of character as Rembrandt, he is certainly supremely gifted in portraying the gaiety, warmth and decent kindliness of the average human being.

Rubens, although among the very greatest, does not quite rank with Rembrandt and Velasquez. Technically superb, bold and colourful, even flamboyant, his own vitality and robustness shine through all his work. Only beside Rembrandt's do his portraits look a shade superficial or melodramatic; only beside Titian's do his pictures lack some nobility; and compared with Velasquez, his colour appears rather too hot.

Personally, I have a great feeling towards Rubens's portraits— they contain so much vitality, a quality I find extremely attractive.

Van Dyck, a pupil of Rubens, if not as profound as Rembrandt, or as scintillating as Hals, is still supreme in the great tradition of magnificent Court portraiture. His triple portrait of Charles I, his portraits of Henrietta Maria—particularly the more intimate studies—are superb achievements. He combined a brilliant technique with a capacity to make his sitters look aristocratic and elegant, as well as endowing them with character and individuality.

Lely and Kneller continued this noble tradition, but Hogarth was the first great portrait painter to be born in England. The group of portraits of his own servants is rich in observation of character, and full of homely, tender feeling. The artificiality of Court portraiture is dropped in favour of quiet sincerity.

And so we come to the great period of British portrait painting. with Cotes and Hoppner, Reynolds and Gainsborough, Romney and Lawrence.

I am always surprised when I look at an original Reynolds by the bold simplicity of his treatment. The general effect is always so rich, elaborate, and realistic, that unless you study the paintings themselves you are not always aware how daringly they are painted. Detail is kept to a minimum, his conceptions are broad and free, and his accents vigorous and dramatic.

Gainsborough, though considered the finer artist of the two, because of a more subtle understanding of colour and a greater sensitiveness of feeling, seems to me to lack the vitality of Reynolds. But his delicacy, refinement and grace are ample compensation for an occasional weakness in characterization. At his best he is unsurpassed as a painter of his period.

Romney, if not as great an artist as these two geniuses, was a brilliant portrayer of the grace and beauty of the eighteenth-century woman. In a portrait such as the delightful "Parson's Daughter", he rivals Reynolds in painting youthful charm without sentimentality.

For sheer virtuosity and a capacity for catching a likeness, Lawrence is perhaps the most brilliant of them all. Sometimes his facility overwhelmed his artistry, and some of his later portraits are a little cloying in their sentiment. I always enjoy looking at his rapidly painted head of George IV in profile. It is a completely convincing likeness of that exuberant monarch, and a grand piece of bravura painting.

Raeburn has a strength and simplicity that puts him among the giants. He is an example of a practising portrait painter who kept an amazingly high standard all through his work. In the major portraits his dramatic power is truly magnificent. He extracts the utmost value from a strong top light. This brings the eyes into deep shadow, making them appear dark and glowing in contrast to the brilliant light on the forehead and cheeks. White collars and dresses reflect the strong light up to the neck and chin, giving the whole head a luminous quality.

These fine painters represent the zenith of British portrait painting, and from then on a decline set in which lasted till the end of the nineteenth century.

America produced two fine painters in Copley and Gilbert Stuart. Their best work is in the fine tradition, and the famous portrait of George Washington by Stuart is worthy of its subject.

In France, portrait painting was naturally influenced by the taste of the Court. Largillière, Boucher, Greuze, Nattier, Le Brun and many others painted in the artificial, sentimental or grandiose

style required. It was a period of luscious artificiality, and it seems to me that few portrait painters managed to avoid these traits.

Naturally, their work has charm and elegance, but lacks depth and truth. I find Greuze too sentimental, and Boucher too lush.

During the Empire, David became the official painter, and worked in the required classic style.

Goya remains unique in this period as an isolated original genius. It is impossible not to feel strongly about this great artist. His almost brutal portraits are forceful comments on some of his sitters, but he can also be tender and graceful when his subject moves him. It is interesting to compare his portrait of the Duke of Wellington with Lawrence's of the same period. It is obvious that Lawrence's is the better likeness, but Goya's has an arresting quality that puts it in a different class. You feel that he has interpreted the spiritual quality of the young general better than Lawrence. All his work has a peculiar attraction, and if, when compared to his English contemporaries, he seems to lack charm and grace, it has nevertheless that particular quality of beauty that comes from a profound understanding of the truth.

Ingres closes this epoch, which was followed by the Romantic era. It was Manet who opened up new vistas in painting, and rebelled against a tradition that had become stale and lifeless, chiefly through imitation of the past and not looking to Nature for its inspiration.

NINETEENTH-CENTURY PORTRAIT PAINTING

UNTIL the nineteenth century, speaking in the most general terms, painting had travelled along traditional lines. Naturally, in different countries there were periods of development, full maturity and decadence; but painters as a whole agreed on fundamental principles. The great Italians of the Renaissance, Raphael, Leonardo, Michelangelo and Titian were looked on as the final word in the art of painting. No one questioned their supremacy, and most painters were very much influenced by them.

Towards the middle of the nineteenth century, however, new voices were heard, and former standards were being questioned, not only as regards their supremacy, but their finality.

In England the Pre-Raphaelites discovered beauties in the works of the Italian painters before the height of the Renaissance, which had until then been considered technically inadequate. They felt that by returning to the study of Nature, instead of the study of art, they could recapture the simple attitude of wonder at natural beauties that pervades the work of artists like Botticelli and Piero della Francesca.

If they had actually succeeded in doing this, instead of attempting to recover, synthetically, a point of view that belonged to a past era, their break with tradition might have been fruitful. As it was, their experiment ended in failure because it did not, in fact, return to Nature, but tried in vain to recapture the spirit of a period which was long past, and confused the study of Nature with a detailed imitation of its forms.

In landscape painting Constable and Turner had actually

broken new ground away from the classical ideal, but it was in France that their influence was most felt, and the rebellion against stale academic tradition was far more successful there than in England, culminating in the greatest period of French painting. Delacroix and Courbet are the links between the old and the new; Manet is the turning point and the first, and possibly the finest, of the great modern school.

Manet, Renoir, Degas and the rest of the Impressionists were never portrait painters, although they painted many portraits. They were far too revolutionary to appeal to the average person who wished to be painted. But their work influenced all painting and created new traditions.

The portraits of Manet are painted in the "direct" manner. Instead of a monochrome underpainting he uses a full brush of colour; detail is discarded, and the concentration is on freedom of handling, and the relationship of one colour value to another to create a new sense of harmony. His pictures are enormously stimulating to study. They are so obviously the work of a born painter who enjoys handling such rich pigment and is interpreting what he feels in terms of paint. Although his work may not seem so revolutionary to-day, it should be compared with the meticulous Ingres portraits; then it will be clear what a new world Manet had opened up for all painters.

Whether it was coincidental that photography had recently been invented or not, the new trend was all away from photographic representation and towards the discovery of fresh fields for the painter to conquer.

Renoir was another born painter. This means that just as a poet expresses his emotions in the rhythm of sound and words, so Renoir expressed himself in the rhythm of colour and form. He discovered new possibilities in the expression of colour by breaking up light into prismatic primary colours. He combined a natural tenderness with a warm earthy quality, and so managed to avoid his pictures becoming sentimental. His portraits are gay and original. One of the loveliest is the woman in "La Loge". The head is painted with a deceptive simplicity, and the richness

of the elaborate gown, with its bold black stripes contrasting with the lace frills, roses and pearls, is suggested with consummate ease. Compare the treatment with the painting of the embroidered gown in the woman's portrait by Ingres in the National Gallery. However we may marvel at the patience and technical skill, how much more beautiful is Renoir's poetical treatment. In fact, the comparison between these two portraits illustrates perfectly that mere imitation is a method that leads to sterility, and that a free interpretation is alive and exciting when employed by an artist of vision.

Degas, another artist for whom I have the greatest admiration, should be studied for his masterly drawing, his style, his powers of selection and his exquisite taste. His portraits have sensitiveness and integrity. The handling of the paint has enormous variety and, if some portions of his pictures appear to be arbitrarily treated, it is all part of the whole design, and nothing is, in fact, left to accident.

These great artists opened up vast new possibilities for painters and lead the way to further experiments. Each brought his own contribution to the development of painting and, although they are often loosely grouped together as Impressionists, all had something entirely personal to add to the movement. They all shared a desire to free themselves from the shackles of the past, to understand the effect of light on Nature, and to analyse and intensify the painting of colour.

Van Gogh, Gauguin and Cézanne, known as the Post-Impressionists, followed even more individual lines.

Van Gogh, an isolated genius, painted many portraits, using bright, pure colours, and vigorously piling on the paint. A violent and disturbing spirit animated all his work, and to try to imitate him is useless. His technique is the expression of his own nature, and unsuited to anyone else. It has an immediate appeal to the young and impetuous, for it seems comparatively simple, as well as exciting, to take a full brush, brilliant colours and paint with enthusiasm. But Van Gogh reached maturity of expression the hard way, as a study of his earlier work will show it, and it

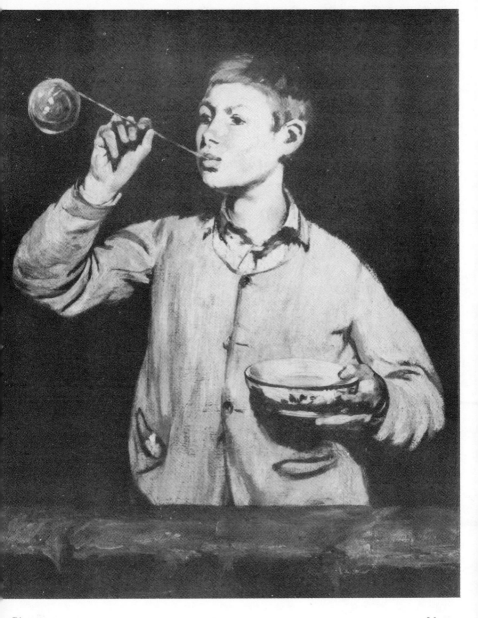

Plate 14 BOY BLOWING BUBBLES *Manet*

A fine, strong, richly painted picture. The bold simplicity of the conception reminds us of Velasquez,
but the direct attack with a full brush of colour marks the beginning of a new era of painting.

National Gallery

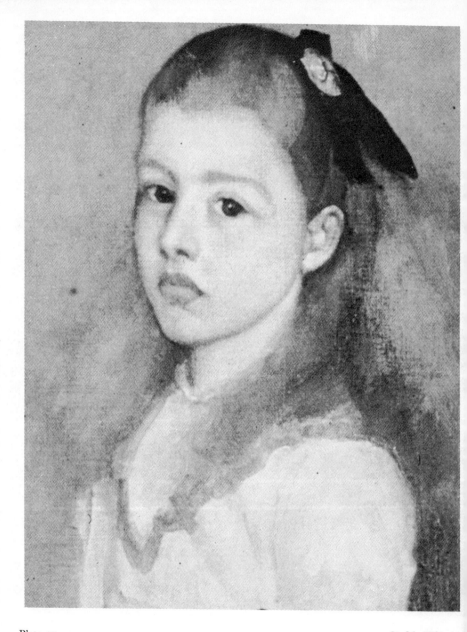

Plate 15 MISS ALEXANDER *J. M. Whistler*

A lovely example of Whistler's exquisite work. One is aware how much thought and technical knowledge have been brought to bear on this painting of a small girl, and yet there is nothing laboured or heavy in the result. He has shown the essential simplicity and gentleness of his sitter, without making her appear sentimental. All unimportant detail is submerged in the general effect and the accents placed as carefully as in a Holbein drawing. Notice the painter-like treatment of the hair.

Tate Gallery

Plate 16 ASCHER WERTHEIMER *John S. Sargent*

Sargent at his most convincing. The man stands before you as if about to speak and you feel he has been 'caught' in a completely characteristic attitude. As a composition it does not compare with the work of the great Masters, but it is a brilliant piece of bold, direct portrait painting.

Tate Gallery

Plate 17 THE SMILING WOMAN (detail) *Augustus John*

This masterly portrait compares favourably with any portrayal of feminine character ever painted.
It is strong, vigorous and dashing, but no mere display of skill. It is a penetrating and sensitive study
and a richly painted piece of modelling. It has all the great traditional qualities as well as being of
its own period. Tate Gallery

is his burning sincerity that lifted his work into the first rank. Gauguin was more interested in pattern and new harmonies of colour than in painting individuals, but Cézanne based his painting on a logical theory of interpreting form in pure colour, and his work has had a far-reaching influence on modern art. His portraits are somewhat devoid of humanity, or perhaps I should say that they have a universal humanity that lifts them above the usual portrait of the individual.

His great contribution to painting was to use the discoveries of the Impressionists in the realm of pure colour, and combine them with a classical formality of design. He searched for the basic forms in Nature and, instead of using the atmospheric softness that was beginning to weaken the Impressionists' work, discovered a way of conveying a feeling of recession by the relation of one colour value to another.

While these new experiments were proceeding, portrait painting continued its course for the time being along conventional lines, both in France and England and other European countries.

Winterhalter was one of the most popular portrait painters, and succeeded in making his Royal patrons look noble and virtuous, as well as handsome and aristocratic. But in spite of his technical ability, his work looks superficial and sentimental to-day.

Millais was typical of a rather later period. Although he began as one of the Pre-Raphaelites, he discarded their ideals and became the most fashionable of portrait painters. His work is interesting to study, because, in spite of his undoubted talents, we can see how he achieved popularity very largely by an appeal to sentiment. His sense of colour is poor, and his technique, though skilful and elaborate, lacks breadth and freedom.

Watts, in a quiet way, painted a number of worthy and serious portraits. They were much influenced by the earlier masters, especially the Venetians, but he only succeeded in imitating their surface without the underlying draughtsmanship. All the same, he achieved a higher standard than the average Victorian academician. These worthy gentlemen, such as Herkomer and Luke Fildes, were sound craftsmen; it is easy to sneer at them now in

the light of wider knowledge. The new French school, although contemporary, had not made its influence felt across the Channel, and the French academicians were no better than the English.

Actually, these Victorian painters had technical resources not to be despised and, when their best work is put side by side with some modern portraits, it often makes them look flimsy and weak. They were thorough and painstaking, but lacked a feeling for real beauty. In fact, they were not fine artists.

An exception was Whistler, American born, but working for choice in England, and much influenced by French and Japanese art. His portraits are unique in his period, both for beauty of design, immaculate taste and sensitiveness of characterization. They may not probe deeply into character, but each picture is a considered work of art, and completely satisfying aesthetically.

Lenbach was attracting the rich and famous to Munich. He had great technical virtuosity, but his portraits are loaded with Teutonic sentiment and pomposity.

Suddenly, at the end of the eighties, a brilliant new star arose, again born of American parents, but English by adoption, John Sargent, in the opinion of many the greatest of modern portrait painters.

Perhaps it is too soon to evaluate his position as an artist. He was undoubtedly a great virtuoso, with an unerring eye for tone, a consummate mastery of the brush, and a keen sense of character. Few painters are above criticism, and Sargent's work has been criticized for lack of design, pretentiousness and poor colour. No doubt there is some truth in these remarks, and I have more often mentioned his work in these pages as a warning than as an ideal to be followed. Nevertheless, I have tremendous admiration for Sargent's best work. It is richly painted, vigorous, free, realistic, brilliant and effective. As a practising portrait painter in modern times, he is almost unrivalled. I can only repeat that in spite of all these qualities his work is dangerous to try to follow, and he represents the culmination of a style of painting rather than a fruitful source from which to draw inspiration.

Although he influenced a whole generation of portrait painters,

none of them has been more than a shadow of him, and none had gone further along the same lines. All the same, I believe Sargent to have been a great portrait painter, whose best work will stand comparison with the masters of the past.

De Laszlo was Sargent's nearest rival, but there was too much of the courtier in his make-up, a quality that Sargent lacked altogether. De Laszlo, whose own virtuosity was outstanding, seemed always to be consciously "flattering" his sitters. Where Sargent was brilliant, De Laszlo seems merely slick. Enough that he was enormously successful, and people with old family portraits felt that his style, an imitation of the "grand manner", fitted into their elegant drawing-rooms. Sargent seldom painted Royalty, because Royal etiquette forbade long sittings in the artist's studio. De Laszlo, with his almost lightning technique, had, therefore, a clear field, and painted all the crowned heads of Europe one after the other, dashing off skilful likenesses in a few hours.

Again, I admit, it is easy to sneer at this kind of ability. Unquestionably De Laszlo was at the very top of his profession, and succeeded in pleasing most of his sitters. But he himself would, I believe, have been the first to have admitted that he had not developed the full powers that lay within him, and had deliberately set out to paint in a style that flattered the vanity of his sitters. He worked to a certain formula, so that his men and women all looked aristocratic and elegant. If one of Rembrandt's old rabbis were hung in a gallery of De Laszlo's lovely ladies and gallant men, they would immediately seem like pictures of stuffed dummies.

Lavery and Shannon were the next most-sought-after portrait painters at the beginning of this century, and both combined elegance with sound technique. Jacques Blanche, painting both here and in France, contributed a Gallic style and wit to the contemporary manner.

V

TWENTIETH-CENTURY PORTRAIT PAINTING

McEVOY, Orpen, Glyn Philpot and John represented new trends in portrait painting.

McEvoy developed a completely individual manner, wrapping his dainty women in a haze of mysterious colour and charm. The Impressionists had begun their influence on English painting, and McEvoy was one of the first portrait painters to be affected. The fact that he was an artist of distinction and integrity saves his work from being too superficial or whimsical, a criticism to which it might otherwise be open. He was an artist who was able to give "glamour" to his women sitters without being either vulgar or cheap. He painted with great sensitiveness and subtlety, and underneath the wayward colour was a firm structure of good drawing.

Glyn Philpot employed a rich technique, using the classical manner of glazing and underpainting, but with a modern feeling for colour. A sensitive artist, he was not always happy under the strain of professional portrait painting, and suddenly threw up a successful career to study again in Paris. He returned with a fresh point of view, painting in a much higher key of delicate greys and yellows. He tried to combine his new sense of colour and design with the requirements of a portrait painter. He seemed about to solve many problems that face the artist who wishes to work in the modern idiom, and still retain some of the humanity that is essential to a good portrait, when he unfortunately died. His best portraits are extremely satisfying, particularly some of his negro heads, and the texture and surface of all his paintings are very beautiful.

Orpen has been dead for many years, but it is perhaps still too early to assess him as an artist. I feel, however, that he will rank extremely high in the ranks of British portrait painters.

He surpasses Sargent in two main qualities: colour and design. He was born twenty years later, so that he was more influenced by the Impressionists and, although his work is entirely English in tradition, he added his own contribution of Irish wit.

The 1914–1918 war brought his work to full maturity, and the portraits in the War Museum show him at its most brilliant. He kept up an amazing level of high quality, and his "Chef", "Surgeon", "Dame Madge Kendal", "Refugee" and dozens of others are all fine examples of his art.

He possessed many qualities which can often lead the artist astray unless they are firmly controlled. His facility seldom became too facile, his brilliant colour seldom vulgar, his virtuosity seldom slick. He had brains, intelligence and heart, and there is an underlying passion for truth that gives humanity to all his portraits. He had his minor affectations and mannerisms, such as his use of mirror reflections and draped curtain backgrounds, but in his hands they seldom struck a wrong note. I place him higher than Sargent, and only below John, who is a painter of genius. His consistency is greater than John's, but John at his best is on a higher level altogether than Orpen ever achieved.

Orpen's work is worth studying by every young portrait painter. He was so alive, so human. He painted so freshly and happily. His work has the quality of permanence, combined with a feeling of spontaneity, and this is amongst the most difficult combinations to achieve.

And so we come to Augustus John, a giant among painters, who is still painting vigorously. He ranks above Orpen because he is gifted with that rare quality—genius. Orpen's talents almost amounted to genius, but stopped just short. John has painted some defiantly brilliant failures, but his triumphs are masterpieces. His "Smiling Woman" is a great portrait, revealing all the mystery, fascination, and devilment of the feminine sex. It is strongly imagined, daringly painted and completely successful.

John has almost the passion of a Van Gogh, the draughtsmanship of Rubens, the power of El Greco. Does he rank alongside these great artists? It is too soon to say. Enough that if his output is uneven, if he may not have achieved the ultimate masterpiece that might have been expected of one so gifted, yet his work is consistently exciting, stimulating and still experimental. He has never allowed himself to get stale, nor into a rut. His success has not turned him into a factory. He continues to paint to please himself. Long may he do so. His research into the painting of form in colour has gone further than most because of his consummate draughtsmanship. If some of his work has disappointed his admirers, it is only because he himself has set such a high standard. At his best he is unsurpassed by any living portrait painter.

And, finally, what of French painting to-day? As far as I can judge, no first-class painters are bothering to paint portraits. The genius of Picasso, Matisse, Derain, Braque, Rouault and their generation has diverted all worth-while talent into new channels. A visit to the *Salon* will reveal some excellent portraits, but on closer inspection they are all by British painters, and were exhibited at last year's Royal Academy. The French portraits are conventional or merely slick. The French genius for painting seems to have discarded portraiture as being bourgeois and out of date.

These powerful artists, of whom Picasso and Matisse are the strongest, are working out completely new problems in visual expression. It is possible that the intelligent layman may in time wish to be painted through the eyes of artists who work in a similar vein, but a long experience of painting rational human beings leaves me in doubt.

I want to make it perfectly clear that I admire these great men enormously. They are artists of genius, whose experiments in colour and form and imaginative interpretation have opened new worlds to the artist. But a portrait must hold on to reality. I think that the tradition of portraiture will continue, and that the work of original geniuses will keep injecting it with new vitality, and so prevent it from becoming stale.

Plate 18 DAME MADGE KENDAL *Sir William Orpen*

Brilliant, colourful and effective—a marvel of skilful craftsmanship. In spite of all the fireworks it remains a sympathetic portrait. Only a professional at the height of his powers could have achieved this tour de force—those less experienced would be wiser not to attempt such a glittering effect.

Tate Gallery

Plate 19 THE MOST REVEREND COSMO GORDON LANG, *Sir William Orpen*
ARCHBISHOP OF CANTERBURY

Another example of Orpen's superb skill. He has obvious enjoyment in the handling of his medium and in painting the rich folds of velvet and satin. Perhaps his work would have been more restful if he could have controlled his excitement a little, but we can undoubtedly share his pleasure in his virtuosity.

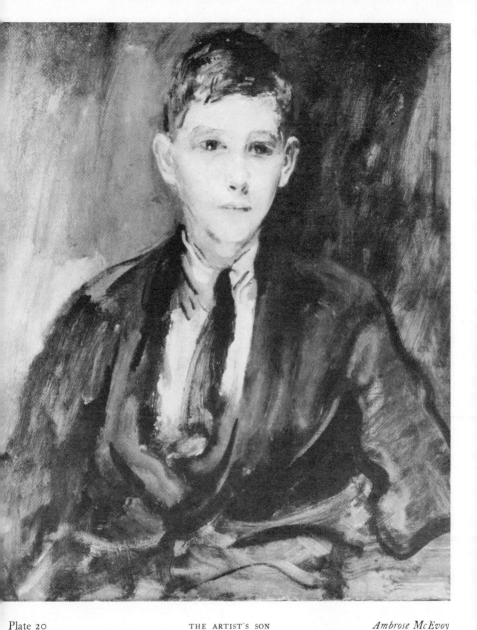

Plate 20 THE ARTIST'S SON *Ambrose McEvoy*

This portrait has great charm and sensitiveness. The handling of the background and clothes is so lively and spontaneous that it escapes the charge of being called merely 'tricky'. The apparently accidental effects are, I should imagine, the results of having the knowledge (and courage) to stop when a brilliant effect has been achieved.

Tate Gallery

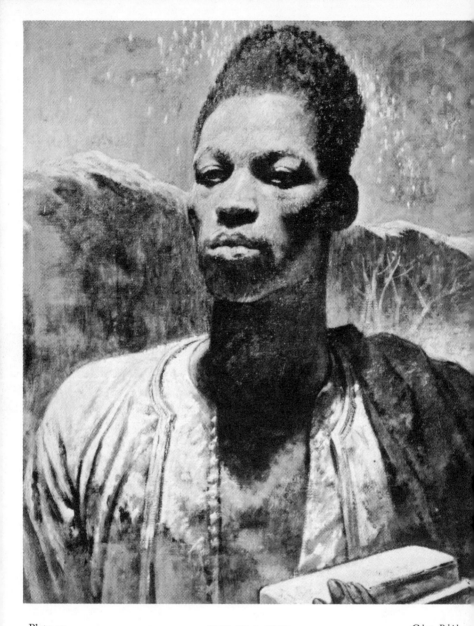

Plate 21 HEAD OF A NEGRO *Glyn Philpot*

A strong, imaginative conception. Philpot always used his medium with understanding of its essential richness and beauty. Note how every part of the canvas is given its relative importance and see how beautifully he has managed his edges, emphasizing and losing where necessary.

Collection of Lord Melchett

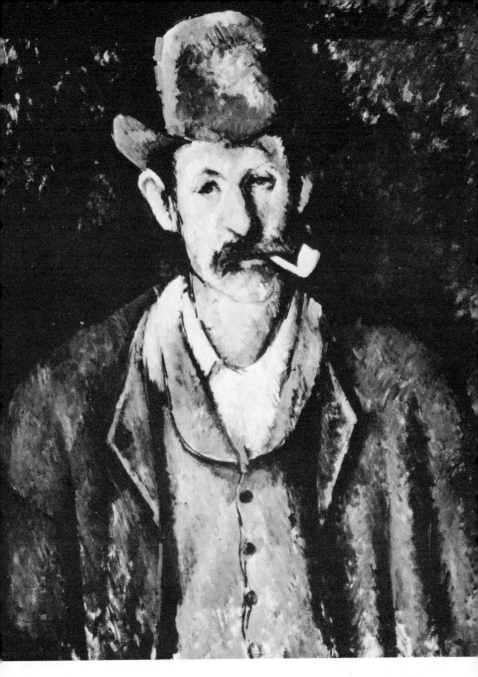

Plate 22 MAN WITH A PIPE *Paul Cézanne*

A Cézanne painting which is not seen in colour loses half its excitement—but even in monochrome we are still aware of the artist's deep integrity, his search for the truth beneath the surface appearance of things. This picture is a fine example of his careful intellectual approach to a portrait.

Tate Gallery

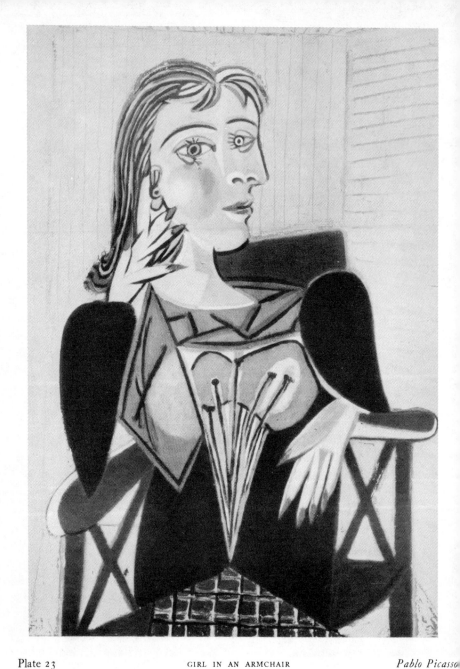

Plate 23 GIRL IN AN ARMCHAIR *Pablo Picasso*

If you have Picasso's originality, force, violence and imagination, this is how you might paint a portrait. If you have not, don't try. You don't want to be Picasso and Water, you want to be yourself.

Twentieth-Century Portrait Painting

Few people would really care to have themselves painted by Picasso or Matisse, and fewer still would like the result if they were. But a new generation of artists may be rising who are being influenced by them, and may, if they remember the secret of how to keep their portraits human, succeed in combining the new ideas with the old, and so satisfy the intelligent layman.

For, after all, that is part of the job of the professional portrait painter. He must appeal to the normal human being. If he fails to do this he will cease to be a portrait painter, and, provided he has a private income or is prepared to starve, must seek other fields in which to exercise his talents.

VI

PRELIMINARY NOTES ON DRAWING

BEFORE describing the best way I know to set about drawing a portrait, there are a few simple principles that I wish to discuss.

One of the major difficulties of drawing a face is to recognize basic forms, and not to be confused by the detail of the features. The features are so intrinsically interesting that the beginner is apt to be led astray, and concentrate too much on them. The result is that the eyes, nose and mouth are not properly related to each other, or to the whole structure of the head.

Let us start by considering a simple oval (Fig. 1). This looks completely flat. If. however, we draw a curved line across it (Fig. 2), it already gives an illusion of roundness, and looks egg-shaped.

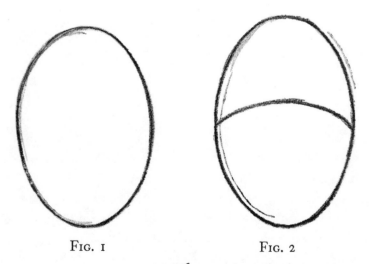

FIG. 1 FIG. 2

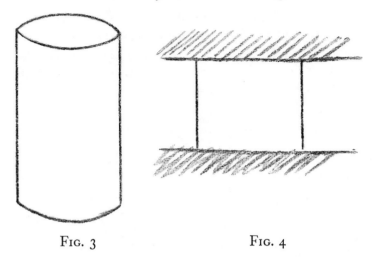

FIG. 3 FIG. 4

A cylinder can be represented by a simple drawing as in Fig. 3. If, however, we mask the curves at the top and bottom (Fig. 4), we know nothing about the form. It is the lines across that reveal it.

These two simple demonstrations are to show the vital importance of thinking *across* what we draw.

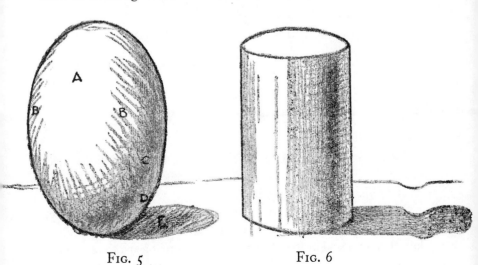

FIG. 5 FIG. 6

Now let us introduce a source of light. Suppose the light comes from the top left-hand side, then the egg-shape of Fig. 2 will looks like Fig. 5. (A) represents the area of highest light, (B) the area of modelling graduating into (C), the area of deepest shadow, and (D), the area of reflected light.

FIG. 7

If we place the egg on a flat surface, it will cast a shadow which will have a definite shape (E).

Fig. 6 shows a cylinder affected by a source of light, and casting a shadow, and shows how a cast shadow reveals the form of the object on which it falls.

Now these demonstrations may seem extremely elementary. The object of stating them here is to remind you that a portrait is largely composed of these forms, and you must learn to recognize them. For instance, the whole head is really a simple egg-shaped

form, and the neck a cylinder. If we place them in a similar light to the one in the previous illustrations, the same facts will hold true. The highest light will come on the forehead, the turn of the cheekbone and jawbone will be clearly modelled, and there will be a certain amount of reflected light on the cheek. The nose resembles half a cylinder; the cheeks and chin are like parts of the egg form—so are the eyes.

The shadow cast by the nose will reveal the form of the upper lip, and the one cast by the jaw the form of the neck.

As for the actual pencil treatment, it must remain very largely a matter of individual feeling. I usually follow the natural movement of the wrist. This is a good way of treating a surface that is passing into shadow. The phrase I use is: "taking it back". It is also useful in the treatment of cast shadow. When modelling, let your pencil travel round and across the forms in the most expressive way you can.

"Line" is one of your important means of expression. "Line" is really a convention to indicate the edge of a form or plane. If the line is sensitive, it will be able to express a great deal about the form it encloses. By its hardness or softness, its thinness or its fullness, by its rhythm and flow, you will be able to make your drawing as expressive as possible.

Do NOT think in terms of "outline" and "shading". These terms reflect a basically false outlook. Think of "line" and "modelling", and think of them as almost inseparable and interwoven. Distinguish between cast shadows and surfaces turning away from the light.

You will be wise to draw a number of groups of simple objects before starting a portrait seriously—jugs, bowls, books and so on. These will teach you how to express basic forms before attempting the complicated and exciting features of the face.

It will also be necessary to know something about the structure and anatomy of the head and neck. Someone once remarked that to become a good draughtsman you should learn anatomy, and then proceed to forget all about it. There is much wisdom in this. It is good to have a comprehensive knowledge of what you are

drawing, and know what is going on under the surface, as long as you do not let your drawings look like illustrations to a book on anatomy.

Briefly, then, we all know that the skull is a hard bony structure, and this must be felt for in your drawing, wherever the hair permits. From the bald-headed man to the woman with a mass of elaborate curls, it is always necessary to make the head seem as if it has a solid, hard structure beneath the surface. Wherever the shape of the skull is revealed, stress it in your work. The forehead and temples are basically characteristic of the sitter.

The eyes are round balls, placed in bony sockets; the iris projects slightly like a boss.

The eyelids are like two shutters over them, and it must be clear that they can close over the eye. You must show that the eyeball is *inside* the lids. The lids themselves have a certain thickness which must be indicated in your drawing.

The cheekbones are usually clearly revealed, depending on the plumpness of the cheeks. They run from the ear round to the nose, curving down under the eye-socket.

The bridge of the nose is hard bone and always clearly visible. The cartilage which forms the tip of the nose, and is usually a little larger than you think at first, joins on to the bridge and the nostrils tuck in underneath.

The jawbone is usually clearly marked as it runs from behind the lower part of the ear to the chin.

The muscles round the mouth affect the expression very much indeed. The lips should not be considered separately from these, but should fit into the surrounding muscles, tucked in the corners. With middle-aged and older sitters it is very important to distinguish between essential structure and superficial "lines", sagging muscles and plumpness. For instance, do not stress the furrows from nose to mouth to the extent that you would a cheekbone. If you examine these furrows closely, you will see that they are more softly modelled than they at first appear, and in any case are of a fleshy nature, and should be treated accordingly.

It is not the purpose of this book to deal fully with anatomy.

You should, however, become familiar with the structure of the human body; not only with the head and arms and hands, but with every part. The ability to create the illusion that there is flesh and blood and bones underneath the garments you paint very largely depends on your knowledge of anatomy.

VII

DRAWING A PENCIL PORTRAIT

Now I want to describe the best method I know of drawing a portrait; one I have used for twenty years myself. Although I prefer charcoal for professional use, there is no doubt in my mind that pencil is the finest medium for the purposes of study. It is an extremely sensitive instrument, and can express the most subtle and delicate line as well as the most vigorous accents. It responds immediately to the slightest pressure; it can be removed cleanly and without difficulty; it does not smear; it does not get gritty or sooty. In fact, it is a perfect instrument of expression.

A pencil study can be worked at for a long time without becoming spoilt, and is therefore particularly suited to the student. A pencil does not flatter the artist, as chalk or charcoal are liable to do, but reveals the quality of his thought and feelings. As we have seen in the work of Ingres, Orpen and John, a pencil drawing can be a subtle and beautiful work of art.

I advise the use of a B or HB pencil, with a long, sharp point, on a good quality cartridge paper. If the paper is fairly smooth, you might try a 2B. On the whole a B is excellent for general purposes.

You need a well-made drawing board, about 24″ × 16″. Rest one end of it on your knees and the other on the back of a chair or desk. If you prefer to stand, then draw at an easel, but whichever way you work see that your board is steady. The slightest vibration is fatal to good results. Use strong drawing pins, at all four corners of your paper.

Do not be casual or haphazard about your work. How often

have I seen students begin a drawing on creased paper with a couple of drawing pins stuck in the top, their pencil-points blunt, a dirty piece of india rubber and a wobbly easel! How can they expect to produce good work or learn anything? A drawing is a delicate, exact and sensitive operation, requiring the highest degree of concentration. Your materials must be of the best quality, and able to respond immediately to your lightest touch.

There is a direct current passing from what you see, through your mind, down to your hand and so to the paper. The current must not be interrupted by any accident or material obstacle. I particularly wish to emphasize this point.

If your mind is not fresh, your eye keen, your pencil sharp, your paper smooth, your board steady—it is waste of time attempting to draw a portrait. I might even add that your hands should not be moist or sticky, as they will be touching the paper while you are at work.

So much for your materials. I would like to add: do not use an india rubber. I know this is a counsel of perfection—but I will try to prove that you are better without one, except in special emergencies.

Now let us decide exactly what we are attempting to do. We are going to draw the *form* of the head and features of our sitter. We are going to search out the bone structure, and the subtleties of modelling.

If our drawing is good, a sculptor should be able to make a model from what we have drawn. We are not concerned with tone or colour values, as in a painting. Local colouring, such as in the eyes, lips or hair, should be treated conventionally, and not be confused with the drawing of form. We are reconstructing, on a *flat* surface, something which is *solid*, bearing in mind everything that can re-create its solidity.

The way in which the light falls on the sitter is very important, and should reveal the maximum amount of form. It is best to have one source of light, preferably from a window through which a clear view of the sky can be seen, not necessarily a studio window, but one that is reasonably high. Let the light fall rather

from one side. This will reveal the face in the most natural manner. There should be just enough shadow to show up the features clearly.

Be on a level with your sitter. If you wish to stand at an easel, place him on a platform so that he is at your eye-level.

You have a choice of full face, three-quarter view or profile. Your selection must depend on the characteristics of the sitter. You will also have to decide whether the eyes should be looking towards you or away.

Make up your mind, first of all, what is the outstanding characteristic of the model. Whatever it is must be brought out to the full in the drawing. I will deal with the whole question of posing in a later chapter.

You should be fairly close to the model, so that you can see everything you draw quite clearly—say about three feet away. A pencil drawing should be well under life size, about five inches from the top of the head to the chin.

One more word before you start. Do not forget that your eye is an unreliable instrument, which your mind must criticize. You may see a nose too long, an eye too big, and you must constantly be on the lookout for these mistakes. The theory on which I base my method is, first of all, to let your feeling express itself freely, and then to let your critical faculty assert itself and modify what you have done where necessary. The first tentative lines and modelling should be gradually merged in the rest of the drawing as you continue. Every touch you put down should *mean* something. All such dreadful notions as "blocking in" and plumb lines are unnecessary.

For our first demonstration I have chosen a three-quarter view, the eyes looking towards us and the light falling on to the right side of the face.

The Start

Having judged carefully with your eye exactly where you are going to place the head on the paper, begin at the top of the nose, searching for the bone structure between the eyes.

The reason for starting here is simple. This part of the face is rigid, central, and a key point in the all-important triangle formed by the two eyes and the tip of the nose. The correct placing of the eyes either side of the nose is of the utmost importance in getting the likeness.

Your pencil should be used lightly, but with precision. From the very beginning think in terms of modelling. Make careful judgments of distances, but do not rely on your first statements. *Check and re-check.* The eyebrows, which begin to grow just above where you have started, are a useful signpost. Place them accurately, see how they follow the bone structure of the brow, and relate them to the eyes. Place the eyes correctly in relation to nose. Select only the simplest forms, but at the same time search for delicate bits of drawing to guide you. Draw down the bone in the nose, watch where the cartilage joins on, and turns under to form the tip of the nose. Check the distance from the inside corner of the eyes to the wings of the nostril.

Think across the form. Let your mind travel over the bridge of the nose, into the hollow at the corner of the eye—over the bulge of the eye itself, and search for the bone structure in which the eye is placed.

Feel for the cheekbones and the structure of the forehead, which usually shows clearly round the temples. Do not stay on any part too long.

Think rapidly, but take all the time you need to be certain that the eyes are placed with absolute accuracy on either side of the nose, and that the nose is the right length. There is a natural tendency to make the nose too long. Guard against this by careful observation, and keep referring back to the point at which you started.

The time element must always be kept in mind. Let us assume that we are going to take two and a half hours over this particular drawing, an average time for a careful pencil portrait.

The Development

We will now take it that you are satisfied that the eyes and

nose are correctly placed in relation to one another. This relationship is the very core of the drawing, and it should already be apparent whether you are getting a likeness.

Now move rapidly down to the mouth, judging the length of the upper lip with great care, and draw the mouth itself. Complete the structure of the cheeks, comparing one side of the face with the other.

Continue with the forehead. Watch the way the hair grows on to the skull. Feel round the top of the head, place the ears, come round to the jawbone to the chin, and check that the chin is in the right relation to the mouth.

Never try to judge distances that are too far apart. Constantly insure against inaccuracies by counter-checking.

Build from your first attempts to more accurate second judgments. Put down your tentative lines or modelling, and restate them, several times if necessary. Where a part of the head is in shadow, do not do more than "take it back" lightly. Treat your cast shadows with equal lightness and watch for their shape; for instance, those made by the nose and chin.

Up till now everything should be kept very light in touch. When you have drawn the whole head in this way, and felt for the column of the neck, and the way it fits on to the shoulders, you are ready for the third and last stage. The development should have taken about an hour and a half in all.

The Final Stage

The drawing now lies in front of you, and you are in a position to judge it as a whole. Pause for a few moments and consider it carefully. Are the proportions correct? Has it got the likeness? If you feel satisfied with your progress, then carry on in the following manner; if you are not quite happy, search for the cause of the trouble and correct it.

Now select some particular feature that interests you, the eyes for instance, and develop them more fully. Strengthen your darks, accentuate bits of drawing. As one part of the portrait begins to grow, you will have little difficulty in deciding what to do next.

You are by now certain that everything is in its right position, and can move freely from one part of the head to another, as it calls for your attention.

The placing of accents will give a liveliness to your work. Through having held them back till now, you're in a position to put them in with assurance. Surface detail, round the eyes and eyebrows can be delicately but firmly indicated. The meeting of the lips should be well defined, and you can allow yourself some freedom in the treatment of the hair. Model the cheeks firmly, emphasizing the bone structure wherever possible, search for the subtle modelling underneath the eyes and round the mouth.

Before pronouncing the drawing finished, take another few minutes' rest, so that your eyes, which may be a little strained, will regain their freshness of vision.

So we come to the final touches, completing the neck and shoulders, and the drawing is done.

To sum up:

First Stage. Make absolutely certain of the correct relationship between the eyes and nose.

Second Stage. Develop outwards from this triangle, and complete the whole head lightly, searching for the bone structure.

Third Stage. Develop the individual features, the general modelling, and place your accents.

In the next chapter I shall discuss the construction of individual features, and describe in detail how to treat them.

It is possible that I have conveyed a feeling of urgency while describing the foregoing method. This is not unintentional.

I do not mean that you should be in a rush—far from it. But there should be a liveliness in your thought, a certain vitality in your attack, and rapidity in execution. Your eye and mind must be alert, and your feelings aroused. If you are merely slogging away in a routine matter-of-fact manner, your work will look laboured and lifeless. Drawing requires the highest degree of concentration. Your vision must be at its keenest. As you work you should alternately express yourself freely and criticize yourself severely. If you "let yourself go" too much, you are liable to land

in trouble. But if you are too careful, the drawing will look laboured.

The method I have just described allows for both self-criticism and freedom of handling. I have found it invaluable.

VIII

DRAWING A PENCIL PORTRAIT
(Continued)

THE choice of pose is very important.

If you are drawing a portrait consisting of the head and shoulders, you have a fairly wide selection.

So far we have dealt with a three-quarter view, eyes looking towards us. There is, of course, a range of pose from one profile to the other—and occasionally beyond. You must also decide whether to tilt the head up or down, or to one side.

The profile, as seen looking towards the left, can be an excellent choice. I have often selected it when I am short of time. It is nearly always a characteristic view, and on occasions the most characteristic of all. Some actors have been known to make a reputation by their profiles alone.

In some ways it is the "easiest" view. It is certainly the quickest way to get a likeness. Naturally, it omits a great deal that may be important, particularly in the eyes.

When drawing a profile, commence by feeling the edge of the forehead, before coming down to the bridge of the nose. The forehead is a hard surface, and the relation between the forehead and the bridge of the nose is very important.

Then begin to place your eye and eyebrow in relation to the forehead and nose, and proceed much as in the three-quarter view. If the sitter is facing the light, the bone structure of the nose, cheek and jaw will be well defined. If the head is turned away from the light, the emphasis is more on the profile itself.

Your line should be particularly expressive in a profile.

Differentiate between the bony forehead and bridge of the nose, and the softer tip of the nose and the lips. Then feel the firmness

of the chin. Do not let your profile seem as if it were on the side of a coin in relief. Remember to show that the head is solid. This can be achieved by attention to the form of the back of the head, the treatment of the hair, and by observing how the light falls on to the head generally.

See how the eyeball is tucked well inside the eyelids. This is clearly shown in profile, and must be closely observed.

I have been amazed at the difficulty some beginners have found in seeing what is actually there. They seem to have a mental image of what the eye is like—something resembling Fig. 8, when, in fact, it is more like Fig. 9.

FIG. 8 FIG. 9

Watch how the lips close softly together, the lower lip tucked underneath the upper.

Place the ear accurately in relation to the nose. Check its distance from the corner of the eyebrow, and again round the jawbone to the chin. Try to draw it with as much simplicity as you can, searching for its main curves, and not getting involved too soon with detail.

The view which shows the further eye just visible beyond the nose can be just as characteristic as the profile itself. It reveals less of the back of the head and more of the structure of the forehead and possibly a little of the further cheekbone.

There are certain problems round the mouth that need solving —a little of the further cheek may be visible, and the receding plane of the chin must be recognized. Otherwise proceed much as in the profile.

Now comes the first of two distinct three-quarter views, and it is wisest to keep the eyes looking away until the head is sufficiently turned to allow the sitter to look at you without strain.

This view is good for showing the sitter in serious or contemplative mood, or if he cannot return your look without self-consciousness. It is also a good pose to choose if you wish to give an impression of movement, the head turned away, although the shoulders are facing you.

Next we come to the three-quarter view, eyes looking towards you. This is one of the most satisfactory of all poses. It gets the "look" of the sitter, as well as a clear view of cheekbones, and a suggestion of the shape of the head. I have used it many times, and seldom regretted my choice.

Front face has also many advantages. It is excellent for a very symmetrical face. It gives an impression of frankness of character. It cannot fail to give a great deal of information about the sitter. If the light is from one side, the structure of the cheeks can be almost as clearly felt as in a three-quarter view. You must suggest the shape of the nose jutting towards you. Proceed exactly as in drawing the three-quarter position, being careful to balance one side correctly with the other. This view brings out the beauty of a well-balanced symmetrical face to the full.

Leonardo da Vinci makes it an axiom that in a portrait the eyes, head and neck should all be turned in different directions, giving a graceful impression of movement. This it undoubtedly does, but it should not become a formula. There are many sitters who are not graceful by nature, and if I were drawing a rugged, straightforward farmer, for instance, I would want to express his downrightness, rather than suggest a non-existent gracefulness.

The problem of tilting the head a little depends very much on the sitter. When it seems quite natural for someone to sit with his head slightly on one side, or perhaps looking up or down a little, by all means let him do so. But watch carefully that you do not mix two points of view. When you are drawing a head that is level you are immediately aware if it becomes tilted. When, however, the sitter is already posing with his head at an angle, it is not so noticeable if there has been a slight change. It is very easy to fall into the fatal trap of mixing two poses in your drawing, and this must be guarded against at all costs.

However, a graceful pose, with the head turned and tilted, can make a delightful drawing, and I am only warning you to watch your sitter carefully to see that he, or as in a case like this probably she, keeps the pose well.

Whichever pose you choose, be sure that your sitters are comfortable and at ease. Not so comfortable that they look slouched or sloppy, and not too upright so that they look rigid and set.

Now let us consider in detail the treatment of individual features.

We have already dealt with the importance of placing them accurately, and made it abundantly clear that if they are in the wrong position there is no point in proceeding further.

The Eyes

So much of the success of a portrait depends on the eyes that a full understanding of them is essential.

All eyes are beautiful, and they should be drawn delicately, with subtlety and feeling.

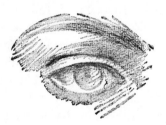

Fig. 10

They reveal the true nature of the sitter more than any other single feature. You may fail to recognize your nearest friend if a mask is placed over his eyes.

We have spoken of their anatomy in a previous chapter, and mentioned the facts about the eyeball, the lids and the manner in which they fit into the bony structure of the socket. All this must be constantly kept in mind while drawing them.

In Fig. 10 I want to illustrate the first feeling towards drawing the eye, before you begin to stress the details.

Starting at the inner corner near the nose, you should sweep along both edges of the upper lid, and place the iris in its true position, feeling immediately for the shadow cast by the lid and the lashes on to the eyeball. This will keep the eye inside the lid. See how the light catches the lower lid. Do not try to draw the edge of the lower lid by means of two lines, but search out how its thickness is revealed, very often at the corner as a narrow horizontal plane between the eyeball and the soft pouch underneath the eye. Look also for the thickness of the upper lid, where it is visible, as in Fig. 10.

Suggest the darker colour of the iris, but very, very lightly, and leave the highlight untouched.

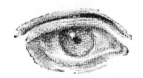

Fig. 11

See that the slight protuberance of the eye is suggested. Fig. 10 gives the feel of the eye and eyebrow before you have started to stress detail or accents.

To continue: draw the upper lid more firmly. The top edge is usually clearly marked, and you should note the form between it and the eyebrow. Emphasize the lower rim where the lashes grow.

Draw the pupil, and realize that the iris is like a convex mirror, reflecting the room. The highlight is on the side nearest the light, being a reflection of the window, and is surrounded by a dark area. The other half of the iris is filled with light reflected from the part of the room illuminated by the window. (See Fig. 11.)

Try to avoid the highlight coming directly on to the pupil. This gives a glassy look to the eye.

The upper part of the iris will be shaded by the lid and lashes.

The iris is often smaller in relation to the whole eye than you may at first imagine.

Feel the form of the lower lid, but do not unduly stress the pouch of the eye. Draw the two eyes as much as possible at the same time.

In the three-quarter view the further eye always presents certain difficulties of foreshortening. You must remember that it is turning away round the curve of the head. Watch its relation to the nose and to the cheekbone. The usual tendency is to make it come out too far. Guard against this common error by very careful mental checking. The iris is elliptical in shape when turned away.

From this angle you can see the thickness of the upper lid very clearly. Watch where the two lids meet at the corners.

Note the outward curve of the lashes.

In profile the iris is a narrow ellipse. Notice its transparency. Keep the eyeball well inside the lids. If the eye is turned towards the light, be sure that the further side is in shadow, including the white of the eye and the lids. (Fig. 12.)

Fig. 12

The "expression" should come if you draw sensitively, watch how the eye fits into its surroundings, particularly into the part beneath. As a person begins to smile, the lower lid puckers up a little. Keep your final accents for the pupil, the lashes and the clean line of the upper lid.

The Nose

If your nose is well drawn you have solved one of your major problems.

64

Being the most rigid feature, you should tackle it firmly from the start. The bone is clearly marked. Think of the nose as a sculptor would. It has receding planes on either side, and one across the front. At the tip there is a fullness that turns under. The wings over the nostril must lie back on either side.

In the full-face view you can check the length of the nose four times—from the corner of each eye to the wing, and from the corner where the bridge meets the brow to the tip, on either side.

In the three-quarter view you have three checks, and in the profile three as well—the outside edge, the modelling of the bone, and the corner of the eye to the wing.

FIG. 13

Where the nose casts a distinct shadow beneath, treat it as such, as shown in Fig. 13. The darkest accents are usually the nostrils. Watch how the structure curves round them.

The Mouth

The mouth presents particular difficulties—partly due to its extreme mobility, partly to its local colour.

You must not think of the mouth as if it were just two firmly-chiselled lips pressed tightly together. People's mouths vary so much, from the thin tight-lipped variety to the full clearly modelled kind.

Characteristics to note are as follows: The top lip, although often a clearly defined cupid's bow shape, has not got a hard edge. Keep in mind that lips are of the softest texture.

The corners must tuck into the surrounding muscles.

The meeting of the two lips is usually the most clearly defined part, and is often accentuated by shadow.

The upper lip is usually turned away from the light—the lower more exposed, and often revealed by a shadow underneath. Do not be confused by colour. As far as possible, ignore it. If your sitter is feminine and uses lipstick, indicate this by a very light general tone all over, but do not let it be confused with the modelling.

If the mouth is very slightly open, watch for the shadow cast by the upper lip. A smile will naturally tend to enlarge the mouth and deepen the corners.

If the teeth show a little, make no attempt to draw them. Merely indicate that there is a light surface visible.

Variety of movement often makes the mouth difficult to draw. From the point of view of likeness there is often "something the matter with the mouth". Many times it is not the mouth that is really at fault but the modelling round it.

The Chin

Keep in mind that most chins are rounded, often with a slight cleft and need the same sort of modelling as if you were drawing part of a sphere. There is usually a fairly strong reflected light from the neck or collar, and this will help you to show the form.

The Hair

The hair lends itself to individual treatment. You can afford to let your pencil flow more freely and rhythmically.

If you are drawing a woman, search for the sculptural qualities of her hair-style. Keep the head as a whole in mind. Do not be confused by colour. If the hair is dark, by all means suggest it in your treatment. But, again, do not let it interfere with the form, which is your primary concern.

Observe how the hair grows from the forehead. Observe the outer edges. It is wise to use a simple background for your sitter, so that the silhouette is revealed. Do not let detail and uninterest-

ing accident get in your way. But do not hesitate to use a way-ward curl or graceful wave to give your drawing variety and movement.

We have now come to one of the major considerations in drawing, and indeed in the whole sphere of art. This is the question of *Selection*.

Up till now I have stressed the importance of selecting the significant structural elements in a portrait. When it comes to drawing things like hair, clothes and so on, the selection must inevitably be more personal. Each artist will select from the mass of detail what he considers interesting or attractive. One will be fascinated by the rhythm of falling waves, another by the glossy texture of the hair. It is not necessary to make any rules. Your selective powers must be brought to bear on the problems, and your work should not be a conglomeration of unrelated detail.

Selection is at the very core of an artist's work. All the time he is studying nature he is consciously or unconsciously selecting what to express next. And selection implies rejection. Rejection of the uninteresting and the unimportant. What these are, the artist himself will eventually decide.

Till now I have tried to indicate some of the basically important things—structure and form. When we are treating anything as variable as hair or the folds of a dress, we are much more free to express ourselves in what I should call a lighter mood, still keeping in mind structure and form.

Naturally, there will be differences in the way you draw young and old, men and women.

Children must be drawn with exceptional delicacy, lightness and sensitiveness and, if possible, rapidly.

Young people of both sexes can be treated more firmly—the form is usually clearly modelled.

As women grow older, the changes in the form of their faces is often very slight. The merest touch of emphasis under the eye, or round the mouth and chin, makes a woman look five years older. Even when she is well into middle age, it is not necessary to overstress these indications of maturity.

I do not mean that you should flatter your sitter, or omit these no doubt unwelcome signs of age; only that you should give them just enough importance, and no more.

With an old woman, if you treat her sympathetically, the signs of age will give character. Remember that surface wrinkles and lines *are* on the *surface*, and that the bone structure, which may be clearly revealed, is of greater importance.

With men, advancing age often gives more character to the face, and the study of an old man's head can be the most interesting of all to draw.

A feeling for what is beautiful and exciting, the power to select and emphasize particular characteristics, combined with tact and sympathy—all these qualities are helpful when attempting to draw a good portrait.

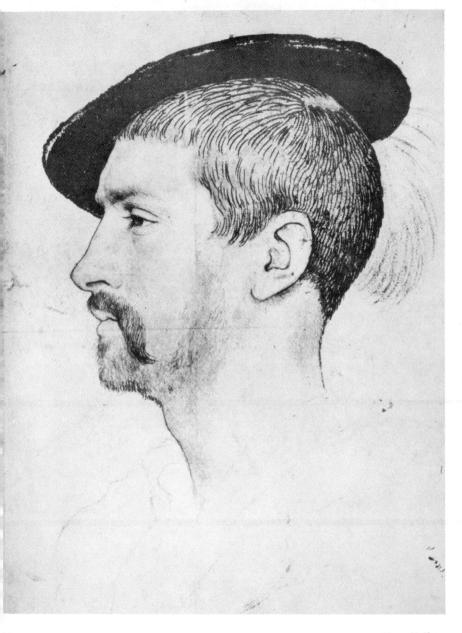

Plate 24 SIMON GEORGE OF CORNWALL *Hans Holbein*

A fine, strongly felt drawing. How skilfully the artist has emphasized the profile, and enjoyed himself with the pattern made by the hair and moustache. And study the simplicity of treatment of the hair.

Windsor Castle

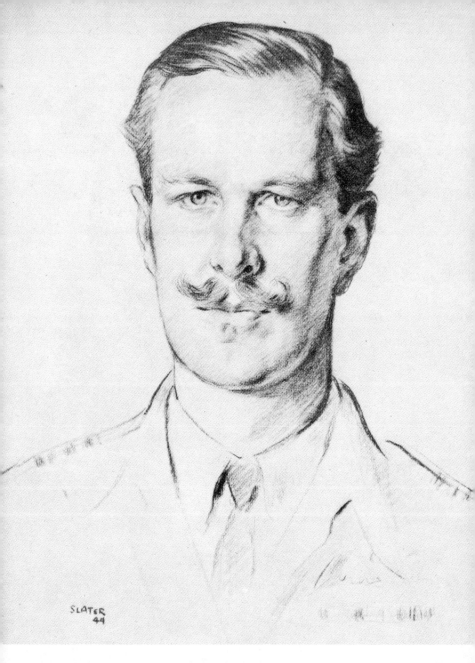

Plate 25 GROUP CAPTAIN GEOFFREY AMISON *Frank Slater*

This charcoal sketch was completed in a couple of hours, using the method described in Chapter IX. I try to use charcoal as delicately as if it were a sharp pencil and still retain, if possible, its rather richer quality.

PORTRAITS IN CHARCOAL AND OTHER MEDIA

U P till now I have been discussing the drawing of a portrait in pencil. I must repeat what I have said earlier. *Pencil is the best medium for study.*

Once, however, that you feel you can tackle a pencil portrait with confidence, you will wish to experiment in other mediums.

I would like, at this point, to recount how I discovered the particular qualities of charcoal.

I had been studying for many months with the point of the pencil, and I believed I was making some progress at the Art School. When, however, I made some sketches of my friends at home, the results seemed perhaps a little hard, and rather formal.

I had become acquainted with a fellow student, a charming woman whom I admired, but whose work I considered amateurish. She had a beautiful studio in Chelsea, to which I was one day invited. On the walls hung several very attractive charcoal portraits. I was amazed to learn she had done them.

I was, quite rightly, a serious student, who despised all flattering aids to my work. But I realized that if occasionally I allowed myself to indulge in the luxury of charcoal, tinted paper and white chalk, I too could produce a very attractive portrait.

So I evolved a technique that seemed to combine the delicate and clear handling of pencil with the richer, more effective charcoal. I avoided any kind of full tonal effects, with black shadows and rubbed-in half-tones.

I kept the piece of charcoal finely sharpened, *constantly renewing the point with a razor blade.* I drew life-size heads, and allowed

myself richer treatment of the hair. I tried to extract the best out of charcoal, and to avoid its chief disadvantage, a tendency to be sooty and "smeary".

Its many advantages are as follows:

It has a very wide range, from deep black to the lightest possible touch on the paper.

It can, with skilful handling, occasionally rubbing it with the tip of the finger, express the most subtle nuances of form on which the expression depends so much—particularly round the mouth.

It is more realistic than pencil, and gives a more vivid impression of life.

It reproduces better than pencil.

You must be careful to avoid making your drawing too "photographic", which means trying to imitate the tones. Sargent's earlier drawings were really "paintings", that is to say, studies of tone values, admirable in their way, but NOT a style to be recommended. His later drawings avoided tone, and were much finer works of art.

Materials

I recommend sticks of hard Venetian charcoal. They can be sharpened to a fine point, and do not crumble easily. Do not hesitate to discard one that is gritty or does not respond to your lightest touch.

Ingres or Michallet paper is the best, and the colour I prefer is light grey. If you use white paper, you cannot enjoy the advantage of white chalk for the highlights.

You need a piece of putty rubber, which leaves no grains behind after use. It can be twisted into a fine point if you require to pick out a highlight.

A piece of white Conté chalk, also sharpened to a fine point, will be found most useful.

Finally, you need a bottle of charcoal fixative and a spray.

Procedure

Begin exactly as you would a pencil drawing. Do not be in a hurry to use the white chalk.

When you are ready to develop the drawing from the first stage, you will be able to feel for the form more easily if you touch the lights with a suggestion of white, and pick out the highlights in the eyes.

You are also able to express the hair more convincingly with charcoal, and if the hair is grey or white, your chalk will be very useful.

If you are drawing someone with a mobile expression, and this means nine people out of ten, you will find charcoal most convenient for following the changes of expression without committing you to any particular one, until you have made your final choice.

As you talk to your sitter, and watch the play of expression on his face, you often wish to experiment with slight changes. Charcoal, *within certain limits*, allows you to do this, without spoiling the freshness of the drawing. With the merest touch of your finger you can modify a subtle piece of modelling that will make all the difference.

Your experience will teach you that the human face is full of endless surprises. If you do not know your sitter well, your first impression will often have to be qualified as your drawing proceeds. Charcoal allows for this. But do not treat it with disrespect. It cannot be pushed around indefinitely. You cannot satisfactorily alter a fundamental mistake in drawing. If you have got into a muddle, it is best to start again.

What charcoal *does* allow is the freedom to suggest those infinitely slight changes of contour that make a face look human and alive.

When you are finishing the drawing, do not hesitate to strengthen your accents to the full. Be sure that you select the exact positions of the darkest darks and highest lights before you give them their full value.

Should your sitter be wearing glasses, the white chalk will be found most helpful. Watch, too, how the shadow cast by the rims of the spectacles helps to reveal the form of the cheek. Your treatment of glasses should be light in touch, and you must see that the eyes are kept well behind.

Here and there you can afford to let your line become quite forceful and accentuated. Charcoal is particularly suited to this. It is important to get to know the full possibilities of your medium, but it is wisest to keep everything as light as possible before "letting yourself go". Nothing is more disagreeable than a dirty or smudgy charcoal drawing.

Every medium has a beauty of its own. Pencil has the charm of delicacy and sensitiveness. Charcoal can be almost as delicate with an added force and depth.

As you become more skilful you will be able to select your accents so that they give the maximum vividness and excitement to your work—but be sure there is first a sound foundation of form.

Personally, I have a prejudice against any kind of "stunt" lighting, or anything else that can in any way cheapen your work.

I must admit, however, that if you have an urge towards unusual lighting, either by the use of a mirror or artificial light, charcoal does lend itself to this kind of experiment.

Whatever lighting you choose, taste and good judgment should keep your work from becoming vulgar. Orpen and McEvoy made use of unconventional lighting with charming effect.

It is wisest for the student to remain as austere as possible and not to rely on artificial aids to make his work interesting. His drawing must be basically sound and solid. He should be a seeker after knowledge, and not try to gain superficial effects without anything much behind them.

This brings us to the introduction of colour into drawings.

I must again stress my own prejudice, which is in favour of absolute purity of style. It is, however, undeniable that many fine artists have introduced traces of colour into eyes or lips or hair, with great charm and delicacy.

The purpose of this book being to help the student, my advice about the use of colour in drawings is "don't". However, once you feel confident of being a good draughtsman, and wish to experiment, there are several mediums that can be used in con-

junction with pencil and charcoal, in particular water-colour and crayon.

Keep in mind that a drawing is a drawing, and should not become a half-baked painting. A drawing deals in form, and if you introduce colour, it should not attempt to be more than a surface decoration. A delicate tint in the eyes or on the lips and cheeks of a woman's portrait can be very effective, but you must know when to stop. The colour should not be an attempt at full tone, but a transparent tint (if in water-colour) suggesting the local colour only.

I am frankly not enthusiastic about this kind of work, and have never indulged in it myself, but I do not wish to impose my personal prejudices on others.

In a word, "anything goes" if it is done by a good artist—who will have his own standards of good taste.

Pen and ink is, of course, a very difficult medium for portraits, because of the impossibility of erasing. But it can be an interesting method for testing your accuracy of judgment. It can be introduced into a pencil drawing to accentuate detail here and there, but it needs considerable experience to place these accents accurately.

Chalk is a beautiful medium. It has, however, two disadvantages—it is difficult to erase, and tends to get clogged sooner than pencil or charcoal.

The fact that it is difficult to erase carries with it the corresponding advantage that it does not smear so easily; but it may give a feeling of strain to know that if you wish to make an alteration it may completely spoil the look of the drawing.

However, chalk and pencil make an excellent combination, with the pencil used to indicate delicate bits of drawing and emphasis.

Once you can really draw, you will instinctively find the medium of expression most suited to your temperament.

A final word about fixing your work.

All charcoal and chalk drawings should be fixed immediately on completion. Stand about two feet from the paper and blow the

fixative steadily through the spray, moving it so that the drawing receives it evenly all over. Do this only for a few seconds at a time, otherwise there is the risk of it running. Repeat the operation several times and test the darkest parts very lightly with the tip of your little finger to be sure that it is properly fixed.

Never roll your drawings. From the time you buy your paper it should always remain flat, and if you wish to preserve a good drawing, keep it in a large portfolio, or, if it merits a frame, put it under glass as soon as possible.

General Summing-up

A considerable experience of teaching has proved to me that most students make the same mistakes to begin with.

I have absolute confidence that the methods I have been describing are practical and sound, and I want to be certain that you will find them helpful. I should not like to feel that you were discouraged if at first you fall into errors that are continually being made by others.

If you make some of the mistakes that I am going to mention, you will realize that they will cause only temporary set-backs, and you will soon learn to overcome them. If you are warned before hand, it may not prevent you from making them, but it will keep you on the lookout, and possibly help you to get out of difficulties before it is too late.

The principle underlying the method I have described is to train your eye to be severely critical. By never using artificial aids, such as plumb-lines, holding up your pencil to measure, "blocking in" and like devices, you are constantly training your vision to become more reliable.

All the same, however well trained your eye becomes, there are always certain illusions and traps into which you are liable to fall. But there is no need to worry unduly if you make errors of judgment, as long as you are working in the right way and are able to correct them before they can do you any real harm.

The most common error is to make the nose too long. I have seen this happen again and again. If the nose is the wrong

length, you will never get the likeness. So do not be satisfied until you have checked the length in relation to the eyes and cheekbone several times, to your complete satisfaction.

Do not make the eyes too big.

Do not make the eyeball seem to be popping out of the lids.

Do not get the further eye out too far.

Do not make the edge of the lips too hard.

Do not let surface markings interfere with the basic forms.

Do not let the features be unrelated to the structure of the face.

Do not leave uncompleted forms.

Do not mix two positions.

Do not make your drawing dark or heavy.

Do not try to "finish" surface detail too soon.

Do not forget that every part of the head must relate to the rest—and fit together as snugly as the pieces of a jig-saw puzzle.

Do not leave empty spaces without any meaning.

Do not run away from an obvious mistake. Search out the cause, correct it, or, if necessary, start again.

Do not be illogical. For instance, do not draw one eye, and leave the other untouched for a long time.

Do not forget that the first judgments of distances you make constitute your scale, and must often be referred to.

Do not let local colour influence your drawing of form.

Do not be afraid to draw the white of the eye in shadow, if such is the case.

Do not attempt to suggest the colour of the cheeks.

Do not confuse a cast shadow with modelling.

Do not concern yourself with the actual darkness of shadows.

Do not attempt to draw anything you cannot fully understand. If necessary, go up close and look at its construction.

Do not draw one single line that does not *mean* something.

Do not stay too long on one part.

Do not rub charcoal accidentally with your hand or wrist.

Do not use charcoal heavily.

Do not use charcoal without a fine point.

Do not experiment with additions of colour, or trick lighting

effects, before you have become a sound draughtsman, and then only with the utmost discretion.

Do not be afraid to start again if you are in trouble.

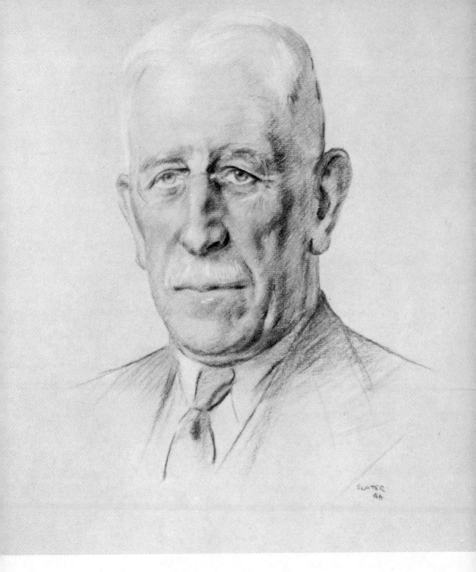

Plate 26 SIR HERBERT WALKER *Frank Slater*

This rather more fully modelled drawing is as far as I care to take a charcoal portrait. It took three and a half hours and was done at one sitting. The white chalk was invaluable in suggesting the hair, moustache and spectacles.

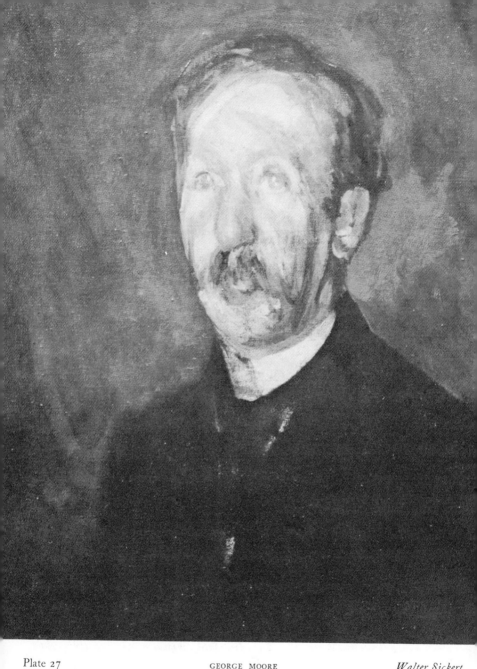

Plate 27 GEORGE MOORE *Walter Sickert*

One of Sickert's few straightforward portraits. This searching study of character is handled by a master. All inessentials are subordinated to the general conception, the watery blue eyes emerging from the rather indistinct moon-like face. Sickert saw Moore in the light of his own personal vision, but the sitter's individuality comes through very strongly.

Tate Gallery

X

MEMORIES OF WALTER SICKERT AND
HIS TECHNIQUE

I WAS fortunate, while at the Royal Academy schools, to work for a time under that very great artist, Walter Sickert.

It was a unique experience which I shall never forget. In three months he taught me more about painting than anyone else before or since.

He said to the students: "I am going to teach you everything I know. Then, if you wish, you can pass the knowledge on to others."

So I want to put on record what he taught us.

Sickert was no portrait painter. Frankly, he had not much time for the man who made his living by painting portraits. But there is in his teaching a great deal that is extremely valuable to one who does.

When he came to teach at the Royal Academy schools, the classes were divided into the usual sections: Antique, Life, Portrait, and so on. For a week he went prowling round the schools, observing what was going on. Then he called the students together.

"From now on," he said, "while I am in charge, the whole routine of the school is going to be different. I have certain things to teach you, and I am going to see that you learn them. I have, during my lifetime, painted in many different ways, some good, some bad. Now I want to show you what I consider to be the best way of all. It is my duty to teach you, and your duty to learn. I worked under Degas and Whistler. You will be in a direct line through them, from the great masters.

"I find you here painting single figures and portraits. I want you to learn how to paint life—real life. I want you to learn to paint pictures. Life is movement—light—one figure cutting across another—people *doing* something. These endless upright figures you draw are like sticks of asparagus. These heads without bodies are only suitable for portraits of John the Baptist, with his head on a charger.

"I am going to show you how to paint *anything*.

"The routine will be as follows. There will be models on alternate days only. Three models will be posed in a group together.

"First of all, you will make a colour sketch of them, *thinking only of the colour relationships*. Then you will make careful drawings. On the days that the models are not posing, you will build up your picture, from your drawings and colour sketches."

His theory was this: The essence of painting is colour. Colour is the true relationship of one colour value to another. In a word —harmony. There is no such thing as an ugly or muddy colour *by itself*. There can only be an ugly combination of colours.

In Nature, colour effects are fleeting. The sun moves, light changes, clouds pass, dawn breaks, a mist lifts. These particular effects can never happen again. Therefore, some means must be sought to catch them as rapidly as possible.

When you study Sickert's own work, you will realize that each of his paintings represents a particular lighting effect. This is what stirred him most: he was, after all, a disciple of Degas, one of the great Impressionists. But he realized that a rapid sketch could have little permanent value. He therefore made his sketches in front of nature purely as guides for his finished pictures.

Although colour is fleeting, form is permanent. So he would draw his subject with considerable care in his own characteristic way—perhaps several times.

Then came the job of making a picture.

Not for Sickert the careful building up of an architectural composition. He preferred skilful selection and ingenious placing.

Having decided just how and where he would cut his drawing

to make the most happy arrangement, he squared it up and transposed it on to a suitable size of canvas.

He then painted a bold monochrome in some very light colour —a warm tone if the picture was cool, as in a landscape, and cool if the painting was warm, as in an interior.

On the top of this monochrome he painted his colour, using his colour sketch as a guide, transparently or semi-transparently.

Every colour would have been carefully selected and passed through the intellectual filter of his mind. What eventually emerged gave the illusion of brilliance and spontaneity, but was, in fact, the fine distillation of emotion recollected in tranquillity. This makes his work poetical and significant.

It is a completely logical process, and it is impossible to find a flaw in it—so far as it goes. What it proved to me was this: Painting must, by some technical means or other, be kept fresh in colour, or it will look lifeless and heavy. The relationship of one colour to another is the key to all beauty of colour.

Sickert's Practice

For his colour sketches he used a fairly small canvas, as he considered it more convenient for rapid work, especially out of doors.

Before starting he covered the canvas all over with a warm neutral tint, and let it dry.

With a small brush he made a quick, map-like drawing of the general outlines and placing of his subject. Then he chose a key-point at which to start, where two or three colour values touched, one of them being, if possible, dark. He judged his dark colour first, because he believed this to be the easiest to judge by itself, and then immediately judged the other two against it and each other.

He would work outwards from there, always meticulously judging one value against another. He pressed his paint firmly on to the canvas, rubbing it in even harshly at times. This kept his paint at the required thinness without having to resort to mediums.

His half-tones were never neutral. He preferred to emphasize their tendency to purple or blue or green.

Not attempting to achieve accuracy of drawing, he could make a colour sketch in half an hour or an hour. The neutral tint of the canvas gave unity to his rather "broken" touch.

His drawings were essentially studies for paintings. Again he would start at some place where objects touched one another, and judged his distances from this key-point. He achieved form by an ingenious variety of emphasis and selection—stressing a line here, an accent there. He did not believe it possible to work calmly in front of nature, and he wanted his finished pictures to be the result of quiet deliberation.

Before he started to paint his picture away from nature, he studied his drawings carefully, and selected just which portion to enlarge for his composition. If you look at a painting by Degas, you will see that he used a similar method. Sometimes he places his main interest high up in the canvas, and leaves a vast expanse of foreground. At other times he will cut a figure arbitrarily in half. But there is nothing haphazard about this practice. It is carefully planned, and achieves interesting and unusual effects.

The monochrome underpainting was done entirely from the drawing, after it had been squared on to the canvas. This gave the picture a solid foundation of form. By separating it from the colour, Sickert was dividing his difficulties.

He preferred to use flake white mixed with Indian red under a landscape, and with terra verte under a figure composition or interior. The highest lights were painted in pure white. The darkest darks were kept very pale. This light underpainting gave the picture brilliance. He painted with a full brush, and the vigour and freedom of his handling gave a feeling of richness and painter-like quality to his work.

When the monochrome was thoroughly dry, he painted his colour on top, using his colour sketch as a guide. He simplified and, where necessary, emphasized accents of light and colour. He put on his paint with force and courage, because he knew exactly

what effect he was trying to achieve—and it was the colour relationships that were important to him.

Some of his remarks were extremely pungent and to the point. On alternate mornings he proceeded to criticize what we had done the day before. Seated before an easel, with the students behind him, he asked us to place our work on the easel, and then said exactly what he thought. As long as we were working in his method we were comparatively safe from his sharp tongue. He did not care whether the student was talented or inexperienced. He praised freely if the student had grasped what was being taught and were making an honest effort to carry it out.

The great advantage of his way of painting was that it allowed the student to express himself as freely as possible for the particular stage of development at which he happened to be.

Here are some of his remarks and advice that I have remembered, expressed as far as possible in his own language.

"There is nothing to be gained by working in a difficult and complicated technique, when a simple and comparatively easy one can achieve better results."

"Mere hard work for its own sake has no particular merit."

"If you use the right technique, you will be able to express what you have felt without the barrier of layers of paint between you and it."

"No one should attempt to make more than a sketch directly from nature."

"To continue painting after a particular effect has gone is illogical and leads to dullness."

"If there is not time to make a colour sketch, make notes and write down, in a kind of shorthand, jottings that will remind you of exact relationships."

"A finished picture should give an impression of lively emotion, but be in fact the result of calm intellectual deliberation."

"If you continually over-emphasize your colour, how are you going to paint a Scotch Tartan!"

"You do not put on four or five pairs of trousers every morn-

ing; one is enough. Why put on more than one layer of colour? It is just as illogical."

"We cannot all be stars. There must be small-part players as well. Do not worry if you feel you are not a genius. If you feel you have something you want to express, do so, to the best of your ability, and it will be worth-while."

"Even the Old Masters had to get up in the morning, brush their teeth and have breakfast before starting work. They were human beings just like you, and had the same difficulties to contend with. The important thing is to paint the right way."

"Many talented people become confused and muddled by oil painting, not because they are stupid, but because of elaborate and muddled techniques, or, worse still, no logical method at all. You should not try to think of form and colour at the same time. My method of separating them solves the chief problem."

I listened eagerly to all he had to say, and it solved many of my problems. But a major one remained. Could you paint a good portrait in this technique? Logically, you could paint anything, but somehow portraits that I tried to carry out in this manner did not satisfy me.

It so happened that Sargent had recently died, and there was a memorial exhibition of six hundred paintings in the Royal Academy at the very time Sickert was teaching. I had spent a good deal of time studying them, and was naturally much impressed.

I asked Sickert: "How does Sargent fit into your scheme?"

He looked at me with a cold eye.

"Of course," he said, "if you want to be a portrait painter, and have duchesses sweeping in and out of your studio, and earn fifty thousand a year, I have nothing more to say to you. That is commercial work, with which we are not concerned here.

"When I was a young man", he continued, "Lenbach, who lived in Munich, was the fashion. Society ladies passed through Munich on their way to the Riviera and on their return the

portrait would be ready. Just a commercial factory. Here we are concerned with Painting and Art."

This effectively silenced me, because I realized that not only was he completely out of sympathy with the portrait painter, but that his method of painting did not solve the portrait painter's problems. I felt you could not dismiss the portraits of Rembrandt and Velasquez and Hals, or even Sargent, with a few clever words. A theory of painting should cover all kinds of work without exception.

Now Sickert's principles convinced me that they were absolutely sound, as far as they went, but I recognized that they did not allow for the one inescapable fact that many artists, including myself, were only moved to paint their best in front of nature, and that without the immediate contact their work failed to convince.

Sickert would have argued that he must learn to overcome this failing. I tried—but soon realized that it was impossible to alter my personal temperament. And, in any case, why should I? Admitting most of his contentions, I set out to devise a technique that combined the principles that he advocated, and yet allowed me to paint direct from nature all the time. I was convinced that most portrait painters required the stimulus of the sitter to be able to imbue their work with true vitality.

I realized that all good portraits painted from life were the result of a technique that managed somehow to keep the colour fresh. In another chapter I will describe two or three techniques that, in my opinion, stick to most of Sickert's principles, and yet allow for the temperament that needs the stimulus of nature all the time.

Sickert admitted that many fine artists had been more successful in this way than in their more considered work done in the studio.

Constable was a case in point. His vast canvases, painted for the Academy, are not now thought equal to his sketches done in front of nature. Compared to the freshness and truth of his spontaneous paintings, his large pictures seem lifeless and tired.

Sickert even admitted that several fine artists had made reputations on what he considered to be sketches only, and he cited Manet as an example. Sickert was a disciple of Degas, who certainly painted exactly in the manner described, and the tradition of painting pictures from sketches and drawings goes back to the beginning of painting. This book, however, is concerned with portrait painting, and although I advise you to experiment in Sickert's method, do not be discouraged if you find it too difficult.

Sickert himself occasionally painted portraits, notably one of George Moore. His insight into the character of the sitter makes this a fascinating painting, but as a rule his portraits are more general impressions of personality, and if carried out by anyone without his particular genius might easily degenerate into caricature.

XI

CREATING A PORTRAIT IN OILS

WE are now ready to discuss the actual creating of a portrait. I use the word creating because, before you put brush to canvas, there are many circumstances that should be arranged to give you the maximum advantage in carrying out this extremely complicated task.

First of all, there is the place in which you are going to work. The essentials are space and light. Space to be able to see both your model and your work from a distance, light to see clearly what you are doing and to reveal every subtlety of form and colour of your sitter.

The light should come from a certain height. There are several reasons for this. Firstly, it will fall on your canvas and on the sitter without any intervening shadow, either from yourself or the canvas and easel.

Secondly, paint is a shiny medium and will reflect light that is thrown directly on to it, so that you will not be able to see your tones and colour correctly. When the light falls from above, and you tilt your canvas slightly forward, this reflection is avoided.

Thirdly, in my opinion, the features are revealed in their most characteristic and interesting way by a light from above. I do not mean a very steep top-light that casts heavy shadows, but one that falls from an angle of about 50 degrees.

The light should come from the sky. If there are buildings or trees intervening you will get red or green reflections which will be extremely confusing.

Again, if your window is high, you can place the model well inside the room, and you will have plenty of space to walk back.

Finally, there is no doubt that unless the light is from the north or north-east, you are in for a lot of trouble. Once the sun comes into the room, you will get an endless changing of light and reflected light that makes continuous painting impossible. The ideal room in which to paint a portrait should not be less than 25 by 20 feet, and the top of the window should be *at least* 12 feet above the floor.

You do not necessarily need a very large window—in fact, a comparatively small one, if rightly placed, can give an excellent light. But the light must be pure, and shine brightly on your canvas and the sitter.

If your window is not quite high enough, it is wisest to paint almost at right angles to it. This will prevent the light reflecting on your canvas.

Should you be unable to work in a proper studio, cover the lower half of the window with a screen or thick curtain to a height of at least 6 feet from the floor.

There are, of course, many other ways of lighting a head that can look extremely attractive. You can use a second source of light, either from another window (with a north-easterly or easterly aspect), or from reflected light off a mirror. This can illuminate part of the shadow side of the face, and make a very pleasing effect. Be careful, however, when experimenting with mirrors, not to create too many accidental lights and shadows which may over-emphasize unimportant changes of form and alter the expression.

A mirror placed on an easel, reflecting the window on to the cheek, neck and hair of the sitter, has often been most successfully employed. Orpen was a master of this kind of lighting; McEvoy made great use of mirrors—so did Eves.

Try to avoid anything that may tend to look "cheap". There is only a very small margin between the brilliantly effective and the vulgar.

Instead of a mirror you can also use a piece of white material thrown over a screen. This reflected light is naturally not so strong as that from a mirror, but fills the shadow with an agree-

able coolness. If the head is turned away from the direct light, it is an excellent idea to illuminate the shadow side in this manner.

Artificial light can also give extremely interesting effects. When painting by artificial light I use a strong 150-watt lamp hanging high up behind me, shining both on the canvas and on the sitter, as well as another softer lamp, shaded from my eyes, and close to the sitter's face, usually placed below and to one side.

I have used this arrangement during dark winter days, cutting out the daylight entirely, and every now and then pulling up the blinds to check up on my yellows and blues, the main colour difficulty when painting by artificial light. Blues are difficult to see, and flesh tones tend to become too yellow if you do not watch very carefully.

Lamplight can be very effective in a woman's portrait, especially if she is in evening dress. I do not, however, recommend it as a general practice; shadows tend to be too harsh, and you may find the work a strain on your eyes—and the sitter's.

What I have found very useful, and can thoroughly recommend, are tubular daylight lamps for use on dull winter days, in addition to daylight.

I have in my studio an ingenious contraption which I let down from the ceiling on a pulley over the window to augment the daylight. It consists of four five-foot tubes on a wooden frame, and when they are switched on they appear to turn a dull day into a bright one. This arrangement has saved me from much anxiety, and I cannot imagine how I ever did without it. There is nothing worse than being dependent on the weather and, in London, from November to March, there are few days when I do not make use of this valuable installation.

It can, of course, be used at night as well, and gives a pleasing illumination, to all intents and purposes the same as from normal daylight.

You will need a raised platform or dais (on which to place the sitter's chair), usually 14 to 16 inches in height, when your model's head should be on a level with your own as you stand. See that you have plenty of room to walk back. Do not paint

with a wall just behind, or indeed any furniture or obstruction. You must not feel cramped, and there should be a minimum of 10 or 12 feet clear behind you.

I have painted portraits under many conditions, but very often the effort needed to overcome bad conditions has detracted from the merits of the work. You need all your energies for your painting and if you are worried by changing reflections, a feeling of being cramped, inability to see your work at a distance, or a poor light, your work is bound to suffer. So much, then, for your studio.

Now for your materials.

Let me start by giving a word of useful advice. Use nothing but the best. You cannot afford not to. If you use inferior materials you are wasting your time. Poor materials do not allow you to express yourself clearly. They interfere between you and what you are trying to do. It is no *real* saving to try to save on your materials. Always get the best available.

You need a good strong easel—one that can hold a fairly large canvas without wobbling or swaying. It should be easily adjustable to height, and allow your canvas to tilt slightly forward. It need not be cumbersome; there are plenty of comparatively light but strong easels on the market that can carry a 36″ × 28″ canvas without difficulty.

You need a well-balanced, fairly large palette. Be sure that it is well balanced, otherwise your hand and wrist will soon feel strained. It should be about 18 inches at its widest measurement.

Brushes.

You require a number of good hogs' hair brushes, and two or three sables. For portraits they will range from a comparatively small size to quite large. The ones I have found most useful, particularly for the face, are "filberts"—fairly long-haired and flat, but curved at the top (Fig. 14).

For a start I recommend six of these, and about a dozen others. Build up your stock of brushes continuously. You can scarcely have too many. Treat them with great respect. Clean them meticu-

Fig. 14

lously. For this purpose ordinary soap and water is the best. Rub the dirty brushes on to the wet soap, then on to your open palm. Squeeze out the paint with your fingers, and run the brush under the cold tap. Be sure that no paint whatever is left in the brush, particularly hidden away in the centre of the hairs. Paint dries hard and ruins brushes, taking away their flexibility. When you have thoroughly cleaned them, squeeze the water out of each one separately with your fingers, and leave them in their correct shape to dry upright in a jar.

Paints

Any good make by a recognized manufacturer, such as Lechertier Barbe, Newmans, Reeves, Winsor and Newton, Rowney, Roberson, Clifford Milburn, Cornellison, and so on, are to be relied on.

The colours I have found to be the most useful for portrait painting are as follows: Flake White, Cadmium Red, Alizarin Crimson, Indian Red, Yellow Ochre, Cadmium Yellow, Viridian, Terra Verte, Cobalt Blue, French Ultramarine, Burnt Sienna, Ivory Black.

You will find these sufficient with which to paint any normal portrait. If your sitter happens to be wearing something particularly vivid in green, yellow or mauve, or some other specially bright colour, you can always obtain a tube of Lemon or Chrome Yellow, Cobalt Violet or Emerald Green, as required. But these bright colours are otherwise best avoided. The list I have given above is one I have used for years, and I have found it completely satisfactory.

Mediums

You require some refined turpentine, and either linseed oil or copal oil medium. I have found this last medium very helpful for portraits.

89

You need a dipper, and abundant rags. You will find a screen very useful, and a wide choice of different coloured pieces of material to use for backgrounds when necessary.

Your model's chair should be comfortable and agreeable in proportion and appearance. It must support the sitter's back and arms, but should not obtrude too much.

FIG. 15

A suggested arrangement for the palette.

I suppose it is inevitable that, when considering a portrait, you are inclined to think of the figure and the "background". In theory you are painting a picture, where every part is of relative importance. This remains true in all circumstances, but in a portrait the head always commands the most interest. Nevertheless, every other part of the picture must be so arranged as to be inter-

esting in itself, besides being a setting for the head. It is obvious that you will need a wide choice of backgrounds to suit every kind of sitter.

First of all, your own studio may form an excellent background. You may have an agreeably coloured wall—possibly of some neutral soft grey, or there may be some wood panelling or a book-case that will look well in certain portraits. A figure seated natur-ally in a pleasant room usually makes a successful portrait. The fact that he is on a platform may put him in an unusual relation to his surroundings, but I do not advise you to paint while seated yourself, unless there is no alternative. If you paint while stand-ing, and your model is seated, you will see him at an awkward angle. On the whole it is best to have him on the raised dais, and arrange the background accordingly.

Your first concern, when choosing the background, must be the relation of the colour and tone value of the background to the colour and tone value of the face, hair and dress. These various values must be in harmony with one another. However well the head may be painted, it will lose most of its effect if it is not properly related to its surroundings.

The most useful backgrounds, to my taste, are the soft pastel colours of blue-grey, beige, cream, mole, silver-grey, off-white or blue-green. Darker shades of subtle greens, and warm dark reds are very helpful and, of course, very dark browns and black. In fact, the greater variety to choose from the better. Sometimes I have thrown an old bit of worn curtain, or natural canvas, over a screen and achieved the exact colour value I required. A piece of tapestry can look very effective, but be careful not to let your backgrounds become stereotyped.

If you are using a fairly pale coloured background, you can, if you wish, convert it into an out-of-doors effect. A suggestion of clouds and distant landscape is a scheme that has been used successfully in portraiture throughout its history.

If you use a screen which has three or four panels, you can arrange the shadow of one to fall across part of the rest. A very useful idea is to paint a darker part of the background against the

light side of the head and a lighter part against the shadow side. This reveals the character of the head to the full. Rembrandt often uses this scheme, which alternates dark, light, dark, light across the picture.

Both the colour and tone of the background must be carefully studied. If the face has delicate natural colouring, it is generally unwise to have a highly coloured background. If the head has strong features and brilliant colour you can afford a more striking background, either in depth of tone or vividness of colour.

An atmospheric effect is often desirable, and in any case you should always make it apparent that there is a considerable distance between the sitter and the background, and that he is surrounded by atmosphere.

I think we are now ready to imagine that we are expecting a sitter. I want to describe some preliminaries that are likely to occur before we actually start to paint.

First of all, I consider it essential to have studied the appearance and character of your sitters, if possible for some time, before attempting to paint them. You should have a very clear idea in your mind what you are aiming at before you start.

I usually invite prospective clients to tea, which can be an agreeable occasion and gives them a chance to feel at ease.

The very moment I meet my sitter, whom we might call Mrs. A., I a have very clear idea whether I can make a really successful portrait of her, or whether she will be a "difficult" subject. I notice her bone structure, whether her temperament is calm or restless, whether she is shy or self-possessed. I try to retain a first impression, which is always of some value, but realize that until I have studied her features in the correct studio light I cannot make any final decision about the portrait.

The first meeting should not be too long, so as to avoid any undue feeling of strain or self-consciousness. I usually ask to visit Mrs. A. in her own home in a few days' time. People are always more natural in their own surroundings, and I take the opportunity to see her in different dresses, and sometimes even suggest

that she buy a new frock of a certain colour if none of her clothes seem suitable in which to be painted.

During this time I am gathering further impressions of Mrs. A.'s personality, and I am now ready to pose her in the studio.

I usually ask her to come at about eleven o'clock, for an hour or so of posing only. I have already conceived a general idea of what I want; the chair is placed in a suitable light, and a possible background arranged beforehand.

On arrival I ask Mrs. A. to put on the dress we have selected and to make herself comfortable in the model's chair.

Now, for the first time, I can see my sitter in the clear studio light. Quite often new and interesting facts are revealed, particularly about the structure of the face and features. My mind and eye begin to work very rapidly. I want her to reveal the very best aspect of her best features, as well as to assume both a natural and characteristic pose.

We talk for a while, and as she begins to feel relaxed she sits more naturally. I watch for a graceful line of the neck, and study how the head fits on to the shoulders. I notice the silhouette of the hair, compare one view with another, and hope that a moment will come when everything suddenly seems just right, and a satisfactory combination of grace and character is achieved.

How long this takes depends very largely on the sitter. I may have to alter her position in the room many times, to move the chair this way or that, to place a mirror on an easel to throw a reflected light on her face, to place a cushion at her back, to ask her to lean forward on her arms or to rest more on one elbow. If I notice that she is getting self-conscious, or strained, I stop for a few minutes and ask her to relax in an easy chair away from the throne.

Nearly all the best poses are achieved by letting the sitter fall into them herself. You can arrange the lighting and the background and the necessary comfort, but the sitter must settle into the final pose almost unsuspectingly. I make general suggestions and watch for results. I try to achieve a pose that gives an effect of what I should call controlled vitality, a look of being at ease and

yet ready to speak or turn at any given moment. I aim at giving the feeling that the sitter is a live human being.

I dealt exhaustively in Chapter V with the posing of a head for a drawing, and most of this is applicable to a painting as well.

If your sitter is a very paintable type, one difficulty may be that there are so many satisfactory poses that it is difficult to choose which is the best. Do not be in a hurry to decide, but by a gradual process of comparison eliminate them one by one till you are quite certain you have reached the best.

On the other hand, if she is ungraceful or has plain features, it may be difficult to find a satisfactory pose at all. The principle on which I work is to find the pose that reveals the best features at their best, and then arrange the rest of the pose accordingly.

The most "difficult" people are not usually so because of their outward appearance, but because of psychological difficulties. Shyness, self-consciousness, "nerves", inward uncertainty, personal worries, inferiority complexes, all these things may make a sitter a very troublesome subject. You need experience, tact, patience to deal with them. It is useless to start a portrait until you are in harmony with your sitter, and your sitter is as much at ease with herself or himself as is reasonably possible.

Many people suffer from a dissatisfaction with their own appearance—often quite unnecessarily so. Sometimes, in childhood or adolescence, a rude or tactless remark about their features will cause an inner hurt to their vanity that will last a lifetime. It is for the portrait painter to make the sitter feel that he or she is an interesting subject, worth painting. People are naturally sensitive about their appearance. To be stared at for a long time by a comparative stranger may be quite an ordeal for them. I do not suggest for a moment that you should lie to them or flatter them unduly. Within the limits of the truth, tell them of the interest or beauty of their features. You are in a special relationship to them, almost like that of a doctor. If your sitter has a fine forehead or lovely neck-line, tell her so. She may not have realized it before. If she has character and poise, make a point of remarking on it. Everyone is intensely interested in his or herself. It is your job to

get them excited about the portrait. Talk to them about it—invite their co-operation. Tell them with perfect honesty that their co-operation is essential to its success. They will have to work hard—sitting is no easy task—but it is not a question of just sitting still, but of giving out—of being themselves and of revealing their personalities. They must feel free to talk, to change their expression as much as they like, as long as their head remains in roughly the same position. Make them feel they are your partner in this delicate and exciting operation, even if it may occasionally be a trifle uncomfortable or tedious.

Before you put brush to canvas, you should have a complete picture in your mind of what you are going to try and achieve. Even before you are satisfied with the pose, arrange the background carefully, so that it harmonizes with the face, hair and dress. When all this is done to your complete satisfaction, what is in many ways the most important part of your job is finished. I sometimes say to my sitter at this point: "Well, now the picture is practically finished—all I have to do is to paint it!" After all, when a photographer has got so far as this, all he has to do is to snap the shutter.

Your painting is now conceived, and it is up to you to see that it is brought on to the canvas as closely as possible to the original conception. One reason why an artist is often dissatisfied with his work is because he so seldom matches this original idea in actual execution. Only he knows how far or how near he has come to achieve his aim.

A portrait painter has a different point of view from other artists. His work is a constant challenge. He is saying, in effect, all human beings interest me, all faces are full of excitement and beauty, and I can make a picture out of any one of them. Other artists may be moved by sunlight and sky, an arrangement of colour and forms in nature, the mood of a landscape. A portrait painter starts off with only his sitter, and round him he must build an arrangement that is aesthetically satisfying. During the posing session the relationship of colour and tone and form must be carefully studied, and when you have achieved the most

characteristic pose you still have to let the play of light on arms and dress and background make a satisfactory pattern. You must create a good design on your canvas. If you have unlimited time, it is an excellent thing to make some preliminary sketches, either on a smaller canvas or perhaps in water-colour.

Sometimes, in the following pages, I shall make suggestions which I hope will be very useful, but which, by reason of my own temperament, I do not myself employ.

For instance, if you are the sort of person who prefers to build up his effects patiently, working out every detail beforehand, leaving nothing to chance, creating a careful architectural structure, balancing, arranging and rearranging—then you may spend two or three sittings on preliminary sketches, perhaps making a few drawings, and painting colour sketches. Of course, you will require a good deal of extra time for these, but it may be time well spent. However, if you are that sort of person, you must insist on the time being given to you by your sitter. Your work is essentially an expression of yourself. If you are a careful planner by nature, then you will want to plan your portraits with extreme care.

I myself, like most people, have a mixture of different, sometimes contradictory qualities. I will take endless trouble to get the right effect; I can be infinitely patient, when patience seems necessary, and can work intensely at high pitch for a long time. But I have a strong streak of impatience as well, almost of impetuosity, and experience has taught me that hard labour and careful planning can turn out a picture that is lifeless and flat, where a more courageous and spontaneous attack will give the picture the breath of life, without which no portrait is worth while.

This touches on one of the most important aspects of painting —and of art as a whole—the proportion of intellect to emotion. If you are an artist whose emotional nature outweighs his intellectual, you will want to attack your portrait as soon as reasonably possible, while your impressions are fresh and your excitement at fever-pitch. If your intellect is stronger than your emotions, you

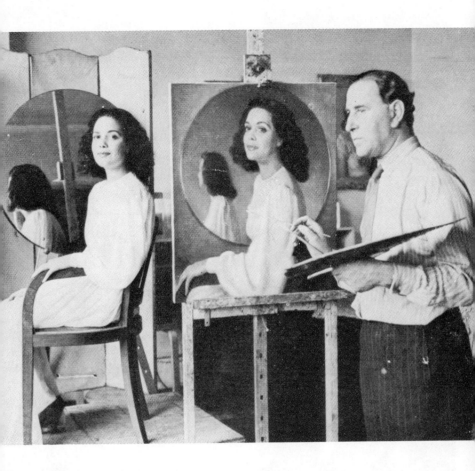

Plate 28 THE AUTHOR AT WORK

A few practical details to be noted are the small platform, which can be taken to pieces when not in use; the type of easel, strong but not cumbersome; the mirror placed in front of the screen to form an unusual background; the chair which allows the sitter to relax and yet gives good support.

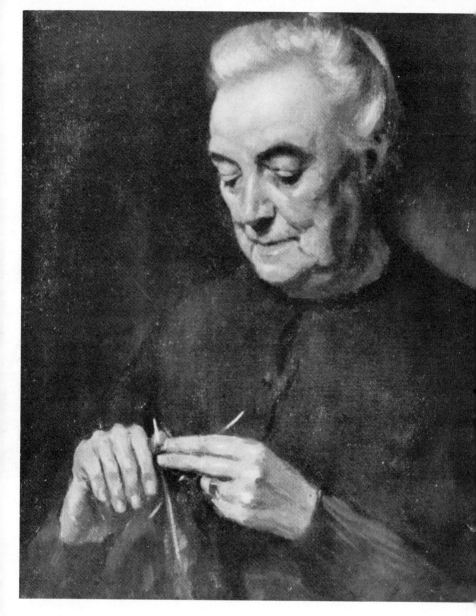

Plate 29 OLD LADY KNITTING *Frank Slater*

This study was painted in three consecutive sittings. It made a change from the conventional portrait to have the model doing something while posing with her eyes looking down. It helped to keep her natural and at ease while sitting.

will control them until you have worked out a scheme which will satisfy your mind, before you allow your emotions full scope.

The secret of it all is to understand your own nature. This may take some time and involve you in many painful experiments. You will be influenced by the work of other artists, you may want to paint in this style or that, you may work with vigour and attack on one portrait, and patiently and quietly on another, with different degrees of success.

If you want to be a professional portrait painter, and your living and reputation depend on the success of every portrait you paint, then I think it is best to work out a technique that suits your temperament completely, and stick to this technique as a general rule.

I do not mean a formula. This is death to all good painting. But a working programme is essential. You need to be a good craftsman, and have a technical equipment at your command ready to cope with every situation. If your plan is rigid and standardized, you will never be able to fit the infinite variety of human beings into its mould.

To return, then, to our preliminary sitting, there is much to be said in favour of making preparatory sketches or drawings if you feel they are going to help you. Naturally, for a large composition with several figures, or a full-length portrait of considerable size, such studies are essential. For an average portrait of modest dimensions, up to 28″ × 36″, I do not myself usually make preliminary sketches.

I work as follows:

Having decided on the pose and arrangement of the background, I take my blank canvas, place it on the easel and pick up a piece of charcoal. *Very lightly*, I begin to place the figure on to the canvas, feeling for the general form and movement, and ignoring all detail. I am "pretending" to start. As I continue, freely and lightly, without bearing the responsibility of actually having started the portrait itself, I get the "feel" of what I am doing.

My aims in this preliminary run are twofold. Firstly, the cor-

rect placing of the figure on the canvas, relating it agreeably to the four sides of the rectangle; and, secondly, to get a foretaste of what it will be like when I actually do commit myself in paint. Quite often, after a few minutes, the sitter may relax into a still more characteristic or graceful pose. How frustrating this would be, if I had really begun to paint. It is quite usual for models to become more at ease after work has actually started, and they have become accustomed to the rhythm of your movements. By means of this trial run I achieve the opportunity of a second or third chance of getting the best possible pose.

The charcoal drawing can be dusted off with the flick of a rag, and all I leave is just an indication where to start next time. *This drawing was in no way intended to be a foundation for the portrait itself.* It is done entirely to convince myself that the conception is completely satisfactory, and will fit the canvas in a balanced manner.

The sitting is now over, and I arrange for the sitter to come in a couple of days' time, when I shall start the painting itself.

Until the next sitting I have time to consider my ideas quietly. Perhaps I am thinking about the portrait just as I am falling asleep at night. Something may occur to me suddenly, perhaps some minor dissatisfaction that I have been hiding from myself comes into the open. I lie in the dark and think about the problem. It is all part of painting a portrait.

DIFFERENT METHODS COMPARED

BEFORE I describe what I have found to be the technique
most suited to my own temperament, I want to discuss
several different methods, and weigh up their advantages
and disadvantages.

As I have already made it abundantly clear, you will have to
find out for yourself by trial and error which approach is best
suited to your own nature.

There are as many good techniques as there are good artists,
but I think for the beginner it is best, for a time, to stick to one
of the more traditional methods as a jumping-off point, before he
attempts any wild experiments himself.

There are, broadly speaking, two general methods of approach
—the "direct" and the "indirect".

The word direct speaks for itself, but portraiture is such a
complex and difficult job, that you can easily be misled if you
think you can attack a portrait in the same direct way you may
have been using for still-life. Of course, from one point of view,
your sitter should be considered simply as a piece of still-life, and
it is an excellent thing to remember this, all the time you are
working. One of the pitfalls that await beginners is the fact that
a human being has eyes, nose and mouth and "expression", and
he rushes at these exciting new features, and forgets that before
he can deal with them there must be a great deal of straightfor-
ward painting and accurate weighing of one value against
another.

Your aim should be to carry your portrait forward both as a
painting and as a portrait, at the same time. This is not easy—

but "expression" and "likeness" cannot be injected suddenly at the last minute. From the moment you start you should have in mind the characteristics of your sitter, and be thinking of them simultaneously with your judgments of colour and form.

The direct method requires concentration on many things at the same time, and courage, vigour, stamina and a capacity for continuous work at high pressure.

I have seen students painting a portrait as if they were just doing a routine job. There should be nothing easy-going about the work—every touch counts and should mean something. I believe it was Whistler who said he mixed his paint with brains. Portrait painting is the most intense brainwork I know.

One disadvantage of direct painting is that if you get into real difficulties it is almost impossible to emerge from them success-fully. Your drawing must be accurate and your values true, before you can begin to achieve subtlety of expression. Once you get into trouble and start altering and repainting because of actual mistakes of drawing, you are in for a bad time. Even if you pull through to some sort of finish, the painting may have suffered irreparable damage to one of its most vital qualities—freshness. A direct painting that has been much altered and laboured on is a lifeless thing.

How, then, are we going to learn this difficult direct method?

My suggestion is that you admit its difficulties and carry on in face of them. Be prepared to start again if you get into trouble, and at other times carry on and learn by your failure. I shall attempt, in the next chapter, to describe in detail how I tackle these difficulties myself, but I know only too well how hard it is to follow another person's method step by step. You must be prepared for failures, and not be too easily discouraged. The joy of your successes, which will become increasingly more frequent, will fully compensate you.

I can promise no easy or quick way of learning to paint a por-trait by the direct method, and many might think it wiser to begin by using the indirect method.

The essential difference between the two ways is that the in-

direct separates the main problems of colour and form. You begin by painting a monochrome, and work out your form first, leaving the problem of colour till later. This was the most general method used in the past, and direct painting, as we have seen, only came into use for portraits with Manet, based on a study of Velasquez.

When you have painted the monochrome to your satisfaction—and it is naturally far easier to paint with one colour mixed with white than with a full palette—you commence to rub on transparent or semi-transparent colour, knowing that the foundation of form underneath is sound.

There are useful compromises lying between the two methods.

One is to paint a thinnish monochrome first, using it as a guide and a means of exploring the problems of form ahead of you, and then painting over it by the direct method, and covering it entirely with opaque paint.

Another compromise is to paint in two or three colours only to start with, before using the full palette, a mixture of warm and cold, say black, red, yellow and white. It is amazing how far you can go in realism with a very restricted palette. In any case, I recommend this as a very useful exercise.

Understanding of "warm" and "cold" is most important. Generally speaking, the light falling on someone in a room is cold, that is to say, it comes from the sky which is grey or blue. The half-tones are cool too, being still influenced by the nature of the light, but the shadows, which are affected by the reflected light from the room, are *relatively* warmer.

Blue, black or grey, green and blue-violet, are cool colours. Red, brown and orange are warm. Mixture with white tends to cool any colour.

These important facts should be borne in mind all the time you are painting. A feeling for the *relative* warmth or coolness of one colour to another is essential.

To sum up, here are four different approaches:

1. A monochrome underpainting in some cool or neutral colour, black, green, brown or blue—naturally mixed with white.

Over this you glaze with transparent and semi-transparent colour and place your accents.

2. A monochrome underpainting, but merely as a guide for a direct painting on top.

3. A very simplified palette, using two or three colours only, and then gradually introducing more colours as you continue.

4. A full palette, and go all out for a direct result.

Sargent is supposed to have agreed to give private tuition to a student on condition that he painted only from paid models for two years, used no friends or relatives as sitters, and undertook no professional work. He wanted his pupil to feel completely free from the responsibility of always getting an exact likeness and from the embarrassment of letting a friend or client know if the portrait were not a success. Thus he could attack each painting with complete freedom from outside strain, and concentrate entirely on the problems of paint. No doubt, if you are in the fortunate position of being able to afford to do this, it is a wonderful way to learn your craft. But professional portrait painting carries with it, as part of the job, these extraneous strains and difficulties, and perhaps the sooner you get used to them the better. In any case, someone who is excited by portraiture wants to get a good likeness each time, even if he is painting a professional model entirely for his own instruction.

What Sargent wanted, of course, was for his pupil to go all out for the attack, and to gain complete confidence. As we have seen, when discussing Sargent's own work, his was essentially the skill of a virtuoso, and he was training his pupil to become one too.

I advise the student who has talent and determination to tackle the problem of portrait painting under all kinds of conditions. It is certainly convenient to paint your friends and relatives, and if anyone offers you a commission while you are still learning, by all means take it and do your best. The extra stimulus of working professionally, and being on your mettle, may bring out the best in you, and help you to conquer any lack of self-confidence.

Try everything. See how far you can take a head in one sitting. See how long you can spend in developing it to the last detail.

Paint thick, paint thin. Take an hour—take a month. Paint people you know intimately and paint professional models. Get to know your own strengths and weaknesses. Once you have found your true form of expression, you are three-quarters of the way to success, and only by trial and experiment can you be certain what form it is going to take.

Let us discuss further the relative advantages and disadvantages of direct and indirect painting.

For me, one of the primary qualities of a portrait is a feeling of freshness and vitality. The direct method, when successful, gives this impression admirably. Since the time of the Impressionists, painters have discovered possibilities in direct painting which are particularly suited to portraiture. Amongst the chief of these are brilliance and purity of colour, and the actual surface texture of the paint. If you are in a picture gallery, and you pass from a room of Old Masters to one of more modern pictures, the immediate impression is one of lighter and more vivid colour. I am not trying to praise the present by disparaging the past. The great masters are supreme, and we must all remain humble before their achievements. But, however great an artist may have been, he cannot escape from the century in which he lived.

The fact remains that certain developments have since taken place, and it is impossible to ignore them. We have discovered new possibilities in the handling of paint, and it is natural for us to want to use them. The method of painting with monochrome and glazing was taken to its ultimate limits of expression by masters such as Rembrandt and Leonardo da Vinci. No artist has been able to model a head more subtly or with more delicate insight than Leonardo, no one has painted portraits with greater knowledge of modelling in light and shadow than Rembrandt. Anything we may attempt on these lines must suffer by comparison with the past. Is it not natural, therefore, that while admitting our debt to these masters, and learning all we can from them, we strive for something different?

Direct painting seems to me to be in keeping with the period in which we live. The method of careful underpainting, followed

by a series of transparent glazes, implies time and leisure that belongs to a past age. Born painters like Augustus John, who passed through an early period of indirect painting, have shown us what miracles of portraiture can be achieved by the direct method.

My advice, I repeat, is to try several different approaches, and discover for yourself which you prefer. But do not imagine that you can just begin without plan or considered technique.

In the direct method your essential problem is how to keep your colour fresh, and yet be able to search out all the form and character possible.

Inevitably there must be compromise.

In the indirect method there is nothing to stop you working out the form to the utmost subtlety—but then you will have to compromise with colour. In the direct method you must see just how far you can elaborate your modelling and still keep your colour fresh. Each artist will find his own compromise, but he must understand exactly what he is after. It is no good just trying to "copy" what is in front of you. You must realize that form and colour are the two basic elements which you are handling, and that each demands something at the expense of the other.

To paint form in pure colour is one of the most difficult exercises of all. Cézanne, who was the pioneer in this field, painted his portraits in this way, but he did not attempt to convey a realistic representation of life. Since his time, many modern artists have strived to paint portraits in pure colour, and have found that it was necessary to sacrifice some of the gradations of modelling to gain added brilliance of colour.

All painting techniques are really a method of combining colour and form in different proportions. We saw with Sickert how he worked out a particular scheme which he found satisfactory for himself, but which in practice was not really suited to the straightforward portrait painter. The more you model, the less brilliant your colour. Augustus John, at his best, has reached a point where he can pitch his colour to considerable brilliance, and, because of his consummate understanding of drawing, express

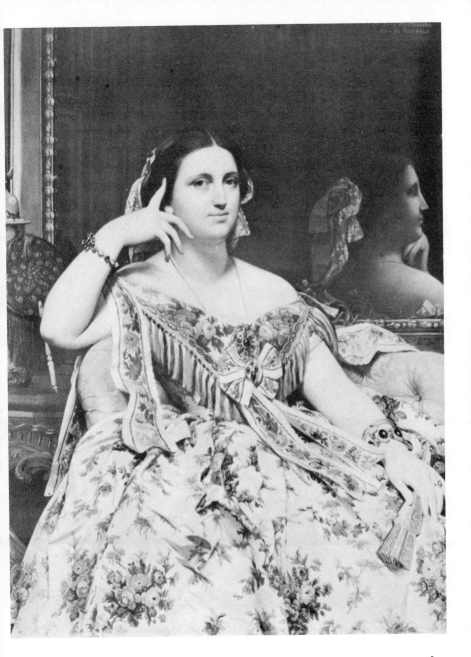

Plate 30 MADAME MOITESSIER *Ingres*

This amazing tour de force *in painting an elaborate gown should be compared to Renoir's treatment of a similar problem. In Ingres' portrait we are immediately conscious of the incredible craftsmanship —but the woman herself seems quite impersonal and lifeless. After we have admired the labour there comes a feeling—was it all worthwhile?*

National Gallery

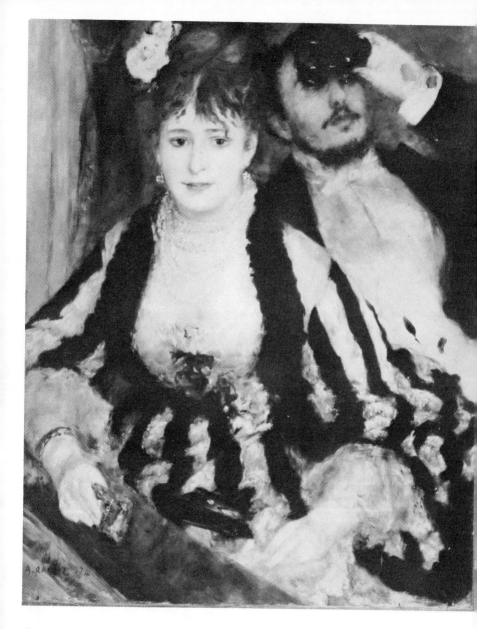

Plate 31 LA LOGE *Renoir*

*Renoir succeeds here in handling a complicated, **fashionable** toilette with the imagination of a
Master. Everything melts into a delicious harmony, and the woman emerges from her gown warm,
feminine and entrancing. This is one of my favourite modern pictures, and I return to it again and
again to marvel at its beauty of texture, colour and feeling.*

National Gallery

the form perfectly by the relationship of one colour to another. This needs great experience, and can only be achieved by a highly trained vision. The artist who can paint in terms of pure colour, and model satisfactorily at the same time, has come a long way.

I hope it is quite clear that, when I am talking of "colour" I do not mean local "colouring", which, of course, is something quite different. Local colour, such as red lips or blue eyes, can be superimposed over the most elaborate modelling, without loss of form. By "colour" I mean the relationship between one colour and another throughout the picture.

There is another technique which is helpful in achieving these relationships—one which might be called the "dib-dab" method.

This, as the name implies, is a way of building up your picture touch by touch, keeping your colour as pure as possible, rather in the manner of the Impressionists. If successfully used, this gives a lively and brilliant effect, but there is a danger of the painting looking spotty, and the face and complexion acquiring an unpleasant appearance, as if the flesh were disintegrating. All the same, I recommend you to try it as an experiment. In the final count, of course, if you can bring it off, any technique is a good one, and the "dib-dab" has the great advantage of not requiring such long sittings, as it is fairly easy to stop without inconvenience at any given time.

Before describing the method I now employ myself, I should like to explain how I came to develop it, and how it was arrived at by a logical process.

My aim has always been to be representational, without being photographic, re-creating life without slavish imitation. I wanted to get the "likeness", express the character, give a feeling of life and vitality.

For some years I tried the different methods I have described. I soon discarded the indirect method as being unsuited to my temperament. I either got bogged in the monochrome, or was dissatisfied with the colour achieved by the glazing, and ended up by painting direct over it.

Then, for a time, I painted a monochrome underneath as a guide to a direct painting on top, and found the preliminary study of the head this afforded most helpful.

As I became more experienced I discarded this as wasting valuable time. Time is an element that, for better or worse, cannot be ignored by a professional portrait painter. As I developed, and was able to *see* more and more, I found my real danger was in my work becoming laboured. I had kept the Sickert ideal in front of me all the time, and knew that a painting that had lost its freshness was worthless.

I tried to counteract this tendency to work too long on a portrait, and thereby spoiling it, by attempting one-day sketches.

I had always tried to do these at different times, but had seldom felt satisfied with the results, believing them to be too superficial and not expressive of all that I felt or knew.

Now, however, I had reached a point where a head painted at one sitting was, in total effect, better than one I had laboured on several times. It gained so much in vitality and freshness of handling that it was preferable to the more carefully worked out portrait.

For some months I concentrated entirely on these. It was excellent practice, but, naturally, many of these heads were unduly rushed, and I often longed to have more time on them. However, it would have been foolish to tinker with them, when they were essentially designed to be completed in one sitting.

Then I got the idea of keeping the painting wet overnight, and working into the wet paint the next morning, thus stretching the length of time to two sittings, but keeping the technique essentially the same as if it were for one. As long as the paint was wet I was still painting in one "go".

In cool weather, and using a slow-drying medium, this was just possible. I even stretched the time to three consecutive sittings, and was able to work twelve hours into the wet paint. This suited me admirably, and I was delighted.

Then certain disadvantages in this method began to appear. First, it was not always convenient or possible to get a sitter for

three consecutive days. Secondly, in warm weather the paint tended to dry too quickly. Thirdly, I did not like the feeling of being dependent on outside circumstances beyond my control.

I solved the problem simply. I had found that three sittings were, as a rule, long enough in which to complete the painting of a head. It was enough time to put in all I knew, and not too long for the sitter to get bored or for me to get stale.

By rubbing copal oil medium over the canvas before each sitting I found that the surface assumed just the right "feel", and gave the exact kind of resistance to my brush. This was almost as good as working into wet paint, and left me free from the necessity of consecutive sittings.

XIII

THE FIRST SITTING

Now, at last, we come to the actual painting.
It is ten o'clock in the morning. My mind is clear, I am feeling in excellent health and spirits. I have an important job to do and need all the energy I possess.

The studio is prepared; the background and chair are arranged; the stage is set. I am going to paint a head and shoulder portrait on a 24″ × 20″ canvas.

I greet my sitter; but this time my attitude is more that of a man with a job to do rather than of a host who has plenty of time to chatter. The programme is mapped out, and minutes count. I expect to paint till about twelve-thirty, have lunch and a short rest, and then carry on till three. This means about three and a half hours' work in all, but, with a break in the middle, it is not unduly long for anyone to sit. Of course, if I notice the model is strained, I ask her to relax for a few minutes, and sometimes I want to stop myself and give my eyes a rest.

I find the break for lunch enormously helpful. After two and a half hours' concentration it is not easy to be objectively critical about the work I have done; but a large area of the paint is wet and ideal for working into, and it would be a pity to stop altogether. After lunch I come back refreshed, and see just what is necessary to complete the day's work.

To resume our painting.

The moment to commit myself has arrived. My almost blank canvas is in front of me. There remains on it just the indication of where I have placed the figure at the previous sitting. Sometimes, before starting, I take some copal oil medium, pour it on

to the palette and mix it with a little black. Then with a large brush I cover the canvas with a grey glaze.

If I am doing a quick sketch, I always do this. The two great advantages are that the paint works into the oiled surface very agreeably, and some of the harsh whiteness of the canvas is toned down. The only danger is that your work may become a little sticky or slimy as you continue. Your canvas should have a good bite to it, and this should prevent any slipping. If your canvas happens to be smooth, avoid covering it first with oil. You will have to find out for yourself whether this process suits you or not. On the whole I recommend it, but be careful not to use too much oil, and, if necessary, wipe the surface with a rag before commencing.

My palette is arranged in the following way: On the extreme right, next to the dipper, I squeeze out a *big* coil of flake white. Do not be mean with your paints, but squeeze out more than you may need rather than less. Then comes cadmium red, alizirin crimson, yellow ochre, viridian, indian red, cobalt blue, french ultramarine, burnt sienna and ivory black. In my dipper I pour copal oil medium and some turpentine.

I pick up a comparatively small brush—not a tiny one, but one sufficiently sensitive with which to draw expressively. I use a very thin mixture of some neutral colour—the simplest is grey, made up of black and white—and, standing well back from my canvas, and with the easel at a distance of about four feet from my sitter, I begin to paint.

There are excellent reasons for not having left the charcoal on the canvas, and for not commencing with charcoal this time.

One is that it is best to think of a painting *as* a painting from the very first moment. A painting is not a drawing which is then filled in with colour. Painting is relating one colour value to another; painting is done with a brush; painting is not concerned with rigid outlines. Another reason is that your sitter is a live human being, and is liable to vary a good deal during the sitting. You do not want to be tied down too soon to hard outlines, carefully laid down at the very beginning of the picture.

For example, a woman's hair can change from day to day, and you must watch for the changes and develop your painting accordingly.

To start off with, I spend from ten to twenty minutes stating, in general terms, the placing of the head and the disposition of the figure on the canvas, using the minimum amount of paint.

More often than not, my first touches show where the top of the head comes, usually from two to four inches from the top of the canvas, according to the size of the picture. Be careful not to place your head too low, as this gives a squat and unpleasing effect.

I try to indicate the general disposition of the figure, boldly, but also with extreme care, not attempting to suggest any detail whatsoever. The guiding principle I use is to put nothing on to the canvas which is not accurate, but to select just what is essential to help me at that stage of progress. Experience has taught me that although it is tempting to carry on for quite a time in this way, before you know where you are, you are making a complete drawing, and committing yourself to certain facts too soon.

I have found it far better to spend this time taking great care that what I do is correct, rather than doing too much. The illustration will show just how far I carry this preliminary indication.

Do not forget this rather frightening fact. After you have worked for only a few moments, a great deal about the picture is already irrevocably fixed, including the placing, the movement, the angle of the head, the proportions, and the "feel".

If you are casual or vague during these first minutes, your picture is quite possibly already doomed to failure. If for some reason or other I am not happy about the start, I take a rag and some turpentine, wipe it out, and begin again.

When I refer to the "feel" of the work, I am referring to something very significant. An artist is a sensitive human being. As he begins to express himself on canvas, something characteristic of himself begins to emerge. When I see what a student has painted, even five minutes from starting, I already know a great deal about his ability. From the very first moment you are *select-*

ing what to put down from the overwhelming number of facts in front of you. In these first twenty minutes you should select just what is necessary to place your figure satisfactorily on the canvas, and accurately suggest the movement. This feeling of movement is fundamental, and should be sought for at the very beginning. Movement is revealed by searching for the way the head fits on the neck, the neck on the shoulders, the torso on the hips. If you make a statement about these relations between these different parts while the sitter remains in one position, you will probably catch their natural grace. If you fail to get it from the start, the figure is liable to seem stiff or awkward.

I remember once being told by an art master that at the end of the first sitting most students had, without realizing it, already spoilt their chance of a good painting through insufficient thought and care during the first half-hour. I have found this to be quite true, and although it may be a little unnerving to be so aware of the responsibility of your first statement, it is best to realize it and guard against mistakes which will cause you trouble later on.

During the first sitting, to some extent, you feel like a god. There is your blank canvas, and you can paint as you please, with nothing to interfere with your complete freedom. But when you come to the second and third sitting, you will not be so free. Your previous work will affect every touch you add. If it is a good foundation it will be enormously helpful, but if it is weak and inaccurate, it will constantly get in your way. So do not be too much led away by this excitement of the clean canvas. Attack with courage, and then criticize with calm judgment.

During the first sitting, courage should certainly dominate, as this will give your portrait spirit and vitality. Nevertheless, keep your judgment clear, and guard against careless and inaccurate statements.

Very well then; you have placed your figure accurately, and suggested its movement and proportions.

It is time to think entirely in terms of paint.

I *never* in any circumstances start on the face. The first thing I want to do is to get rid of as much white canvas as I can, as

rapidly and intelligently as possible. The brilliance of the bare canvas is a hindrance to careful judgments of values, and I try to cover a fairly large area in a short time.

I look at the background and see where it comes against the hair. I mix a colour on my palette as near as possible to the colour of this part of the background. I use a fairly large brush, mix the paint vigorously on the palette, thinning it by the vigour of my movement. I brush this on to the canvas, right up to and *even a little over* where I have indicated the edge of the hair. One value by itself is not easy to judge. So I immediately mix up another one, to suggest the value of the hair. This I rub on to the canvas with my brush at the appropriate place, and let it touch and mingle with the background tone. I do *not* paint *up* to it, but right *into* it. Under no circumstances would I leave any white canvas between the two values. What I am doing is judging one against another, and this can only be done if they touch and mingle slightly at the edge.

I am not aiming at this moment at getting the *exact* tone of the hair and background, as it really exists, but a correct relation between the two, rather lighter in tone than they are in reality.

All through this first sitting I am holding back. Holding back from full depth of colour and tone, from too strong accents, from hard edges, from anything too defined. Here and there I will feel for "little bits of drawing", and delicate suggestions, but with the certainty that they will not remain for long, but merely be pointers and a "feeling" towards the ultimate result.

The first, and indeed the second, painting of the head is in many ways a preparation for the third sitting. Painting a head is very largely the art of preparation. After all, the thing that really matters is that the result should be good, and nothing is so dismal as a fine-looking start which gradually grows less interesting, and finally gets submerged altogether.

A first sitting consists largely of searching out the problems to come, and acquiring knowledge for future use. You make tentative statements about what you see as you proceed.

So, to start with, fill in the background a little lighter than it is

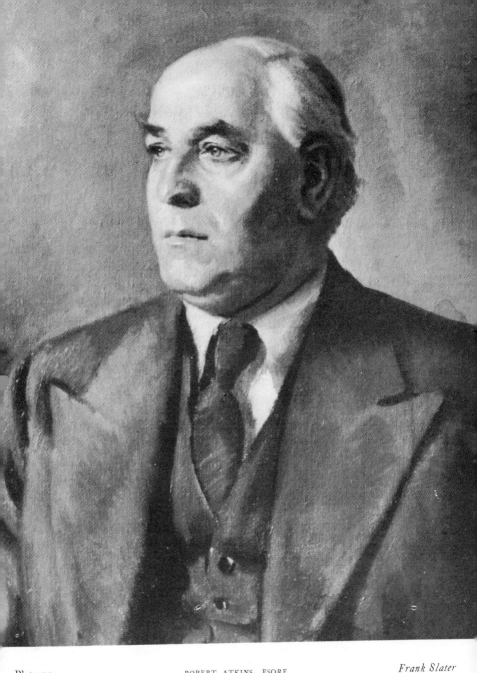

Plate 32 ROBERT ATKINS, ESQRE *Frank Slater*

This sitter has a fine, dramatic head, which I have attempted to paint in a strong light to emphasize the structure. The bright blue eyes also needed plenty of light to bring out their vivid quality and the turn of the head helped to give movement. It would have been more appropriate to have painted this fine actor in a Roman toga, but failing this I have tried to extract what drama I could from an ordinary lounge suit. Not an easy task.

Plate 33 MISS HONOR BLAKE *Frank Slater*

A charming sitter who presented the usual problem of how to paint a pretty woman without seeming too obviously to flatter. I tried to resist the temptation by concentrating on the extremely difficult modelling. I found the turn of the neck on the shoulders most attractive to paint.

all round the head, and, if possible, eliminate the white canvas to the edges of the picture. Almost at the same time begin to paint the hair very simply in two or three values. Forget for the time that it possibly has waves or curls or any detail at all. Concentrate entirely on the correct colour values and *edges*. All through the painting of the portrait this question of edges will recur again and again. It is of the utmost importance.

An edge is one of your chief forms of expression.

No edge should be accidental. An edge should be considered along all its length. An edge is where one distinct colour value meets another, and can be either hard, less hard, soft or almost completely merged.

While you are covering the canvas during the first hour, you must concentrate on judging one colour value against another, the edge involved, and the general character and drawing of what you are painting.

What you are aiming at ultimately is, of course, the form of what is before you, but this is being built up, in the meantime, by correct observation of colour values.

After you have made a general statement about the tones of the hair, it is a good thing to make similar statements about the dress where it comes close to the neck, head and background. You want to surround the flesh colours of the face and neck with tones before you start to paint them.

The manner in which you apply the paint at this stage is very important. I always rub it on very vigorously with the brush, and this presses the paint thinly on to the canvas. You want to avoid thick paint to start with, and you can mix some medium with it if required. You are framing the face with a series of tones and when this is completed—lightly and suggestively—you may start considering the flesh colour.

Mix up a general tone to suggest the flesh colour, using flake white, cadmium red and yellow ochre as a basis, and rub it *right over the entire light part of the face*—very thinly. You may even rub it over the shadow side, as it is really only a preliminary covering in which to paint more definitely.

The First Sitting

Using your filbert brushes, begin to feel the disposition and modelling of the features with a warm tone, not too dark, made perhaps of viridian and indian red.

You are now making your first definite statements about the features and the likeness, and doing it with the brush. Draw accurately, and see that the triangle of the eyes and nose is correct. Begin to model the cheeks, feel for the bone structure of the forehead, draw the nose and the shadow it casts, and remember to think in terms of relative warmth and coolness of your tones. Viridian will cool your indian red, and ivory black, used sparingly, is admirable for cooling your basic flesh colour.

Now is the time to think in broad, general terms about structure, and the way the light falls on the face.

Very gradually introduce some more definite statements about colour, but avoid anything too strong for the time being.

Above all things, do not attempt to work out any detail, and under no conditions try to model the features beyond catching the general character of each one as a whole. Move from one part of the face to another, never spending very long on each.

This is another guiding principle I use throughout the painting. I never spend very long on one spot. As I develop one piece of colour or form, it makes the part next to it look less developed. So, as soon as possible, I move on, carrying forward the whole area I am working on almost simultaneously. This keeps the portrait developing logically and steadily as a whole.

During the first sitting your eye must be trained to see only what it is necessary for it to see at this stage of the proceedings.

You must be searching for the big forms, for the way the light falls broadly over the hair, forehead and cheeks. You should not be aware of surface detail at all, although you must be extremely accurate in your placing of decisive bits of drawing.

You must treat the mouth with the utmost simplicity—not stressing the colour or too carefully defining the shape. The eyes, in particular, must be held back, and the iris suggested by the merest touch, with, maybe, a flick of white to indicate where the highlight comes.

The fact that you have white canvas immediately underneath, and that your paint is thin, will keep everything fairly light in feeling.

Here and there you should place what I call "signposts".

Suppose, for instance, that the eyebrows are very characteristic in shape. It is useful to stress this fact by accentuating them, a little prematurely perhaps, but with the idea of their acting as a guide to your drawing. This can apply to the edge of the cheekbone, the bone in the nose, a highlight on the forehead or in the eye, or any outstanding characteristic. You will find these accents extremely useful as you continue, but remember that they are only temporary, and that at the end you will be merging them into the whole, and quite possibly accentuating other parts instead.

The effect you are aiming at by the end of the first sitting is a general arrangement of colour values, a suggestion of the modelling of the face, the exact placing of the position of the features, a balance of warm and cool colours, the mood and feel of the whole picture, and a foundation to make you eager to continue without anything to interfere with your freedom next time.

Nothing that you do during the first sitting is to remain as it is in the final painting.

However much certain effects may please you, your attitude must be—this is only preparation—and I am going to use to-day's work merely as a foundation.

In spite of the fact that it will all be repainted, the value of a good start is inestimable. A successful painting should go well from the very first touch.

The principle I use when mixing my flesh colours is as follows. When the flesh is neither in shadow or in strong light, but just between a highlight and a half-tone, it can usually be made quite simply from cadmium red, yellow ochre and flake white.

For your half-tones you can mix in viridian and ivory black, either separately or together, according to what it seems to need. Shadows are usually warmer, and can be made of indian red, viridian, ivory black or more cadmium red, with occasionally a

touch of burnt sienna. Keep your alizarin crimson more for mixing with the local colour on the lips and cheeks—you will find that a little goes a long way. Burnt sienna is also a strong colour, but is most useful in the deep shadows of the hair. Blue can also be useful in the half-tones and lights, but must be used with caution or you will get an unpleasant purply look.

I often introduce cadmium yellow into the reflected lights that appear under the chin, but, again, very little is required.

Do not let your colour run wild and paint your face to look like a bunch of flowers. On the other hand, search for the subtle variations and harmonies of colours, for being able to "see" colour is part of the artist's vision.

During the sitting, vary your distance from the model quite a number of times. I usually start off at about a distance of four feet. Then, after a time, I approach quite close, placing the easel right up against the throne, so that I can see exactly what it is I am painting. After a while I may bring the easel back seven or ten feet, and look at the head as one simple unit, often finding that some of the work I have done at close quarters needs simplifying. It is good to paint very close for a time to acquire exact knowledge, but I never stay close for long. Of course, you must decide on a final position for the finished portrait, the best being about four or five feet away; the place at which I usually start. If you are too close you get a slightly distorted view, and if you are too far away you cannot see clearly enough.

Do not compare your work too critically with the model too soon at the first sitting. Paint for some time before standing back and really taking stock. I usually carry on till lunch-time, the first day, without stopping to see whether what I have done is strictly accurate—unless, of course, I feel I am getting into a mess.

The reason for this is obvious. You start with a blank canvas, and there is a great deal of work to be done before you can expect anything that can be seriously compared with reality. If you keep stopping and being over critical, you will never be satisfied, and your work will not flow freely.

So give yourself a running start, and get your canvas covered

all round the area of the head. Your instinct will tell you whether you are working well, so only stop if you get into difficulties.

By twelve-thirty you should have accomplished quite a good morning's work. Put your palette down and think of refreshment.

How has your model behaved during this time?

This depends very largely on you. I do not believe it is likely that you will paint a successful portrait of someone who is sitting quite still and never opens his or her mouth.

My own tactics are as follows. I encourage my sitters to talk as much as possible. I ask them to try and speak without actually moving their head about, but not to worry how much their expression changes—in fact, the more the better.

You may wonder how I manage to work with a constant stream of conversation going on. Actually, I find it stimulating. I seem to possess two levels of mind that are working independently. One is carrying on a reasonably lively conversation, the other is concentrating intensely on the painting.

I do not like working in complete silence. One reason is that painting a portrait is very largely an emotional experience. There is a flow of feeling between the sitter and the artist. Complete silence is like a barrier between them.

The only time I prefer not to talk is if I am painting a young child, and rational or continuous conversation is an extra strain. In these circumstances I either ask someone to read to the child, or play soft music on the radio.

A musical background is an excellent means of keeping an agreeable atmosphere, and I sometimes use it with adults as a change from continuous talk.

People naturally reveal themselves in conversation, and I have noticed that many people find the model's chair conducive to self-revelation. As they begin to talk about themselves, their past experiences, their husbands and wives and children, their love affairs and hobbies and ideals, I often find quite a different person emerging from the one I had previously met.

During the first sitting it is most important to keep your sitters happy and interested. Talk to them about the work—let

them watch its progress. I usually say to them: "By all means come and see what I have done. All I ask from you is NO COMMENT and NO CRITICISM until I ask for it at the end." I explain to them that all that matters is how it looks when finished, and that it will pass through many stages before then, some of which will look very odd to them. Their comments, before I am ready, would only be superfluous and distracting, and uninformed criticism at an early stage can be very harmful.

Usually they are so intrigued by the whole process that they are quite happy not to make any remarks, and I allow them to say a few standard phrases such as: "It seems to be coming on well", or: "It is developing nicely".

During lunch, which I usually serve in another room, to get away from the studio atmosphere, I notice further characteristics of the sitter. Having seen them in one pose all the morning, it is useful to watch them in movement again.

However, I am usually on tenterhooks to get started, and as soon as possible, after a short rest, we resume.

Now I stand back and compare. My eye and mind are fresh. I put the easel and canvas right up alongside the sitter, and walk back and see the two side by side. I may take a hand-mirror and, turning with my back to the sitter, examine the work through the glass. This is a most useful procedure, as not only does it double the distance between you and what you are looking at, but, by giving a new point of view, immediately reveals any serious mistakes in drawing.

It is too early to worry about anything else except the drawing and placing. If these are not satisfactory you must at once make the necessary alteration. You would be very unwise to leave the first sitting with any serious error in drawing. From now on until you put down your brushes, be thinking of the next sitting. What will you want to find when you come next time? A guide and a sound foundation, but not too much to interfere with your free attack.

I usually work for another hour, but perhaps, if things are going well, not quite so long. If the facts are right, it is better not

to overwork the first time. At about two-thirty I pack up, and my sitter often exclaims: "What a lot you have done!" It seems a lot to them, but I know it is really not as much as it appears, as a great deal of it is merely a tentative feeling towards the truth, and nothing definite or permanent.

All the same, by now I know if the picture has a fair chance of success. If I feel happy—all is well. If not—then it is better to scrap the morning's work completely rather than continue with something that is unsatisfactory, and will only turn into a liability before long.

I either put the canvas against the wall and forget all about it, or leave it on the easel. As a rule I leave my unfinished work on the easel till the next sitting, so that, returning, perhaps in the evening, I can see it objectively and notice one or two things that still need checking. I become familiar with its general character, and if I think it is a good start I feel greatly encouraged.

Human nature being what it is, you tend to hide your defects from yourself. By leaving your work open for inspection you soon become aware of any basic errors, and have time to think about them before the next appointment.

However, if you are the worrying kind, perhaps it is wisest to put your canvas away entirely, and so arrive completely fresh for the second sitting.

XIV

THE SECOND AND SUBSEQUENT SITTINGS

Now we are ready to begin the second sitting. This is almost as exciting a moment as when we face the virgin canvas. Already a great deal of spade work has been done. If it is good, it is going to help us enormously.

The first thing we do is to check the drawing again.

Compare your work with the model. Study the two close together for some time. You are like a general planning a campaign. Any serious mistakes must be corrected immediately—not necessarily by re-painting at this stage, but by making a surface indication for future use.

Before painting, pour some copal oil medium on to your palette, perhaps even mixing a little black with it. In order to facilitate the even spread over your canvas, either warm it a little by the stove, or breathe heavily over the surface first. Then scrub the oil on hard—being careful to use just enough, and not too much. The whole surface will become receptive; but, of course, you are not making your paint underneath actually wet again—it is already chemically dry and hard—but merely making a good surface into which to paint over last time's work. Again, it is wise to wipe the surface with a rag, lightly, before starting.

As soon as you have noted any slight mistakes in drawing, start by re-stating the tone of the background where you began last time. A sable brush and a little warm colour is useful for this purpose.

During this sitting paint with a slightly fuller brush and

richer tone. What is already there will guide you, but be prepared to cover it up completely—piece by piece.

Your aim in the first hour, or hour and a half, is to cover yesterday's work completely—using it up as you proceed. Have no regrets at all at appearing to lose what is already there: it was put down for that very purpose—to feed you the second time of painting.

You are now more free to commit yourself to more exact values, and to paint in richer tones. It is still far too early to paint detail, or even your darkest shadows or highest lights. But you can strengthen the contrasts everywhere, and bring out more definite local colour, in the hair and lips and dress.

Again surround the head before tackling the flesh tones. Restate the background, hair and dress near the face. Begin to see more variety in the hair, but *still do not try to make final statements about anything*. Alternate again between standing far and near, but do not be too critical of yourself until the whole surface is repainted. This may take as long as two hours. During this time the work may possibly look rather unpleasing. While it is half this time's and half last time's, it may have a hybrid appearance. On the other hand, the two days' work may merge satisfactorily, and you may never go through an awkward period.

You must have great courage at this stage, as always. You may not enjoy covering up last time's work, but you must have *absolute faith* that what you are doing is part of the necessary development. After all, if you painted well last time, there is no reason why you should not paint equally well this time—even better, with so much to guide you and so many problems already solved.

You must concentrate on your relative colour values. The background and hair can afford to be very nearly at full strength, so as to help you to get the true value of the flesh tones against them.

Your flesh half-tones are your key values. When I look at a portrait from a technical point of view, the first thing I notice is the quality of the half-tones. These are the artist's signature.

Some paint them a cool neutral grey, some tend to green, others to purple, others to blue. They are the sign of the artist's taste, and colour sense, and certainly give the individual quality to the flesh.

The shadows, too, are full of colour, and vary from greeny brown to purple grey and deep warm orange in the reflected light.

But it is the *relation* of the shadow to the half-tone and the half-tone to the light that must be true. If these correct relationships are not observed your colour will be muddy.

No *one* colour is muddy by itself, it is the incorrect relationship with others that gives a muddy appearance.

Alternate between a concentration on values and a critical summing-up of your drawing. Consult your mirror—put the canvas on a level with your sitter and leave it there while you stand back to look; then continue to paint—walking backwards and forwards. This is an exacting process, but about half-way through the second sitting it is strongly advisable. It keeps you from being niggly and working too much on detail. You should still be keeping your handling as free as possible, and only working on the features individually for very short periods at a time. Two or three minutes' work on the eyes, and you have carried them forward enough to last you for half an hour.

Painting is not just putting a statement down, and thinking that that is final. The whole process is one of statement and re-statement and again re-statement. I do not mean making mistakes and then altering them. I mean making a search for the truth, and then using your first approach as a guide to a second approach, and your second to a third and so on. As one part develops you will have no difficulty in seeing what to do next. Move rapidly here and there, emphasizing, losing, accentuating, modelling.

At last you will have covered all the surface that you had previously painted the first day. Extend this so that the background is almost entirely covered. Rub something over the dress, if only to get rid of the white canvas, but do not actually begin to

paint it. You do not want to cover more canvas than you can cope with at one sitting.

By lunch-time the whole surface you intend to tackle is wet. The head should have some sense of reality by now—but still be without much expression or too definite characteristics, and certainly no detail. The only exception to this is your "signposts", which by now include, perhaps, a firm piece of drawing of the eyelids or the subtle line between the lips or the modelling round the nostrils.

This is not actually detail, but sharp observation of drawing where it is most useful. Avoid thinking about "expression"—it is far too early to worry about that—but if you are working well there will already be a well-established likeness, and this should suffice you. If this likeness is not there, or has become lost— stand back again and have a severe critical survey.

After lunch you again arrive with a clear mind, but this time you have more to cope with than previously. You must see that all your edges are considered, and only hard ones left where absolutely essential, in one or two places. You must simplify any unnecessary detail that has crept in and strengthen the drawing.

I usually set about this by a complete re-statement of almost everything into the wet paint—starting again with the background and the hair, and then beginning at the forehead and working steadily down the face, improving and developing the form.

Surprising as it may seem, I am aiming at repainting the whole head once again at the third sitting. Occasionally—especially with children—I may complete the head in two sittings. But this is not desirable as a rule, as there is so much that can usually be said about a face that it needs a minimum of three sittings, or even more, before you can express it all.

So, as the end of the second sitting approaches, I begin to simplify or soften anything that is liable to interfere with me next time.

The third sitting is, in many ways, the most difficult of all. What you have already painted will greatly affect what you are

able to do now. When your sitter poses again, it is quite possible that many circumstances are slightly different. Clothes and hair vary a good deal, so does the light—so does your mood. You may have acquired new ideas about your sitter—you may want to make definite alterations.

Again, before starting, take a long time studying your work and the model together, perhaps for ten minutes. Your aim at this sitting is to achieve a completely lifelike representation. Your immediate problem is to incorporate the work already done into the final portrait, merging in much that is satisfactory, but not hesitating to re-state everything again.

It is a far more difficult process than the beginning of the previous sitting, because there is so much more paint on the canvas and, proportionately, more to lose and to interfere with your freedom. On the other hand, there is more that is useful, and you can now feel free to concentrate on surface appearance.

As before, make a note of any mistakes in drawing. This must always be your first critical concern. If they are in any way serious, make temporary corrections on the surface, to be incorporated as you continue.

Again cover the canvas very lightly with copal oil medium.

Now you can use thicker paint where necessary, particularly in the light parts. You can also allow yourself the full range of tone, from darkest dark to lightest light.

It is wisest to start soberly with the background again, giving it its full colour and strength. It may not be necessary to cover it all over, but certainly make some new statements near the head. Should parts of the background be already very dark, rub scarcely any paint over it at all, but use just a little of the dark colour mixed with medium.

Now tackle the hair, and allow yourself to stress the highlights and the darkest shadows. Do not try to finish it yet—you want to keep everything going together—but use a full brush and see that the edge against the background is suitably merged.

Pay great attention to where the hair grows on the forehead. There is usually a greenish half-tone between the flesh colour and

the hair. If this edge is not well observed, the hair will look like a wig.

Paint the forehead broadly, and build up the highlights with richer paint.

Now begin to develop the eyes as a pair—not for too long, but long enough to give them some degree of reality. Pass from these to the true colour of the lips, and strengthen the modelling.

Keep moving as much as possible, but now you can afford to tackle individual features that interest you, and develop them as far as you like.

You are now beginning to be more aware of the general expression. You notice how, if the sitter is just about to speak or smile, there is perhaps a characteristic pucker under the eyes and at the corners of the mouth. You observe how the modelling of the cheeks affects the whole expression, especially near the mouth.

You begin to select your accents. Perhaps one eye is revealed by a strong dark accent over the lid; the line of the cheekbone may need forcing; the highlight on the forehead made stronger still.

Gradually, the head is repainted in its final richness, and you begin to search for surface detail, the line of the lashes, the curve of the lips, the drawing of the eyebrows.

Here are some points to watch for:

The Hair

Breadth and simplicity of handling. Emphasize your darks. Avoid thinking of it too much as hair, but as a series of colour values. It is chiefly at the edges that you should think of its hair-like quality. Brush the edges well into the background, and avoid any hard edges against the forehead where it grows. Notice how the light plays over the hair and forehead alike.

The Forehead

Aim at getting the effect of light right across it. It is probably the lightest area in your picture, so see that it is *relatively* lighter

than any other part of the face. Do not let any surface markings, such as wrinkles, interfere with the breadth of treatment.

Eyebrows

Note how even quite dark eyebrows are light in tone where the light falls on them, often being a greeny blue colour. Do not paint them too harshly, and remember they are made of soft hair, and are not two black arches.

The Eyes

Do not be carried away by the detail. They are the most important feature of all, but remember their construction, and try to see them as a whole. Be sure that the shadow underneath has just the right value; it is easy to get it too dark, or to be afraid of making it dark enough. Do not force the local colour of the iris. Do not make the iris too large. Do not "fiddle" with the eyelashes— just make the necessary accents where they tell. See that the two dark pupils tally with one another. Catch the light on the rim of the lower lid, and look for the thickness of the upper lid, often a distinct warm red. Do not get the whites of the eyes too light, they are usually half in shadow from the lids.

Above all, keep the eyes in true relation to the head as a whole. The most expressive phrase I know about them is that if the rest of the face is well painted, the eyes will drop into place like jewels into their setting.

The Nose

Model the bone in the nose strongly, and emphasize the shadow underneath if necessary. See that the light spreads across the cheek over the light side of the nose. Let the nostril in shadow be rather lost, but see that the other tells out as a piece of subtle drawing.

The Mouth

See that the edges are soft enough. Even if lipstick emphasizes the colour, do not treat the edges harshly. See that the corners

tuck in well. Be discreet in your use of local colour, untouched lips are very seldom a strong red.

The Chin and Neck

Remember the chin is spherical, and the reflection underneath is often remarkably light. See that the chin and jaw and neck are in proper relation to one another. Watch for the cool green-grey half-tones on the neck, and remember its cylindrical form.

Although you want to carry the painting extremely far at the third sitting, there are still certain subtleties that you can leave till next time. You have had, as yet, no time in which to pay much attention to the clothes, and as a matter of principle it is wise to unite the picture as a whole, rather than finish one part entirely before the rest is complete. So do not feel you have yet said your last word about every detail.

The very fact that the rest of the picture is unfinished will make it difficult for you to make final judgments. However, to all intents and purposes the head is very near completion.

During the last hour, if all has gone well, you should again feel extremely exhilarated. The head has achieved a life of its own and is the image of a particular human being. You are selecting only what is absolutely necessary to complete the painting. Every touch you give makes a tremendous difference. You hold your breath each time you put your brush on the canvas, and wonder if this new dab of paint will add or subtract from the general effect.

There comes a moment when, although you can see more that could be done by merely taking further facts from the model, the portrait has achieved a certain unity of its own.

This is the time to stop. The fourth sitting is still ahead of you.

THE FOURTH SITTING

I BEGIN the fourth sitting in quite a different manner from the others.

Instead of looking at the head carefully, I try to avoid looking at it at all! I do not want to think about it until the rest of the picture is painted in.

I rub copal oil over the canvas, as usual, and immediately start painting the background next to the dress, and then the dress itself. I watch carefully for the colour relation between the two, and keep my treatment as broad as possible, covering in the whole area thinly.

I try to feel the structure of the body underneath the drapery, and do not concern myself much with individual folds or surface trimmings. Clothes naturally vary enormously, from the conventional man's lounge suit to an elaborate evening dress of lace or velvet for a woman. Nevertheless, there are some general principles to remember which are common to all kinds of clothes.

Do not become interested too soon in accidental folds and shadows. Try to feel the weight and solidity of the body underneath. Search for the *significant* accents, and be aware of the light spreading across the figure. Breadth and simplicity of handling should be your chief aim—do not become fussy with irrelevant detail.

In the case of the head and shoulders portrait, the painting of which I am now describing, I should probably spend about one and a half hours putting in the dress before looking at the head again. When the canvas is completely covered, and the full range of colour and tone is established all over, I then consider the picture as a whole.

Plate 34 THE ARTIST'S MOTHER *Frank Slater*

Every artist attempts to paint his mother at some time or other and must always find it a special problem. He knows her so well that his aim is almost impossibly high. I have tried to catch the feeling of affectionate tolerance which many mothers feel towards their sons and to search both for the contours of the face and the experience which lies behind them.

Plate 35 EARLE HYMAN *Frank Slate*

This negro actor seemed to represent to me the very spirit of his race. I much enjoyed painting hi
fine head, with the large eyes looking fearlessly ahead, calmly awaiting whatever a harsh worl
held in store for him.

The Fourth Sitting

During the remainder of the sitting I am concerned with every part of the picture, modifying, simplifying, accentuating.

Edges need special consideration, so do the relative values of highlights and darkest darks. Be careful how you merge your fresh paint on the dress into the neck or shoulders. You may even need to repaint part of the neck to complete this delicate fusion successfully.

You now feel more objective about the face than you felt at the end of the third sitting, when you were very likely nervously exhausted. You may want to soften some modelling round the mouth or eyes, bring out a point of emphasis, strengthen a local colour.

Return again to the clothes and background. Get the feel of the material by a true judgment of colour values. Give the dress a painter-like quality, by letting yourself paint as freely as possible, and avoiding unnecessary detail.

If you are painting a man's suit or uniform, do everything you can to see interesting colour, and try to avoid making him look like a tailor's dummy, without going to the opposite extreme of making him appear sloppy or untidy. Men's clothes are particularly difficult to handle in an attractive manner, and I will deal with the problem separately when I discuss the whole question of dress.

Women's clothes offer great scope to the painter, and there should be no difficulty at all about making them look attractive.

And so, at last, we have almost come to the end of our head and shoulders' portrait. How do we know when to stop?

This is a matter of great importance. Speaking for myself, it amounts almost to a physical sensation. If everything has gone according to plan, by the end of the fourth sitting I have said all I have wanted to or have been capable of saying about a particular head. I get to the point where the urge to continue becomes less and less, and I keep stopping for a few minutes to keep my vision fresh.

If the work is successful, the portrait should be very much like the sitter. I am now searching for just what is necessary to com-

plete the unity and balance of my work, and for the realization of an expression which I have had in mind for a long time, but which quite possibly is not at the moment to be found in the sitter's face. Of course, it is not just one "expression" that I am aiming at, but a complete synthesis of the sitter's character.

My excitement has reached its climax, and rapidly begins to fall off. Now is the time to stop.

Someone is supposed to have asked Augustus John how he knew when he had finished a portrait. "When I am bored with it," he is said to have answered, dryly.

This is really the secret of when to put down your brushes. If you go on after this, the result may look heavy and laboured. Of course, if you get bored before you have said all you had originally intended to say, it is probable that your technique has not been sufficiently developed.

It is certain that many artists go on too long with their portraits, either through a mistaken sense of obligation to their sitters or through becoming too much interested in surface finish. It is a wise artist who stops a few minutes too soon than too late.

Although your painting may be finished, there are still several matters that still need your attention. You should be interested in the final destination of your work, and how it will look on the wall where it will eventually hang.

It is possible that you have already discussed this important matter with your client before the portrait was begun. I am always most concerned about where the picture will be hung. If it is placed in a position where half its value is lost, it is a very disappointing conclusion to a great deal of work. I always stress the fact that a picture must have the right light falling on to it, to give full justice to the colour. The best kind of light is one similar to that in which it was painted, usually from the left-hand side. Under no circumstances should a painting be hung exactly opposite a window, where the light shines full on to it and reflection ruins the effect.

At night, of course, a picture should have its own bracket lamp

attached to the frame. If this is not possible, a lamp placed below the picture gives an excellent effect. The worst lighting comes from a lamp reflecting into the picture from the same level, hanging from the ceiling.

If possible, the portrait should be placed so that it can be seen from a distance. I like to see it hanging at the end of a fairly long room, where it can be seen to its greatest advantage, especially if the colour scheme harmonizes with the decorations. If this can be planned beforehand, so much the better.

The frame must receive special attention. Every artist should see to the framing of his own pictures—in consultation with his client if he so wishes—and keeping the room in mind where the picture will hang.

I prefer to put the final touches to the portrait when it is actually in the frame, so that I can see the whole effect together. What kind of frame you use must, of course, remain a matter of taste. Heavy gilt moulding is now entirely out of fashion, and most artists prefer the light and graceful modern variety. A well-chosen frame enhances the effect of a portrait enormously.

The picture should be varnished six months after it is painted, and if you do this yourself it will make an interesting opportunity of studying your own work objectively after a lapse of time.

Let us return to the fascinating question of clothes.

For women I prefer softly-draped materials that reveal the figure. Semi-transparent sleeves, subtle-coloured velvet, and attractively designed printed silks, all offer an artist scope for expression. It is exciting to be able to paint with greater freedom than you could possibly allow yourself on the face, and this excitement should show in the result.

Be sure that the colour of the dress harmonizes with the face and hair. Do not worry about whether the dress will "date". If it is an attractive garment, that is intrinsically charming, it will still remain so after the fashion has changed. If your painting is good, the fact that the hair-style and dress will "date" should not really concern you. Women are usually very perturbed about this ques-

tion of dating, and a period will certainly come, in a few years' time, if not sooner, when the dress will seem outmoded to the superficial observer.

If, however, the portrait is satisfactory as a picture, no one should find this seriously disturbing, and as time goes on the fashion will regain its charm.

At present, in 1948, nothing seems more out of date than the fashion of the 'twenties, with the long-waisted dresses, the short hair, and the hats brought low over the eyes. But the earlier Edwardian period looks distinguished and graceful, which not so long ago seemed stuffy and over-dressed, and we have quite accepted the delightful women painted by Renoir, Manet and Degas, with their tousled hair and tightly corseted bosoms.

So do not be afraid to emphasize the cut and fashion of a well-designed garment. The so-called "picture frock", and classic hair-style, can suit certain types of women, but are not by any means always desirable. Artists such as De Laszlo and Lenbach often painted their women emerging from nebulous draperies. This may not have confined the portrait to the fashion of the moment, but it certainly dated the picture.

The best artists have usually delighted in the complex and elaborate arrangement of women's clothes. You have only to think of the portraits of the Italian Renaissance, of Velasquez's princesses, of the French Court painters, of Gainsborough and Reynolds and Lawrence, to realize what importance the great painters have attached to women's clothes. In fact, there is no greater source of information about the trends of fashion than a study of the leading portrait painters. Who ever painted more elaborate finery than Gainsborough? Who ever painted such amazing textures as Ingres? Was ever such enjoyment of rich satins and velvets as Sargent showed in his portraits of Edwardian beauties?

A portrait painter should love and understand women's fashions, and clumsy woollen jumpers and conventional sports clothes that are completely unfeminine should be avoided if possible.

Plate 36 'THE SHELL NECKLACE' *Frank Slater*

This very decorative model reminded me of the sultry beauties of the Renaissance. I saw her as a remote, exotic creature living in a world of her own. She wore her 'picturesque' costume with complete naturalness, but I made no attempt to search for character. Her formal beauty was sufficiently exciting in itself.

Plate 37 MISS HILDA SIMMS *Frank Slater*

I tried to suggest the sitter's eager temperament by the slightly forward and upward tilt of the head. The mirror in the background has, of course, been used many times before, but is, none the less, an amusing arrangement to paint.

The Fourth Sitting

Men's clothes, even to-day, offer a surprising variety for the painter.

Sportswear, white or coloured shirts open at the neck, a gay scarf or jersey, all help to make a pleasing colour arrangement. A judge's robes, Court dress and professional gowns all offer scope to the painter, and can be extremely decorative. Orpen was a master at getting a dramatic effect from a peer's robes or a chancellor's gilded trimmings, and yet keeping a unity of design, and allowing the personality of the sitter to dominate the picture instead of being smothered beneath the trappings of office.

What really taxes the ingenuity of the painter is to make an interesting picture of a man in an ordinary sober-coloured lounge suit. Something must be done to modify the drab conventionality of the average tailored garment that most men are forced to wear. Augustus John sees such clothes with a heightened colour vision, and breaks up his greys and browns and dark blues into an exciting scheme of colour values, that nevertheless suggests the exact nature of the actual garment.

Glyn Philpot often cast his men's clothes into dramatic shadow, perhaps turning up an overcoat collar and revealing a gleam of silk scarf at the throat. The paradox arises that a well-cut suit of clothes is not meant to reveal the sitter's true physique, but is actually designed to conceal it! The artist must use taste, discretion, imagination and colour sense to produce both a convincing representation of his sitters' garments, an aesthetically satisfying scheme of colour, and the feeling that there is someone inside the clothes.

I remember making a sketch of a fellow student, an Indian as it happened, at the Royal Academy schools. I was rather pleased with my effort and showed it to Charles Sims, the Principal. He at once criticized the treatment of the suit. Somewhat dashed by what I considered this unfair attitude, I asked him whether he thought the head was well painted. "Anyone can make an interesting painting of a head like that one," he said, "your real problem was to paint the clothes up to the same standard, and there you have completely failed."

133

I have always remembered that lesson when confronted with the less interesting parts of a portrait, and it remains true in every form of painting. It takes the vision of a gifted artist to see beauty in what is, to the untrained eye, drab or dull, and to paint what is apparently uninteresting and make it full of unsuspected charm.

I do not mean to imply that what is quiet in colour or subdued in tone should be completely transformed, and made into something that is totally dissimilar. I mean, simply, that the less interesting parts of a picture need special consideration, so that they take their place agreeably in the general scheme.

Uniforms offer a special difficulty, because servicemen naturally wish to appear "smart", with gleaming buttons and multi-coloured ribbons correct in colour and disposition. Here, again, the artist's colour sense, ingenuity and taste will have to be brought to bear, to avoid the sitter looking like a waxwork at Mme. Tussauds.

The older masters had more dramatic uniforms to paint than we have, as the generals of Lawrence and Reynolds and Goya so clearly show. Khaki could never be called an inspiring colour, and the Navy and Air Force blues do not offer much scope. The treatment of such uniforms is a severe test on an artist's true gifts and painter-like qualities.

After the head, nothing is more important than the character of the hands. In any portrait larger than a 24" × 20", one hand at least is likely to appear. In a 36" × 28" you will probably show both of them.

In posing the hands you must be just as careful to see that they fall into as characteristic a position as the rest of the figure. It must be admitted, however, that certain conventions have developed as to their disposition that it is impossible completely to ignore. Most people are self-conscious when posing and often let their hands drop into clumsy or awkward positions. What might be called a "bunch of bananas" look must be carefully avoided, just as it is equally bad to have the fingers arranged in an unnaturally "graceful manner".

It so happens that there are certain conditions which tend to bring out the individual character of the hands. One derives from a natural action, such as holding the arm of the chair or placing one hand lightly in or over the other—the second from letting the hand simply fall from a flexed wrist, the fingers curving naturally at the knuckles.

I arrange the general position of the hands at the first posing session, but do not place them too specifically until the third or fourth sitting. If I am painting a portrait which includes both hands, I ask for a minimum of six sittings. When putting in the general tone of the dress, I will rub some colour over the part where the hand will come, and see that the edges all round are kept very soft. I prefer to start the actual painting of the hands at the beginning of a sitting, usually the fifth. You can never be quite sure how long a hand is going to take.

One of the practical difficulties is to get the sitter to place the hand twice consecutively in the same position. In fact, to get it in the exact relation to all its surroundings a second time is literally impossible, and it is best to paint for as long as you can before the sitter needs a rest.

As before, I start by painting all round the subject I am tackling, and this may mean repainting part of the dress or chair or background, or whatever touches the hand. I then cover the whole area of the hand with a thin general tone and into this draw the disposition of the fingers and feel the structure, using a warmish half-tone.

Unquestionably, hands do offer special difficulties. If you do not draw them well, they look particularly disagreeable—the fingers seem made of rubber and the wrists filled with sawdust, instead of bone and sinew.

So pay particular attention to the drawing and structure of the hand as a whole—do not be led astray by detail and slight changes of local colour.

Even the greatest of artists have tended to be mannered in their treatment of hands. The most usual mannerism is to elongate them a little, especially the fingers, and so make the whole hand

seem more narrow and graceful. A certain stress on change of direction of wrist and knuckles, and a lengthening and simplification of the fingers can be extremely elegant—if elegance is the effect aimed at. But there can be more real beauty in the observation of character, as, for instance, in the hands of Rembrandt's Jewish merchants, and his other great portraits of old people, than in all the fashionable elongations of Van Dyck or Sargent.

Selection, as usual, will have to be carefully made of what is essential or inessential. An artist's quality and gifts will be revealed in his treatment of hands.

I advise you to paint one hand at each sitting, and not to start the second hand if there is not time to complete it without a feeling of rush, unless the two hands are so closely related—with the fingers entwined, for instance—that it is not possible to think of them separately. There are usually naturally defined areas which you can master at one sitting. If you have placed the hands so that one is very clearly shown, and the other much less, it is quite possible to finish them at the same time.

You must completely ignore, as long as you can, the intricate pattern of veins and small wrinkles and changes of skin colouring. They will only distract you from your main problem, which is one of form. By all means watch for the warm shadows and cooler half-tones, but only at the end introduce the subtle blue of the veins, the pinkness round the knuckles and the shine on the nails.

Bare arms offer particular difficulties of their own. It is very rarely that a woman has really beautiful arms; sometimes they are too thin, sometimes too fleshy. The upper part in particular is difficult to realize gracefully, and many ingenious tricks have been employed to modify undue thickness, such as cleverly cast shadows and arrangements of drapery or fur.

When painting arms, watch for the graceful curves, and how the fullest part on one side of the arm never coincides with the fullness on the other, but, as in all parts of the human figure, a rippling rhythm is created. Again, as always, watch your edges with the utmost care. The arms are soft and rounded, and cannot

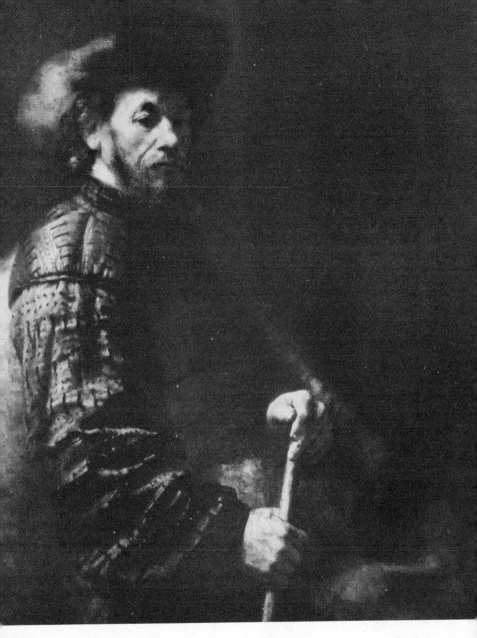

Plate 38 A JEW MERCHANT *Rembrandt*
A noble picture—dignified, restrained and powerful. The hands are marvellously painted and
beautifully placed. The play of light on the magnificently painted sleeve is one of the finest passages
even Rembrandt ever conceived.

National Gallery

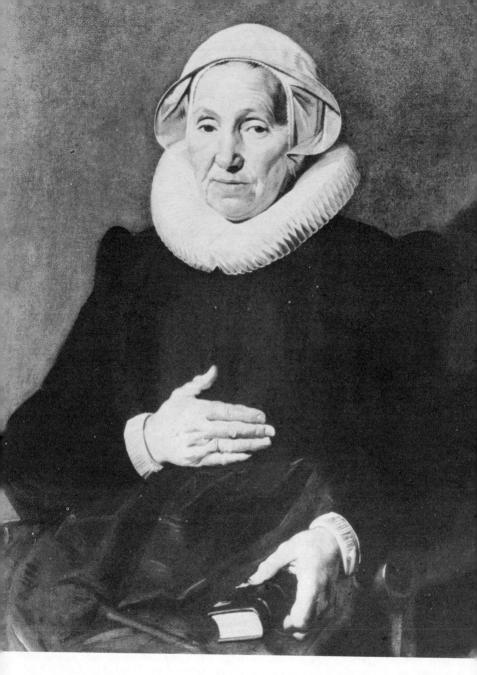

really have a hard edge anywhere, except where an accidental contrast of background or shadow comes up against the lightness of the flesh and causes an unusually strong contrast.

Remember that, although the light may seem to spread to the extreme edges of the arm, the highest light cannot be at the edge, because the arm is cylindrical, and as the form turns away there will be a slight gradation of tone.

I usually hesitate to suggest anything as definite as the actual handling of your brush, but I should like to mention here a most convenient method of painting long cylindrical forms, such as often occur in arms or in drapery. This is to use what can only be described as a wriggling movement of the wrist as the brush descends down the form. This adds to the feeling of roundness, and merges one tone with another.

However, the way you use your brush and handle your paint is as characteristic as your own handwriting, and should not be imitative. If you study the works of other painters, you will realize how each artist handles his paint in an entirely different and individual way. There are, of course, good ways and bad ways. Oil paint has particular qualities of its own, from an exquisitely smooth surface to a rich, creamy and thick impasto. When an artist has reached maturity, his knowledge and experience will give him the ability to handle his medium with assurance. The richness and beauty of his surface texture comes as a by-product of this knowledge.

From time to time you may have to paint a portrait group of two or more people. This will undoubtedly call for great skill and ingenuity.

Groups may vary from mother and child to family conversation pieces. The most helpful advice I can give is to describe one or two of my own experiences in this difficult field.

One of my happiest pictures was of two little girls, aged seven and nine years. The size of the canvas was 36" × 28".

The first problem in any group portrait is to find the best disposition of the figures within the limits of the canvas. On this occasion several factors decided the pose. As I was painting the

children at their house in the country, it seemed a good idea to set the scene out of doors in their own garden. This allowed them to appear quite naturally seated on the ground. A slightly protective attitude in the elder sister, combined with a simple affection between them, helped to create the grouping. Once this was achieved, I made my usual charcoal indications on the canvas while the sisters remained together. When I was satisfied with the placing, I confirmed it lightly with the brush.

I then painted the head of the elder sister by herself, with the necessary amount of background, and asked the younger sister to pose while I scrubbed in the dress and arms of both of them.

Next I painted the younger sister's head, and asked the elder one to sit while I painted the dresses completely, leaving the arms and hands for another time. Finally, I completed the background from notes made out of doors, and finished the arms and hands, and the picture as a whole.

The most difficult group I have ever painted was of five boys, ranging from eighteen months to eleven years of age.

I painted them in their own home, and in the room in which the picture was eventually to hang. There was a long, low stool in front of the fireplace, and this made a natural architectural base around which to form the group. Starting from a simple action— one of the boys offering the youngest an apple, I built up a composition using the stool as the base of a pyramid, and the head of the eldest boy as the apex. Two of them were standing behind the stool and three of them seated on it.

I began by making a number of pencil sketches while all the boys were present, although for obvious reasons these were done under great pressure. I tried to visualize the finished picture, and to keep the image in my mind.

I studied the notes carefully, afterwards, and worked out the general design.

Then, in one day, I made a complete colour sketch of the whole picture. This established the colour pattern of composition, and was most useful as a working guide throughout the painting. The boys posed in twos or threes for short periods as required.

The Fourth Sitting

The colour sketch was painted on a 30″ × 25″, and the picture itself on a 42″ × 34″, with the figures about half life-size.

The next step was to draw the composition with some care on to the canvas. As I was staying in the house, I was able to work during the whole day, and have the boys available whenever I needed them, either singly or in pairs. It required great patience to keep them interested, but it was most important to feel the structure of the picture was sound. I used various architectural features of the room to give firmness to the composition, and the straight lines of the mantelpiece and a bookcase were most useful to stabilize the movement of the figures.

I tried to keep the mass of detail under firm control, and not to have too many hands and arms and legs all over the place.

Once the composition was satisfactorily drawn on to the canvas, instead of eliminating it completely, I brushed off much of the surface of the charcoal, and allowed only a faint impression to remain.

I then proceeded to paint across the canvas from left to right, one boy at a time, trying to finish as far as I could as I went along. As a rule I used one sitter alone, but quite often asked one or two other boys to stand by so as to get the proper relation between them.

In all, I spent nine days' hard work on the picture. I do not think I ever felt so exhausted in my life as when it was finished.

XVI

THE STORY OF A PORTRAIT

THE story of the portrait which is illustrated in this chapter, at different stages of progress, may, I hope, be of some practical value, and add point to the theoretical instruction in the previous pages.

I did my best to follow the technique described, but each particular portrait has its own history and special problems.

For the purposes of reproduction the painting had to be whisked away after each sitting, and I did not see it again until the next week. As a result, when I saw the proofs later on, I was able to study them quite objectively as I had not seen each stage long enough to remember exactly how it looked.

The illustration marked (A) represents the first placing of the figure in charcoal on the canvas. Comparing this with the final picture, it is obvious that I have missed the more graceful neckline and droop of the shoulders. However, once I had *placed* the figure on the canvas, my immediate purpose was completed and the charcoal was rubbed off again. You may ask, why not take longer and do it better? Admitting the criticism, I want to stress the point that I like the first touches on the picture to be made with a *brush*, and the reason for doing a preliminary charcoal sketch was because it could be easily altered, should the *placing* not have proved satisfactory, whereas the brush would have committed me far more definitely. The final picture, however, was already in my mind's eye, even if my first tentative effort towards it was not entirely satisfactory. You learn so much as you proceed with a portrait, that it is just as well not to be imprisoned by your first few moments' work.

Plate 40 HISTORY OF A PORTRAIT (A)

The first placing on the canvas lightly drawn with charcoal in about twenty minutes. This is later dusted off so that the picture is actually begun with the brush.

Plate 41 HISTORY OF A PORTRAIT (B)

*This is how the picture looks after it has been lightly drawn in with the brush in a neutral colour,
such as grey.*

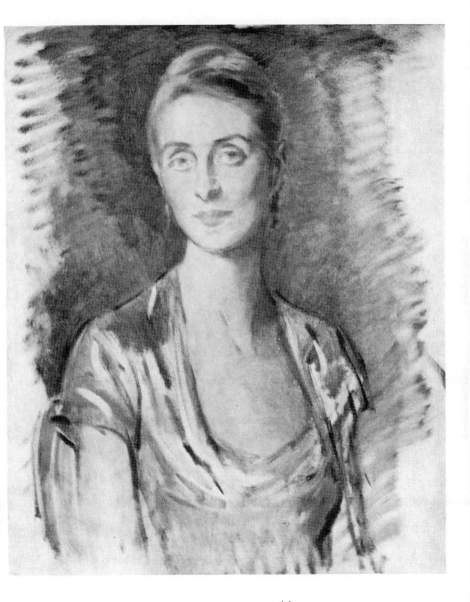

HISTORY OF A PORTRAIT (C)

At the end of the first sitting much of the canvas is covered over. The structure has been felt and the tones kept lighter than in nature.

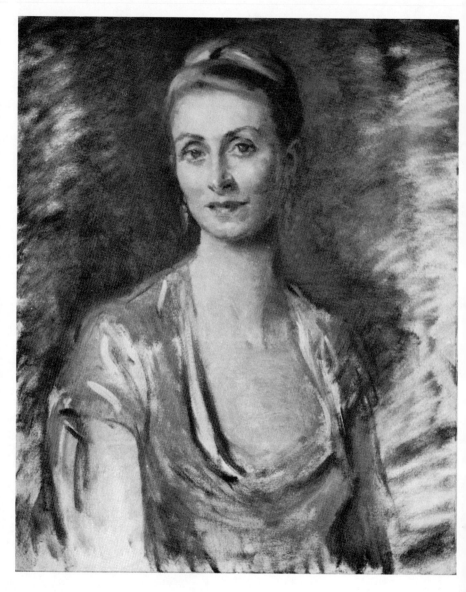

HISTORY OF A PORTRAIT (D)

*At the end of the second sitting the head is more carefully modelled, but the detail of the features
is still incomplete and the highest lights, darkest darks and strongest colours still held in reserve.*

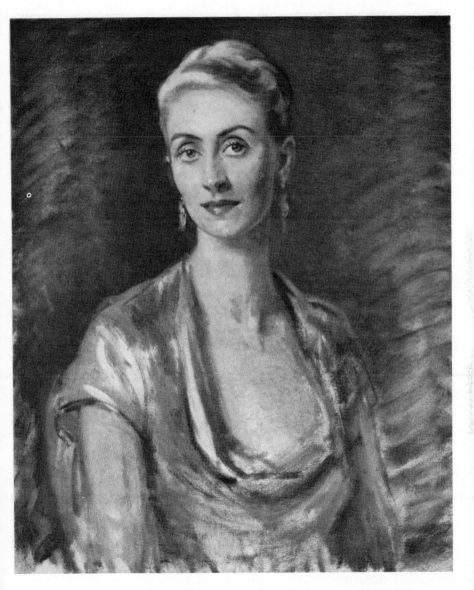

HISTORY OF A PORTRAIT (E)
By the end of the third sitting the head should be almost complete.

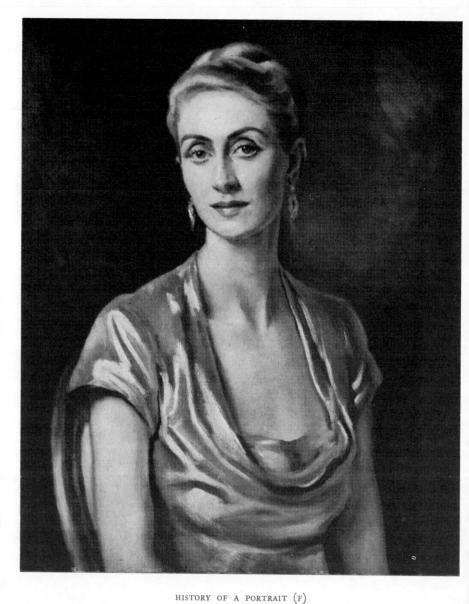

HISTORY OF A PORTRAIT (F)

During the final sitting the whole picture has been worked on so that the head, background and dress are all considered in relation to each other.

The Story of a Portrait

I realize now that in the preliminary sketch I had not made the figure characteristically graceful enough, but because I *completely* eliminated the drawing, this error did not handicap me later. I am stressing my mistakes to show how this technique allows for development, as well as for a certain margin of error, and does not tie you down too much, too soon.

After I had rubbed away the charcoal sketch which had taken about twenty minutes to draw, I immediately took my brush and began to place the figure again on the canvas, in the same position, using a pale mixture of ivory black and flake white, very thinly.

The next illustration (B) shows the result of another twenty minutes' work. This time I was committing myself more definitely.

I then started scrubbing in the back ground and hair, followed by the general flesh tone and the placing of the features. Illustration (C) shows how it looked at the end of two and a half hours' more work.

I have indicated where the features are, but not studied them very carefully. I have paid more attention to the structure of the cheekbones and the head as a whole, and tried to get the atmosphere and "feel" of the subject. The model's hair is not so attractively arranged as in the final portrait, but as I have not committed myself yet, I am able to change it later on when I have become familiar with its variations.

Most of the painting at this stage is thin and fairly non-committal, but relatively accurate in values, and the structure and movement have been considered.

One of my idiosyncrasies is to conceive my heads a trifle on the large size, and then gradually fine them down. I could probably, with care, correct this tendency, and have often tried to do so, but usually at the expense of a certain freedom of handling. I think it is preferable to paint too large than too small, as it is easier to reduce than to enlarge, but neither tendency can do much harm if you are fully aware of it, and bear it in mind as you proceed.

The next illustration (D) rather astonished me when I saw it

some weeks after the picture was finished; it seemed so heavy and lifeless. I had evidently been concerned with developing the solidity and form of the head, and the features and "expression" have not been considered at all. I had been interested in the modelling of the head *as a whole*, and the features, although an integral part, have not been looked at individually. The bone structure is again stressed, and if you compare the head with the previous illustration, you will realize how the flatness has now been eliminated and the face has a certain roundness and solidity. But the eyes and mouth are without expression, and the local colour has not been more than suggested. Every part of the head is equally undeveloped. There is nothing exactly "wrong", but it is all suggested rather than definitely stated. I am in process of creating a head, but it has not yet the facial characteristics of this particular model.

The next illustration (E) brings the picture much nearer to completion. The third sitting is always very important. For the first time I have considered the personality of the model with care. The eyes and mouth have been painted in at the end of the sitting; the face has been fined down, local colour emphasized, the characteristic hair-style painted for the first time. Everything is stronger and richer in colour. It is already something of a portrait. The rest of the picture is roughly filled in with a suggestion of what is to come, and the whole canvas looks promising.

The final portrait (F) may appear at first to be a big stride forward for one sitting, but the spade work had already been done. I painted the background and dress, boldly, in full tone; completed the neck and gradually climbed up to the face, modifying and accentuating at will. The comparative accuracy of the drawing of the head during the third sitting allowed me to rely on it in the fourth, and so I was able to consider the picture as a whole unit. The forehead is now bathed in light, and all the forms strengthened and simplified. The accumulated knowledge derived from the previous sittings was allowed to pour forth freely at the end and capture the particular quality of the sitter.

XVII

OTHER METHODS AND THE PAINTING OF CHILDREN

Now a word about the indirect method of painting a portrait. You begin by painting in monochrome. The colour you use for this is largely a matter of choice. A cool colour is preferable, because you will be painting warm flesh tints on top, and the cooler tones underneath will help to give an agreeable quality to the half-tones.

Reynolds used blue, Michelangelo terra verte. If you feel that a slightly warmer colour is pleasanter to work with, raw umber makes a perfectly satisfactory monochrome. So does ivory black.

Your first and last consideration is to paint form. All colour changes must be ignored. Local colour in the eyes and cheeks and mouth is of no concern as yet. You are studying the shape, drawing and construction of the head, and building up a solid foundation of paint.

You may need three sittings for a complete monochrome of a head and shoulders, and proportionately more for a larger picture. If you are proposing to use your monochrome merely as a guide, and a means of acquiring knowledge of the form before tackling the problem of colour, you may find that two sittings are enough. However, if you are going to allow the monochrome to show through transparent glazes, it must be completely satisfactory before you start putting on the colour.

Let us discuss this method first.

Squeeze out on to your palette five separate portions of flake white. Leave the first one pure white. To the second, add the merest touch of whatever colour you have chosen—say ivory

black—just enough to take away the purity of the white. To the third, add a little more, and to the fourth and fifth a little more still. Mix each one up *thoroughly*, and use them for your complete range of tones.

You will be amazed how well you can model with this comparatively small number of tones. Supposing we call them 1, 2, 3, 4 and 5 (1 being the pure white)—begin by rubbing the appropriate tone over the background near the head, it might be 3; and then scrub in the hair, perhaps a mixture of 5 and 4; then the general flesh tone, maybe 2; and into this draw the features in 3 and 4, and so on. Naturally, you will not be able to stick exactly to these five distinct values, but try not to get your darks any deeper than 5.

As when painting in the direct manner, do not get your paint too thick before you are sure of your drawing. Then build up your light areas with a rich and creamy white base, otherwise your final painting will seem thin, without body or substance. You can use pure white for the highlights, but keep the underpainting fairly thin under the darks.

The monochrome should be broad in treatment, and all surface detail avoided. Experience will teach you just how far to develop the form, but a very good test is to ask yourself: Could a sculptor make a model from the information I have given him?

When you feel this stage has arrived, allow the paint to dry completely—give it as long as you can, not less than a week, or, better still, a month. The reason for this is, that although paint may soon seem dry to the touch, it is not actually chemically dry for some time longer. There may be slight changes in the surface as it continues to contract for as long as six months. If the paint has been applied very thickly, and then glazed over too soon, cracks may appear later on the surface.

However, if your highlights are not too thick, they should be dry enough to paint over in a week or ten days.

Your first aim, when you start to glaze, will be to get rid of the underpainting as soon as possible, so that you can begin to judge your colour values, one against the other.

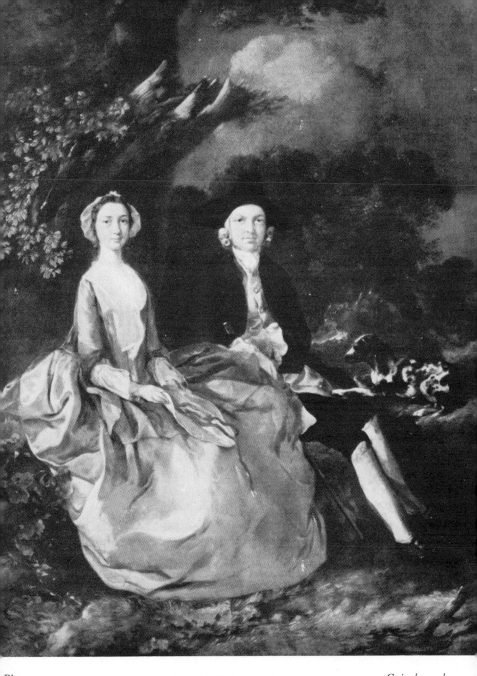

Plate 42 JOHN JOSHUA KIRBY AND HIS WIFE *Gainsborough*

This delightful double portrait by the young Gainsborough shows that he was a master of his art
from a very early age. It has all the freshness, charm and poetry that only a young man can bring
to his work, combined with a consummate technical skill. How much more attractive it is than the
rather dull portrait shown in Plate 12. National Portrait Gallery

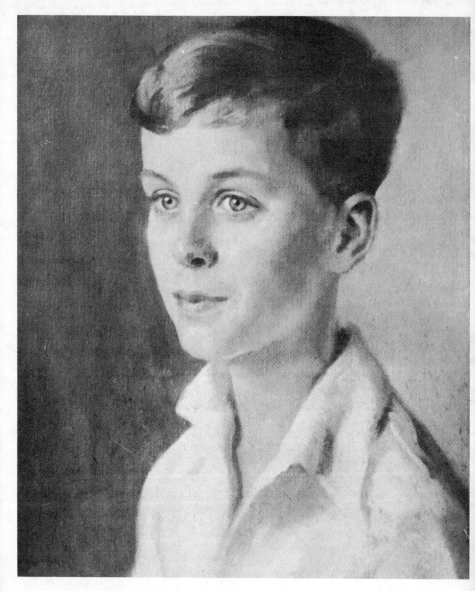

Plate 43 MASTER JOHN FELKIN *Frank Slater*

This boy's portrait was painted in two sittings. I chose a very simple pose and wanted to give the effect of the head balanced delicately on the small neck. The white shirt, throwing its reflection on the face, helps to keep a feeling of lightness and youth.

As before, begin by rubbing in the background tone, then the hair and then the face. Now, however, you are painting transparently, and you achieve your effect by letting the light underpainting show through the thin glaze of colour, and not by mixing your pigment with white paint.

Coloured pigment mixed with an oil medium is transparent. If you mix in a little white, it becomes semi-transparent; and if you mix it with more white, it becomes more or less opaque. If your underpainting is successful, naturally you will want it to show through as much as possible. There is no doubt that the quality of paint obtained by a brilliant underpainting glowing through transparent glazes is extremely lovely, and the most subtle changes of form can be suggested.

Once you have covered your monochrome with colour, go very slowly, and build up your colour gradations with extreme care and subtlety. This is by no means an easy process, and it is at this stage that the beginner often falters. It is a procedure that needs patience and experience, but if your underpainting is sound, it is comparatively easy to modify and change your glazes with your finger or a rag, and you can always find the monochrome underneath. If you discover that your drawing is not satisfactory, you will probably get into difficulties, and the only solution may be to paint over directly on top.

Remember that what you are trying to do is to achieve true colour values by a series of transparent and semi-transparent glazes. After one sitting you should have covered the whole head area with a fair approach to the truth, and have rubbed some colour over the dress.

At the second sitting, attempt to arrive at the full colour, stressing your accents and making sure that your glaze has not darkened the highlights too much. Where necessary, add some opaque colour, which will give variety to the surface.

The beauty, and at the same time the danger, of this process is that you can go on for a long time adding new subtleties of colour and tone, until suddenly the whole thing looks lifeless and heavy. Remember that instead of the beauty of fresh paint, which you

were aiming at in the direct method, the quality of richness is already there in your monochrome, and is shining through your transparent colour.

Study carefully the great portraits of the masters. As you yourself make progress, you will be able to see more and more how they actually worked. Go and copy them at the galleries. There is no finer way of learning their methods. Be sure, however, that you build them up in the same way that they did themselves. Do not start by imitating the surface, but try and see what colour was used for the underpainting—possibly by carefully examining the half-tones—and then proceed to create their effects in a similar manner.

I have already mentioned the advantages of using a very restricted palette as a useful exercise.

This is really a compromise between direct and indirect painting, and you can certainly glaze local colour over a painting done, say, in red, black, yellow and white, or in indian red, cobalt blue, yellow and white.

Sometimes you may find a half-finished work in one of the public galleries. This is always of great value to the student as it usually reveals the painting technique employed.

In the "Kit-Kat" Room in the National Portrait Gallery there is a painting of exceptional interest—a head, by Kneller, of Viscount Shannon, which has just been begun. You can see exactly how he set about his work.

He used a toned canvas of a subtle greeny-grey colour. On to this he painted the pink and white flesh colours and the warm shadows, and allowed the canvas to show through to form the half-tones.

This method has several advantages. The toned background underneath keeps a feeling of unity throughout the face, and the values of the half-tones are more easily arrived at. In some ways it resembles a pastel technique, where the grey paper shows through. It is particularly useful for quick sketches, where the grey tone helps to hold the colour together. If there is a danger, it is a tendency to allow the toned canvas to do too much work for

you, and prevent you studying the true colour of the half-tones with sufficient care.

A toned ground, however, is very agreeable to work on, and I can thoroughly recommend it.

One technical trick, which can be extremely useful in keeping your paint fresh, and not allowing it to get too thick and clog the grain of the canvas, is to remove a great deal of it at the end of a sitting. This can be done either with a palette knife, a piece of blotting paper, or even ordinary newspaper.

If you wish to paint freely, with a full brush, and yet feel that you do not wish to be hampered the next time by too much pigment on the canvas, it is a good idea to taken an extremely clean and sharp palette knife and remove the superfluous paint carefully at the end of the day's work. It will leave behind all the necessary colour values, soften all the edges, and be a very suggestive ground for your next sitting. The main disadvantage is the danger of the surface becoming slippery and that certain useful bits of work may be lost. If your canvas grain is fairly rough, the danger of it becoming slippery is not serious, and I recommend this idea as an excellent experiment, particularly if you are trying to do a head in two sittings.

A similar effect can be achieved if you place a piece of newspaper completely over your work, and then roll it carefully off again. This leaves a most agreeable surface to work on next time.

I must repeat that it is wise to try out several different techniques until at last you find one that fully expresses your own temperament.

One of the best exercises I know is the one-day sketch. When successful, it has certain qualities of freshness and vitality that can be achieved in no other way.

The technique I use is really a telescoped version of the four-sitting portrait previously described. Before beginning, I usually rub the canvas over with a warm grey glaze, so that the white surface does not interfere with my immediate judgment of colour values and the surface is agreeably receptive.

Naturally, the time element plays a very important part in the

procedure, and you must frequently look at the clock to see that you have sufficient time in hand to accomplish all you have set out to do. The maximum you can expect to have is five hours, but that is stretching your own endurance, as well as the sitter's, as far as it can go.

Almost everything that I said about the direct technique is again applicable. Hold back the painting of surface detail as long as you possibly can. Concentrate on constructing the head soundly and getting your true colour values. The features will fall into place in due course, and can be brought to completion in the last half-hour.

Keep the background and dress very free in treatment; a somewhat "broken" effect can look very agreeable—there is no reason why the sketch should not look like a sketch—in fact, it adds to its charm if it does.

You might aim at achieving a bold and daring effect, or perhaps a very subtle bit of modelling surrounded by a more suggestive and simplified area. Whatever you do, enjoy yourself, and the enjoyment will communicate itself to the onlooker.

Seize hold of whatever is dramatic or strongly marked, and force it a little. Have a point of view. Be colourful or gay or dashing. Have that "don't-give-a-damn whether it comes off" attitude, and you will very likely succeed. That does not mean that you should be careless or incoherent, but that you should let yourself be carried away more by emotion than if you had longer time.

And if you do fail, scrape it off—and it is possible that what is left may make you wish to repaint over it another day.

Personally, I have always loved the thrill of painting a head in one "go". If you are painting a commission, the strain is certainly rather severe, but if there is no alternative you may be stimulated by the extra effort involved.

If you can successfully paint a child's head in one sitting, you have almost solved the problem of painting children altogether.

Children are a problem all to themselves. First and foremost, speed is essential, as a child is not physically or mentally capable of keeping still for long. Under the age of six, it is rare for a

child to "sit" in the true sense at all. After that age, if they are remarkably "good" children, and react to a certain amount of discipline, you can get them to pose tolerably well for as long as a quarter of an hour at a time.

In the ordinary process of work, I look first at the model and the painting together, make up my mind what colour value I am going to mix next, look down at my palette, mix it up, and then, with the colour on my brush, look up at the model and the canvas again, to confirm exactly what I intended to do. If during the time I have been mixing my paint the model has moved, I cannot put the paint on the canvas with the absolute conviction that it is exactly right.

Now a child may keep still while you look at it, and hold its attention, but when you look down to your palette it is likely to follow your movement and lose the pose. The result is that you may paint for some time without complete assurance that what you are doing is right, and you may, in fact, be painting inaccurately. This very soon leads to trouble. You *must* make the child realize the absolute necessity of keeping the pose while you look away for a few seconds to your palette. As compensation, give your young sitters plenty of short rests. It is better to work accurately for a few minutes at a time, while the child keeps reasonably still, than for longer if the child is restless

To paint children successfully you must have an understanding of their natures. Most children have certain traits in common, such as asking innumerable questions, but you must recognize the particular character of each child, which varies just as much as that of an adult.

Most children hate sitting still, but you can gain their co-operation in many ways. Sometimes, to start with, as in the case of an adult, you can make them feel that by posing well they are helping you and contributing to the success of the picture. This usually works well for a time, but when the feeling of virtue begins to wear a little thin, you can appeal to them either by flattery—saying that they are sitting better than almost any child you have painted, or by discreet bribery with the promise of some

desirable object at the end. This is not perhaps a very ethical pro-cedure, but the profit motive is always a strong incentive to hard work.

The radio can be an excellent way of amusing them and hold-ing their attention, or you may have someone to read aloud. This is usually very successful, and if you do not find yourself dis-tracted—and personally I find it rather soothing—it is often the best way of keeping a child in one position.

Before starting, I usually explain that there are four distinct movements of the head: turning, tilting, raising and lowering. If I wish them to regain a lost pose I indicate it by making the required motion myself, and they generally imitate me.

It is always better to have a rest before the child is really tired, rather than wait till it gets peevish and "naughty". Occasionally, for the sake of the portrait, I may find it necessary to keep it sit-ting longer than usual, but children recover their natural high spirits very quickly. It is always a difficult decision to make when you know the portrait could be very much improved by an extra half-hour or so and the child seems to have reached the point where all pleas are in vain. It may sometimes be necessary to exert your authority firmly if you feel that the child is not actually suffering any harm. It is wise to let them respect your authority. A child's discomfort passes very quickly, but the painting lasts for ever.

Naturally, children take a great deal out of you, because they make such extra demands on your patience. A badly disciplined child is the most exhausting sitter of all.

Technically, everything is much as before. I usually paint a child's head and shoulders in two sittings of about three hours each, with frequent rests during the sittings, so that I concentrate about twice as much as usual into each time.

By the end of the first sitting I have established the drawing, construction and main colour relations, but rather lighter than in nature. At the second sitting I go all out to finish. If necessary, I paint on during the rests, relying on my memory, and correct where needed when the sitting is resumed.

The pose should be extremely simple, and the clothes equally

so. Boys always look fresh in coloured or white shirts open at the neck; little girls are preferable in pastel or white frocks, and not "got up" as if just going to a party. A suggestion of sky or landscape background gives a pleasant atmosphere, and the whole treatment should be light in feeling. Their young faces are usually so open and honest, that no great search for character is necessary, and if you get a good likeness of their outward aspect it is a true representation of their inner character.

With children under six, you must be a cross between a magician and a saint to achieve success. A magician in your technical prowess, and a saint for patience. No one can blame an artist if he brings in the aid of the camera when attempting to paint babies and tiny tots.

I shall go into the whole question of photographic aids in the next chapter.

Of course, there is the alternative of using drawings. When attempting to paint a baby, these are of great value. You can sit and watch the child and make a number of rapid drawings and colour sketches, and so gain knowledge of the form and colour. When one of the drawings seems good enough to be the basis of a painting, you can transfer it to the canvas by the usual squaring-up process, and then paint either with the child in front of you or from colour sketches.

When discussing Sickert's methods, I had some words to say about painting a portrait away from life. Now I should like to discuss the subject further.

To paint a portrait without the sitter present is an excellent exercise and well worth attempting. Here is how to set about it.

First of all make a colour sketch, along the lines of a one-day sketch, but smaller in scale, and concentrating as much as possible on the colour relationships, and not worrying too much about the accuracy of the drawing. Keep the painting rather more "broken" in texture than if you were painting a direct portrait, so that much of the colour is as pure and brilliant as possible. Aim at getting an interesting colour harmony, and stress the general pictorial value of the study.

Then make the most careful drawing of which you are capable. The purpose of the drawing is to supply all the facts about the form and construction. Go on with it as long as humanly possible. One thing is certain—once you are away from your sitter the more information you have the better.

It is wise to make several careful drawings, and choose the one you prefer as the basis of your picture.

Square the drawing up and transfer it to the canvas, adjusting it to life-size if you wish, and proceed to make an underpainting from your drawing, using the same method as when painting a monochrome.

When you begin to paint over it in colour you can either glaze transparently or start by painting thinly, and then gradually use more opaque colour and make a direct painting on top.

The advantages of painting away from life are many.

You have unlimited time, and no model to distract you and sap your energies.

You can concentrate on purely formal colour relationships and pictorial values.

You can build up a picture gradually, using every resource of imagination and intellect.

You can change your mind and make experiments without the sitter being aware of what you are doing.

If necessary, you can summon your model again and make new studies, but it is very unwise to work direct from life on the picture itself, however great the temptation. The picture is an interpretation of life, made from notes, sketches, memory and imagination. To try to combine it with direct painting from the model is a confusion of ideas, defeats the aim of the whole method, and is almost bound to lead to disaster. I do not say that it can never succeed—merely that it should never be thought of till all else has failed, and you have made no headway at all on your own.

If you are an artist who is capable of conceiving and carrying out a completely original imaginative interpretation, then working away from the model is the best of all methods, and some of

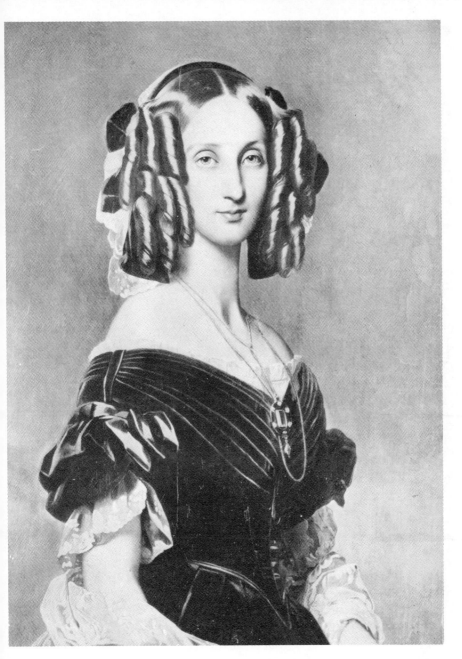

Plate 44 LOUISE D'ORLEANS, REINE DES BELGES (detail) *Winterhalter*
This rather artificial and stilted portrait tells us very little about the woman behind the curls and velvet. She is as waxy as a figure in Madame Tussaud's and leaves us entirely cold. There are hints of a certain graceful stateliness, but that is all. No real human being emerges from the canvas.

Versailles

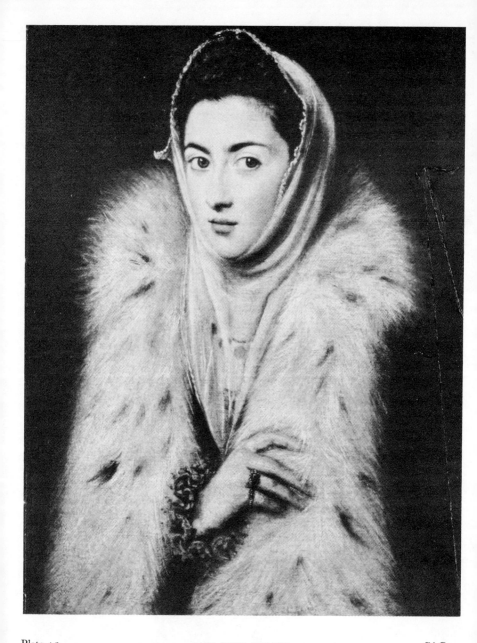

Plate 45 LADY WITH FOX FUR *El Greco*

Although this portrait was painted hundreds of years ago this woman might be a neighbour to-day, who has just popped on a scarf and fur jacket to go shopping. El Greco painted a real woman and saw her as a human being. He scorned artificiality and so-called flattery. It is a wonderful example of the permanence of great portrait painting.

Collection of Sir John Stirling-Maxwell, Bt.

the greatest portraits in the world have been done in this manner.

From one of Sickert's rare portraits you get the effect that the work is entirely subjective, and that the sitter is seen through Sickert's own satirical eye. For anyone with a gift for caricature, working away from life is by far the best way.

It boils down to this. If you are of an imaginative, intellectual temperament, with a strongly individual point of view, if you do not really care for human beings, and do not need the warmth of human contact to stimulate you, working away from life is the right technique to employ. Much as I sometimes wish to work in peace—when I make an occasional flower study I am reminded how restful it is to paint when quite alone—I know that unless I have nature before me the magic is missing.

Because it is magic. I never cease to wonder at the feeling of power and excitement that seem to fill me when I am working from life. It is indeed something of a miracle.

I hope sincerely that this will not be misunderstood. I make no pretensions to being an inspired genius. Far from it. But I have been able to feel something of the joy that has been granted to all creative artists, and I am immensely grateful.

It is, after all, entirely a relative matter. When Rembrandt and Velasquez were immersed in their painting, their chief enjoyment was in the creation itself, and the fact that they were painting imperishable masterpieces was something of which they may not even have been completely aware at the time.

All creative artists should share this feeling of joy and excitement in their work.

To return again to the question of painting from life, I myself only seem to feel the full thrill of creative work in front of nature. This is entirely personal. A vast number of artists work better in the calm atmosphere of solitude, where their minds are free from distraction; but something makes me doubt that many of them are born portrait painters.

There is one kind of portrait, however, that is excellent practice, and can be done in complete peace—and that is the self-portrait.

Most artists attempt this exercise at some time or other and have found it a fine opportunity for experimental painting.

The simplest and most convenient arrangement for work is to have the mirror placed on an easel, just to the left of the canvas, with the light falling over your left shoulder. This illuminates the left side of your face, in a three-quarter view, and allows plenty of light to fall on the canvas. Rembrandt used this scheme over and over again, and he was never tired of studying his own features. No doubt, he felt he could search into the depths of his own character, and paint everything he saw; there was no need to consider anything but the truth, and no necessity to worry about the sitter's feelings.

It is always amusing, incidentally, to note how an artist views himself. Quite often he sees a very fine and dashing fellow in the mirror. Orpen is one of the few who reveal a sense of humour, as many of his witty self-portraits show. John stares fiercely out of the canvas, but I seem to detect a gleam of fun behind the flamboyance. On the whole, artists seem to take themselves very seriously, which is really not so surprising considering the nature of their work.

XVIII

A PORTRAIT PAINTER'S PROBLEMS

THE relation between artist and sitter is a fascinating one. I mentioned earlier that it rather resembled that of the doctor and his patient. There must be sympathy and, if possible, warmth of feeling and real friendliness.

You must have confidence in your own ability, and then you will be able to inspire confidence in your client. Presumably he came to you in the first place because he liked your work, and he should place himself entirely in your hands.

If he happens to be a person of some fame or importance, there is no reason why you should feel any more diffidence about painting him than if he were a friend or acquaintance. In fact, I have often been amused, when painting or drawing celebrities, how ignorant they usually are of the painter's craft, and how ready to admire the artist's skill, forgetting for the moment their own abilities in another direction. If you are painting a great writer or actor it is well to remember that he probably envies you your talent with the brush. The desire to draw and paint is almost universal, and it is surprising how many people have tried and given it up as hopeless, leaving them with a sense of frustration.

While I am in the process of painting someone's portrait I find myself absorbed in their personality, their occupation and their background. Sometimes this interest is exhausted sooner than it should be, but on the whole it usually survives six sittings.

There is an authentic story about Orpen, touching on this subject. He accepted a commission to paint a director of a steel com-

pany, at a large fee. It was his custom to turn out an excellent professional job in three or four sittings. Half-way through the portrait he suddenly turned to the sitter, who, although a shy man, had considerable charm and force of character, and said: "If you don't mind, I would prefer to start again. I thought this was going to be just a routine affair, but I find you such an interesting subject that I am going to paint a real portrait." He worked for eighteen sittings, and the picture is considered to be one of his finest.

Inevitably, you are interested in some people more than others, but there are very few people with whom it is impossible to find something in common, especially if your own interests are fairly wide. You can always get your sitter to talk on his or her own subject, and even if it is one that does not interest you much, people are seldom dull when talking about themselves.

I feel a certain loyalty towards my sitters while they are being painted, and although I may realize their shortcomings, I try not to let them disturb me unduly.

Of course, if your client shows you no consideration, and is unpunctual, restless, impatient and behaves in a thoroughly un-civil manner, the only thing to do is to make it quite clear that they are spoiling any chance of the work being a success, and that you would prefer not to continue.

Fortunately, this happens very seldom and people are usually most co-operative, especially if they are paying for the portrait themselves!

Now a word about the business side.

When you are at the beginning of your career, there are always a few friendly people ready to encourage you by giving you small commissions. Accept them gladly, but remember that a portrait is a very specialized article. There can be no absolute guarantee that you will produce something they are going to like, even at any stage of your career.

The assumption is that people have seen and liked your work and been satisfied with the quality and likenesses of your previous portraits. But when it comes to their own likeness, or the likeness

Plate 46 RICHARD BOYLE, VISCOUNT SHANNON *Sir Godfrey Kneller*

This half-finished head reveals Kneller's technique. He allows his grey-green foundation to be the basis of his flesh half-tones, giving the whole head a certain unity. It is not unlike a pastel technique, where the coloured paper is used as one of the tones.

National Portrait Gallery

of a member of their family, that is a very different matter indeed. Extremely personal feelings are brought into play, and a portrait that displeases can cause a great deal of unpleasantness, and strong animosity, if not directed at the artist himself, certainly towards his work.

So the beginner is well advised to accept a commission with the understanding that if the client is not satisfied with the finished portrait, he is under no obligation to purchase.

If he really dislikes the picture he will be very unlikely to hang it on his wall, and even if he does it will only cause you harm in the long run.

Should you feel his criticisms unfair or unjustified it is still better to accept his verdict with dignity and try not to force him to accept the picture. If you like the work yourself, you can always hang it in your studio.

In practice, I usually find that what I like myself is liked by the client as well, and if I do not like it I will not let him have it in any case. If the likeness is good, and the picture satisfactory, just before it is finished I invite my sitter to look at the portrait and tell me exactly what he thinks and feels about it. Quite often, even though he may express himself delighted, he may have some useful suggestions to make. If it is at all possible, I am only too pleased to make any reasonable adjustment, providing, of course, that it in no way interferes with my own serious judgment or ideas. There are many small things that may make a great deal of difference to the sitter's feelings, such as a touch on the hair, or round the eyes and mouth. Very often his criticism is extremely helpful, and I am most grateful to his fresh outlook. In any case, it is a good thing to let the sitter feel that he has contributed something to the portrait besides sitting still.

Even after the sitter is satisfied, there is always a wife or husband or mother who has a special interest in the picture, and may be responsible for the fee. I never allow them to see the portrait before it is finished. When I feel that it is quite completed I invite them to the studio to express their views. Naturally, I wish them to like the work as well, and am prepared, if necessary, to

carry out any suggestions they may make, if they are reasonable and not inconsistent with what I feel myself.

After this I try to remain impervious to criticism. There are just three people I wish to satisfy—myself, my sitter and one other person who may be particularly concerned. Beyond these, however delighted I may be to hear words of praise, I will not allow myself to be unduly disturbed by adverse criticism. Friends or relations of the sitter feel bound to criticize a portrait and to give their personal opinions. To allow yourself to be upset by any adverse remarks would be foolish and exhausting.

To return to the question of fees, it is wise to settle exactly what the payment is to be before you start.

Do not rate yourself too low. The painting of a portrait is a specialist's job and deserves a fair payment. On the other hand, it is a good thing to tell your client beforehand that if he is not entirely satisfied he is under no obligation to take the picture. Most people will appreciate the fairness of this offer.

A young artist should not accept less than five guineas for a drawing, or twenty guineas for a small painting. As he progresses he can raise his fees to ten, fifteen and twenty for a drawing, and to fifty, seventy-five and a hundred guineas for a painting.

Once his work is in great demand, naturally he can name his own fees.

I have found that there is a large number of agreeable people who are anxious to have a portrait for a particular sum which they feel they can afford, and no more. An artist should be like a doctor in this respect, and if the client genuinely admires his work, and is not in a position to pay more than a certain sum, it would be foolish not to accept the commission, especially if the subject is an interesting one. An artist's work must be as widely seen as possible, and he should seldom turn down a reasonable fee if the offer is genuine.

I have very infrequently had any unpleasantness or difficulty about prompt payment. I have never had a written agreement with a private client, and only in the rarest cases had any bad debts. If I have done a series of portraits for a periodical I have

occasionally had a written contract, but merely as a matter of business routine.

An artist's relation with his client is essentially a personal one and the financial aspect should rest on a friendly verbal agreement. I never ask for an advance before starting, but if the client offers to make one, I accept the gesture in the spirit in which it is offered.

There are a certain number of people who do not feel happy unless they think that they are getting a bargain. In such cases I usually make them feel that I do not care sufficiently about ten pounds, more or less, to argue; but it is not wise to let people imagine that because you are an artist you need necessarily be a fool in business matters.

Some artists, of course, have no feeling for business at all. Others have a strong aversion to discussing money in any circumstances. It is wiser, in that case, to have an agent, who, although he receives a percentage, will probably get far better terms than the artist himself.

I have never employed an agent myself, and although I do not much relish talking over financial details, I have managed, as a rule, to conduct my own affairs without embarrassment.

Sometimes people who are in a position to put work in my way approach me with a view to business. I am always ready to pay them a reasonable commission, and such arrangements have often worked satisfactorily for a time.

On the whole, I rely chiefly on the work already done being a sufficiently good advertisement, when displayed in other people's houses. Of course, an active social life is important. A portrait painter cannot afford to hide himself away. He must meet people, invite them to his studio and get his work talked about.

If you can interest a picture dealer the results may, of course, be very profitable to both sides. He usually takes $33\frac{1}{3}$ per cent of the fee, but you must remember he has overhead expenses far greater than yours.

Dealers are not usually very keen on showing portraits, which I consider a great pity, but is a point of view I can understand. A

business man will always prefer to sell something concrete, and a commissioned portrait must necessarily be something of a gamble. If a dealer recommends an artist, and the painting is not a great success, he is in an equivocal position, as he has to pacify the feelings of both parties.

When it comes to the question of an exhibition, the dealer is entitled to his percentage on any commission which may derive from it. In practice, however, it is impossible for him to check exactly what private arrangements an artist may make with people who have seen his work at the show, and may later approach him personally. It is a difficult position from both points of view, but I feel that there could well be a better understanding between portrait painter and dealer than there is at the present time, with profit to both sides.

One thing is certain. There is a large potential public for a good portrait at a fair price, and this public does not know how to find the right artist.

There are, of course, the usual exhibitions, but the average person does not find it easy to select which artist he prefers, and is very much afraid of making an expensive mistake. He needs professional advice, and who is better suited than a dealer in pictures to give it to him. Every dealer should have a selection of portrait-painters' work at different prices, and be able to send prospective customers to the various artists' studios, so that they can meet them personally and see whether they are sympathetic to each other.

Many people go to expensive West End photographers who would far prefer to have a portrait, if only they knew where they could be certain of getting one at a reasonable price.

I made it clear at the beginning of this book that there was no point in comparing a painting with a photograph. They are utterly different things. A good photograph has unique qualities of its own. However, if you look at the question from a practical point of view, the motives that send people to a photographer are much the same as those that send them to a portrait painter. The underlying ones common to both are personal affection, senti-

ment, and a desire to perpetuate the image of someone they love.

If people realized more generally that, in addition to this record of personality, they could get an attractive picture, which would give them permanent pleasure, they would naturally prefer a painting to a photograph.

I think this is a good opportunity to discuss the use of photographs in portrait painting.

My views are the result of much thought and discussion, and I have reached very definite conclusions.

First of all, I must make it clear that I take up no moral attitude on the subject. From the purely ethical point of view it is immaterial to me whether an artist uses photographs to help him, or even paints over a photographic base. If he finds them indispensable, and the result is a good picture, the end justifies the means.

In former times the Masters employed assistants and pupils who were responsible for much of the preparatory work. To-day, there are a great many prominent and successful artists who do not despise the aid of the camera instead. It is impossible to blame them. If they are good craftsmen, their work will retain its good craftsmanship. If they are good artists, this fact in itself should give their pictures artistic merit. If they are not good craftsmen or artists, the use of photographs will not disguise the fact.

There was at one time some very unjust criticism of a Royal Academician who was accused of using a photographic base. The picture in question was, as it happened, the painting of a London scene and not a portrait, but as the artist was a prominent portrait painter the stigma remained, and many people imagined that he used this device because he could not draw. In actual fact, he was a fine draughtsman, and nothing could have been further from the truth.

Photographic aids may prop up the work of a poor draughtsman, but they will never turn a bad artist into a good one.

Looking at the subject broadly, I see it this way.

First of all, there is the case of someone who is dead. I have

painted a number of posthumous portraits from photographs, often very successfully. If the photograph is extremely clear, and the pose and expression characteristic, I am able to visualize the subject sufficiently well so that instead of sticking slavishly to imitating the surface of the photograph, I have been able to use my experience and knowledge derived from years of painting from life, to put down what I know must have been there.

It is essential to take into consideration the retouching and faking that photographers indulge in, and endeavour to see the true structure and bone formation.

If you can get the necessary information about the colouring, there should be little difficulty in getting your colour satisfactory, if you keep it restrained in feeling.

Naturally, if the subject of your portrait is dead, there is no alternative but to use photographs, and no ethical or moral problems are involved.

What, however, if he is very much alive?

Let me drive to the heart of the matter at once. I love painting portraits. I love painting from life. I derive a feeling of excitement and satisfaction from the work, comparable to no other. Painting from a photograph is a routine craftsman's job. There is no passion, no emotion, and very little pleasure to be derived from doing it.

If I have painted a portrait of a dead person, and in some curious way brought a reflection of their personality back to life, I must admit it has given me a certain measure of satisfaction, especially when relatives have received some happiness from my work.

But that is in a different class from the deep thrill of creation which I feel when I paint from the living model. How can work done in a spirit of creative emotion be comparable to that done from a flat and mechanically produced photograph?

Unfortunately, a large public is incapable of judging anything more than whether a portrait is a good likeness or not, and here lies the temptation for the very successful artist. He may know his job and be able to paint an excellent portrait from life, but if

he is kept very busy, the nervous strain and emotional exhaustion of his work is terrific. There are many very highly-paid portrait painters to-day, turning out first-rate pieces of craftsmanship, who rely almost entirely on photographs.

This method allows them indefinite time for working out the detail of the clothes, and guarantees a good likeness. Clients with more money than taste, often feel they are getting their money's worth if they see every button gleaming on their waistcoats and every stripe of their hideous trousers clearly shown. Women like to see their jewels and velvets exhibited in their full richness, and are delighted not to have to come for many sittings. Every one seems satisfied.

But are they? Surely an artist, if he has any real integrity, will not be really happy if he has sold his joy in creation for larger cheques?

I am the last person in the world to despise money. I know only too well that, if it cannot buy happiness, the lack of it can cause a great deal of misery. I have enjoyed to the full the experience of receiving substantial cheques, as well as worrying where the next one will come from. But the idea of exchanging my method of working from life for a safer and less exhausting technique from photographs strikes me as against everything that I believe to be important, and belongs to a different set of values from the one I possess.

Strange as it may seem, Sickert was the first artist of importance whom I heard admit freely that he used photographs—but not, of course, in the way that a professional portrait painter might do so.

Sickert's theory was based on the idea that the camera could catch certain aspects of life that no human eye was able to do; for instance, scenes of movement out of doors—a horse race, a street fight or a procession. If he saw a photograph that intrigued him, it might be a scene in a theatre or of some public event, he would not hesitate to use it as the basis of a composition. It was the spark that fired his imagination and, with his superb colour sense and flair for imparting a feeling of life to a picture, he painted a work of art.

It was he who first made it clear to me that it did not matter whether an artist made use of the camera or not, so long as he remained in complete control and did not become its slave.

In fact, there was no moral problem involved at all. There was no question of "cheating" or gaining credit for something you had not done yourself. If the result was an artistic success, it did not matter how it was obtained. That is the only standard by which to judge a picture. And that is the first and last word on the subject.

In cases where elaborate robes are to be painted for formal State portraits, it is not unreasonable for an artist to make use of photographic aids, if he finds them helpful. Of course painters managed perfectly well before the camera was invented (and still do) by using lay figures.

There is also the sitter who is quite genuinely unable to give the necessary number of sittings, such as a busy Cabinet Minister or Royalty. In such cases the technique to employ is as follows:

When your busy client arrives there should be a photographer present who proceeds, under your direction, to take pictures of different poses from many angles. These are later examined and the most characteristic one chosen as a basis for the picture. An enlargement is made of the head to life-size, squared up, and transferred on to a small canvas as a drawing. A monochrome is painted from the photograph, and then the sitter is summoned for one sitting, and you make a colour sketch of the head over your monochrome, as well as some further colour notes for the whole picture.

Then, if the portrait is to be a large one, the whole picture is transferred to the large canvas, and almost completed before the sitter comes again for the finishing touches. So that a very impressive-looking work can be completed with only two or three sittings from the model.

This method has, of course, much in common with working away from life, from colour sketches and drawings.

It has the supreme advantage of allowing you to work without the feeling of strain which is so often present during long sittings

from life. You can paint for many hours at a time, quietly and thoughtfully building up your picture.

There is no time limit. You can experiment or change your ideas without the embarrassment of the sitter knowing your problems.

Your colour sketch, from life, should be a mine of information. The values must be true, and the whole sketch full of subtleties.

If the photograph has caught a sympathetic expression and is a true record of form, the combination, with your colour sketch, can be amazingly successful.

I do not recommend this method until you have had a great deal of experience of painting direct from life; but when you have mastered your job, I should not hesitate to suggest that you should try this technique with sitters who are very self-conscious or awkward, or who for some reason cannot give you sufficient time to paint direct.

XIX

THE PORTRAIT PAINTER'S ATTITUDE TO HIS WORK

So far we have been almost entirely concerned with *how* to paint a portrait. Now let us discuss the more intangible, but just as important question of the artist's attitude of mind towards his work.

An artist's work is very largely an expression of his own character, but, as Bernard Shaw has so brilliantly shown in *The Doctor's Dilemma*, it is not inconsistent for a painter to be dishonest about money, unfaithful in love, and an altogether unworthy citizen, and at the same time having the highest ideals in art and the greatest integrity in his work.

It is also true that there are many artists who are faithful husbands and law-abiding men whose work is strictly dishonest.

Here, however, we are primarily concerned with the portrait painter and his particular problems.

Now a portrait painter is, by the very nature of his profession, open to certain temptations. Whether he likes to admit it or not, his work must please most people. If it does not, he cannot expect them to come to him and pay to have their portraits painted.

There are, of course, certain exceptional geniuses who, having achieved great reputations, can afford to work in an entirely personal and independent manner without any consideration for the sitter's feelings. If their clients dislike the result, at least they will have the satisfaction of possessing an original work by these great artists.

The aim of this book is to be practical. *I do not for a moment suggest that you should sacrifice one iota of your integrity as an artist to*

flatter people's vanity or pander to their ignorance. I do, however, maintain that an artist, setting out on a career as a portrait painter, should possess certain qualities of character. Unless he is prepared to see his fellow with a reasonably sympathetic eye, is it fair or wise to expect them to ask him to paint their pictures?

If his interest in painting is purely formal, if he sees his sitters only in terms of colours and planes, can he, however fine his picture may be as a work of art, expect the average man to be satisfied? He will say that he paints the truth as he sees it—and I agree that he is entirely justified. But he should not call himself a portrait painter. He is an artist who uses human beings as a subject, and nothing else.

However, I infinitely prefer to see a portrait that is a brilliant analysis of colour and form and makes an interesting picture— even if the sitter is portrayed as something less than human— than a sentimentalized version of the same subject.

Sentimentality is the greatest pitfall that awaits the artist who is over eager to please his sitters, and one from which few portrait painters have escaped at one time or another.

If the artist is imbued with a very natural desire to succeed he will, almost without realizing, tend to modify or eliminate certain of the less attractive features of his sitter.

Is this justifiable? Is it honest? Is it consistent with complete artistic integrity?

Supposing he says openly: "I want to glamourize my women sitters, I like to ennoble men, I enjoy painting children as adorable little creatures," has he lost all claim to be taken seriously?

Let us look for the answers by examining the works of some artists of reputation in this light.

Now I believe that Van Dyck, Reynolds and Gainsborough, to take only three great examples, were artists who deliberately selected everything that imparted style, graciousness and nobility to their sitters and yet managed, as a rule, to give a truthful study of character. They painted in "the grand manner", and it suited the periods in which they lived.

However, if you look at their less successful pictures, you will

find that Gainsborough's work suffers from a certain insipidity, and Reynolds and Van Dyck are not free from the charge that their portraits were done to a very definite formula.

In the same way, when looking at the paintings by Lely of the beauties at the Court of Charles II, you feel that however lovely the pictures may be, the healthy animal spirits of his sitters are only faintly discernible beneath their simpering, and their consciously "graceful" attitudes.

If you follow the work of Lawrence, chronologically, you can see how a very fine painter deteriorated when he began to "flatter" his sitters, by emphasizing the affected postures of the women and the "prettiness" of the children.

Millais and the Pre-Raphaelites made their children look like little angels, when they must have known from experience that this was very far from the truth.

The Victorian period was riddled with false sentimentality. Sentimentality is the refusal to admit the truth, an inability to face facts, and an attempt to cover up reality in a golden haze of false values. It was the fashion, in those times, that anything disagreeable or unpleasant should not be mentioned or admitted in public, and this had its corresponding effect on the Arts. Portrait painting suffered accordingly by often being sugary, superficial and pretentious.

It is extremely difficult for even a very good artist to escape entirely from the mannerisms and clichés of the period in which he lives. Only the great geniuses are capable of transforming what in lesser hands is trivial or affected into something that will always remain fresh and beautiful.

Another danger arises from the conscious or unconscious imitation of these greater artists. It is so easy to be influenced by a dominating personality, and to end up by merely copying their mannerisms without their content.

The delicate sentiment expressed in the faces of the faces of the Madonnas of Raphael, Botticelli and Piero della Francesca, was later debased into excessive sentimentality by less accomplished imitators.

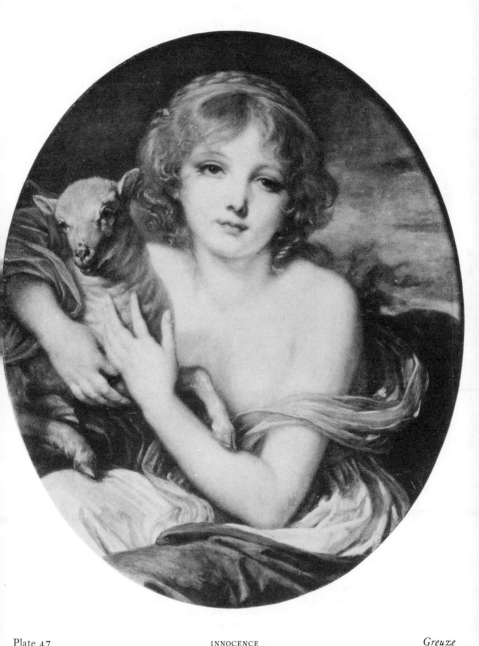

Plate 47 INNOCENCE *Greuze*

Greuze delighted in making his young women as sentimental as possible. Even the lamb seems to drip with sentiment. What a contrast to the delightful girl that Romney painted. I find the Greuze as sickly as marshmallow and cream, in spite of its expert handling.

Wallace Collection

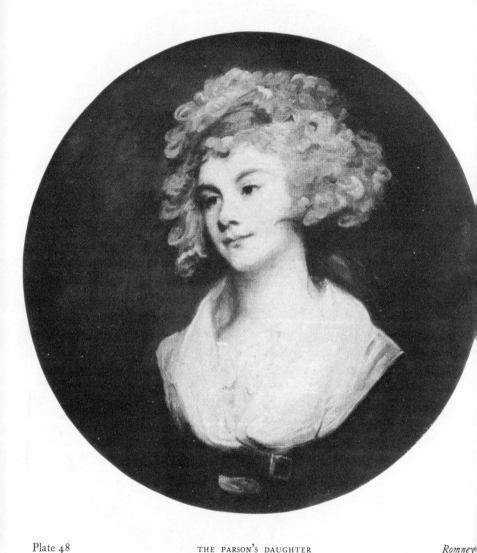

Plate 48 THE PARSON'S DAUGHTER *Romney*

This pretty creature is painted with charm and feeling, but no undue stress on sentiment. Romney has caught her youth and innocence but you feel she will grow into a woman of character and spirit. Indeed there is evidence that she has plenty already. And what breadth of treatment in the painting, especially noticeable in the hair.

National Gallery

The Portrait Painter's Attitude to His Work

The dividing line between sentiment and sentimentality is sometimes very narrow. One springs from a genuine feeling of love and understanding of what you are painting, and the other from a desire to create a certain effect, a wish to please the ignorant and a lack of real knowledge of the subject.

The Dutch have usually been free from sentimentality, and there are few lovelier portraits than the famous Vermeer "Head of a Girl". If you examine the face objectively, it is far from conventionally beautiful—but the exquisite simplicity of the artist's vision has transformed it into something of real loveliness.

Holbein, Velasquez and Rembrandt, above all, seem to me to have escaped from any suspicion of sentimentality. They see human beings in their simple dignity, and whether they are humble or rich, plain or handsome, youthful or raddled with age, each of their sitters has a quality of true beauty, which the genius of the artist has been able to perceive.

Goya, by contrast, was one of the rare, successful portrait painters who saw his sitters with an extremely critical eye, and sometimes painted them with a bitter and savage irony. He was painting the truth as he saw it, and this redeems what might often seem a series of ruthless caricatures.

What have we learned from these few examples? That danger lies in working in an outworn convention; in imitating the style of other artists without the content; in over-eagerness to please; in not loving and understanding your subject; and in not facing the whole truth.

But can you state the whole truth, and is not what you see and feel in other people very largely subjective?

If you are a reckless, flamboyant person yourself, will you be able to paint the mild and reserved people without loss of essential truth? And equally, if you are a quiet scholarly type, can you expect to paint a violent and robust character with complete success?

And when it comes to the particular, are you going to paint the wart on Cromwell's nose?

One artist will paint it with relish, and the other will either turn it from the light or actually not see it at all.

And most sitters have the equivalent to Cromwell's wart. Some have an habitual frown, another's mouth will turn down at the corners, a third will have a red or shiny nose. What is the honest portrait painter to do?

It comes down to an understanding of the meaning of the word "truth".

The aphorism that truth is beauty and beauty truth is at the core of the problem. In other words, Cromwell's wart is a simple fact to be faced, and seen in its true relation to the whole face.

There are many superficial and trivial blemishes that have absolutely no significance at all. The artist must use his natural discretion and powers of selection. If, for instance, a sitter has just a tendency to a double chin, there is no point in forcing it. If, however, a double chin is one of the essential characteristics, it should be painted with honesty as an integral part of the head.

Where women of a certain age are concerned, there are often only slight differences that indicate whether she is five years younger or older. I do not see anything to be gained by stressing these differences, but I should never dream of eliminating them entirely, as is the habit of so many photographers.

It is only natural that people should wish to look their best in a portrait, and there is no reason why this should be inconsistent with a true portrayal of their characters. They are not usually all nobility and graciousness, neither are they all vicious and disagreeable. They are a mixture of qualities, and, in my experience, they are fundamentally decent and kind, with the usual weaknesses of human nature, such as vanity and selfishness.

If you approach your sitter in an understanding frame of mind, I see no reason why you should consciously have to modify anything essential. If you do not allow yourself to get into a formula, if you carefully avoid being led astray by Hollywood versions of "glamour", if you search for the true character, and if you find all people intrinsically interesting, there should be no necessity

to worry about your work giving pleasure, and no need to give up a fraction of your honesty and integrity.

If you strive too consciously to please, the results will be superficial, sentimental and vulgar. This is inevitable. And it accounts, I am afraid, for the appalling number of bad portraits in the world, just as much by reason of weak drawing and sloppy painting.

On the other hand, there is no reason to go out of your way to make everyone look their worst and to emphasize everything that is disagreeable. There is a great deal of truth in the saying that beauty is in the eye of the beholder, and a portrait painter should have an eye that is able to see beauty in everyone.

One curious thing about a bad portrait is that even if you have no idea what the sitter looked like you are certain that it is not a true representation of him. There is something completely unconvincing about it that does not ring true.

I remember reading a biography of Marie Antoinette, illustrated with portraits of her by Mme. Le Brun and other Court painters. They showed the picture of an insipid nonentity, without individuality, and it was impossible to form any real judgment of what she looked like. The last illustration was a rapid drawing done by David. It showed with brilliant economy of line, but absolute truthfulness, the figure of a woman seated on the back of a tumbril on the way to the guillotine.

Stripped of her finery, without her elaborate coiffure, in a coarse shift and her hair pushed under a mob-cap, she had more dignity and more real beauty than in all the Court portraits. David saw the truth, and had no reason to hide it. At last I could see what Marie Antoinette really looked like.

There is another aspect of a portrait painter's work to be discussed, perhaps the most important of all—portrait painting as an art.

I have already made it clear that I do not think it possible to teach anyone how to become an artist, although a talent for drawing and painting can be developed by constructive guidance.

The Portrait Painter's Attitude to His Work

What is it that makes a painter an artist?

I believe that the quality of a man's mind that makes him an artist, whether he be a writer, musician or painter, is a spiritual one, and quite separable from his natural ability. There are painters of great talent who have little claim to be considered good artists, and artists of the highest rank who have only limited ability.

In the same way that talent develops, so the artist's mind matures, although not necessarily at the same rate. A painter who learns his craft with great facility may allow his talent to smother his artistic growth. Similarly, an artist who finds practical progress slow and painful may become so critical of his work that nothing he does satisfies him, and he may give up in despair. Between these two extremes there is the fortunate man whose ability and artistry develop harmoniously together.

A painter's talent represents the material side of his work, his art the spiritual.

The portrait painter is in something of a dilemma. He contracts to paint a portrait, but it would not be possible at any time to guarantee a work of art. If the portrait emerges as one, then the client will actually be getting more than he bargained for. No one should expect a work of art to be produced to order.

It took me a long time to reconcile myself to this seemingly unpleasant fact, but once I had faced it I realized that there was no reason for despair. If your talent lies unmistakably in the painting of portraits, then there is no reason why you should not paint pictures of considerable artistic merit, if not every time, then as often as favourable circumstances arise. If your artistic nature is strongly developed it will be able to triumph over practical difficulties. The artist who consciously attempts to create a work of art often fails to achieve his aim. A portrait painter undertakes to paint a good portrait, and the artistic merit of his work remains a by-product.

The art critics realize this, and the majority of them dismiss a portrait-painter's work as being either technically able or meretricious, as the case may be, and seldom, if ever, consider it seriously

as art. Although I have often felt a deep resentment at this attitude, if I am completely honest I must admit some justification for it.

An exhibition of portraits containing perhaps two or three hundred pictures, representing years of work, is often dismissed by a critic with some damning sentence such as: "The portraits were of some technical proficiency, and no doubt please the sitter's relatives." This kind of thing used to make me extremely angry, for I felt that the critic completely failed to realize what ability and hard work had gone to the making of these portraits. I believe, now, that the critic was only too well aware of this skill and labour, but was searching for something else—artistic merit. Sometimes he would find it in a slight sketch which nevertheless showed genuine feeling. He would select it for favourable comment and ignore the large set-pieces painted by the skilful and the competent.

Now, to paint a portrait at all needs skill, and if the adjective "competent" has grown to have a derogatory meaning, that is because competence so often tries to take the place of something else. But surely no artist wants to be unskilful and incompetent! There was nothing incompetent about Rembrandt or Velasquez. If Cézanne or Van Gogh lacked facility, that does not increase their artistic stature. Degas and Renoir were extremely skilled craftsmen, and no one thinks any the less of them for their competence. But neither skill, competence, patience, ability, talent nor hard work is a substitute for the bright, clear flame of true art. This flame sometimes burns steadily; sometimes erratically; it may burn itself out in youth or flare up in middle age. It does not come as a reward for virtue or application; it is a power given indiscriminately to the strong or the weak. If we recognize it, whether in ourselves or in others, we can only cherish it and try to keep it glowing. If it is neglected it may fade, and if it is misused it will surely die.

This book cannot help you to become an artist: no book can do that. If you have the makings of a true artist, it is in the development of your whole personality through life, literature and

experience that your art will mature. And this maturity, accompanied by good craftsmanship, will lead to your full development as an artist.

A PORTRAIT PAINTER'S CAREER

O NE of the most important factors in making progress is a thoroughly objective and critical understanding of your own capabilities. You should be able to recognize your special gifts at an early stage of your development, and concentrate on them to the full. All artists are endowed with particular qualities of their own, and the sooner they find out what they are the better.

You should know your own potentialities: your limitations as well as your strength. Unless you have a flair for catching a likeness, and a passionate interest in portraiture, there is no point in attempting to become a portrait painter. To take up portrait painting because you think you can make more money that way than by any other is an entirely wrong attitude amounting almost to dishonesty.

Let us assume, then, that you have this gift for getting a likeness and a profound interest in your job. There is in each of us something personal, some particular flavour that is unique. Your work should reflect this special quality and become an outward expression of yourself. Your aim should be to develop your personality in your work, so that eventually it becomes a complete expression of yourself.

There will undoubtedly be weak points in your make-up. It may be your sense of colour, your powers of composition, or your draughtsmanship. Naturally, you must do everything in your power to strengthen these deficiencies, but it is a good thing to recognize them honestly and face up to the fact of their existence. Do not overstrain your natural capacities. It is best to develop

your particular gifts to the highest pitch, and so help to cover up your weaknesses. If your colour sense is poor, do not attempt elaborate colour arrangements, but stick to simple relationships and relatively quiet colour. If your draughtsmanship is not too reliable—although you should develop it by constant study, because it is the foundation of all good work—do not despair if it does not come up to the standard you demand of yourself. Concentrate on colour and attractive composition, and your weakness in drawing may not be such a handicap.

It is amazing what can be done with comparatively limited gifts if you use them the right way and employ a sound technique.

If you have enthusiasm and the power to control it, good taste, attack, logic, integrity of character and the gift of self-criticism, you may be enormously successful with a comparatively limited talent.

On the other hand, you may have great gifts and yet not have the necessary application to develop them. There have been many cases of brilliant and promising students who have never become successful artists due to lack of character.

A portrait painter's life is by no means an easy one. Its very freedom can be a drawback if you do not make the best use of it. You are your own manufacturer, manager, agent, salesman, publicity man. You may often not be quite certain where the next commission is coming from—but you cannot advertise like a photographer. You must constantly be meeting new people, and yet, if you are to keep any self-respect, you must never give the slightest suggestion that you are seeking work.

It is essential to paint a certain number of portraits every year for your own pleasure. If you paint for yourself you will naturally choose models who are attractive and sympathetic to you, and you are therefore likely to do good work. Besides the splendid practise, it is useful to have new paintings to hang in your studio and to send to exhibitions. The freedom you will feel is an excellent tonic to frayed nerves after a number of commissions.

Your work is your best advertisement, and the more good work you produce, the more commissions you are likely to obtain.

On the other hand, you are not a factory. Very few artists can turn out a consistently high level of work without constant renewal of strength.

You should travel, have outside interests and lead a full and interesting life. Of course, unless you have an independent income, you may seldom be free from economic pressure. You have chosen a life which can give you the richest kind of rewards— complete self-expression and the work you love best. It may also bring you great financial rewards, but there always remains the feeling that you must rely entirely on your own powers and resources. There is no monthly pay-cheque, no yearly salary, no pension. On the other hand, you may be able to earn a great deal of money in a comparatively short time, take your holidays when you choose and be responsible to no employer.

If you are to succeed, however, you will be a hard taskmaster and demand the utmost from yourself. Personally, I have a fierce moral conscience about work. Unless I am working hard and well I cannot enjoy the other pleasures that life offers. Work, for me, is a violent appetite that must constantly be appeased; but, like any other appetite, it can become satiated. If I have worked hard for five or six days on a difficult portrait, I may not, indeed I cannot, look at a brush for two or three days afterwards. Then the appetite returns, as strong as ever, and I must be at my easel again or I am miserable. Pressure of circumstances may force me to paint continuously for some time—I have kept it up for as long as twelve or fourteen consecutive days—but it is unwise to attempt this often. A portrait painter must always be prepared to rise to an occasion, but it is far better not to overstrain. I find it wise to conserve my energies, paint with all my heart and soul, and then relax for a short time.

Real progress is only made by regular and continuous painting. What you have learnt from one portrait is then applied to the next. You should always be watching your own progress, comparing this year's work with last, and even with what you did a long time ago. I always have my work photographed, and keep a record of every portrait that leaves the studio. You may find a

certain quality in work you did some time previously that you lack to-day. Try to keep a perspective on yourself and see your work objectively. Do not allow yourself to get into a groove and become stereotyped. Employ different techniques for different sitters and in different circumstances. Never be satisfied. If you have done a good piece of work, do not be afraid to admit it openly, and rejoice. If you have done something unworthy, destroy it, or at least put it aside until you are quite certain it is not good, and then scrap it.

If you are a born portrait painter you are one of the fortunate people of this world. You do not have to search for adventure; you do not have to seek for thrills in violence and speed; you can experience every thrill, exercise your courage and expend your creativeness in front of your easel.

If you have talent, a strong constitution, character, patience, and a love of your fellow creatures, then go ahead and become a portrait painter.

INDEX

Index page.

Index

A CATALOG OF SELECTED
DOVER BOOKS
IN ALL FIELDS OF INTEREST

A CATALOG OF SELECTED DOVER
BOOKS IN ALL FIELDS OF INTEREST

DRAWINGS OF REMBRANDT, edited by Seymour Slive. Updated Lippmann, Hofstede de Groot edition, with definitive scholarly apparatus. All portraits, biblical sketches, landscapes, nudes. Oriental figures, classical studies, together with selection of work by followers. 550 illustrations. Total of 630pp. 9⅛ × 12¼.
21485-0, 21486-9 Pa., Two-vol. set $25.00

GHOST AND HORROR STORIES OF AMBROSE BIERCE, Ambrose Bierce. 24 tales vividly imagined, strangely prophetic, and decades ahead of their time in technical skill: "The Damned Thing," "An Inhabitant of Carcosa," "The Eyes of the Panther," "Moxon's Master," and 20 more. 199pp. 5⅜ × 8½. 20767-6 Pa. $3.95

ETHICAL WRITINGS OF MAIMONIDES, Maimonides. Most significant ethical works of great medieval sage, newly translated for utmost precision, readability. Laws Concerning Character Traits, Eight Chapters, more. 192pp. 5⅜ × 8½.
24522-5 Pa. $4.50

THE EXPLORATION OF THE COLORADO RIVER AND ITS CANYONS, J. W. Powell. Full text of Powell's 1,000-mile expedition down the fabled Colorado in 1869. Superb account of terrain, geology, vegetation, Indians, famine, mutiny, treacherous rapids, mighty canyons, during exploration of last unknown part of continental U.S. 400pp. 5⅜ × 8½. 20094-9 Pa. $6.95

HISTORY OF PHILOSOPHY, Julián Marías. Clearest one-volume history on the market. Every major philosopher and dozens of others, to Existentialism and later. 505pp. 5⅜ × 8½. 21739-6 Pa. $8.50

ALL ABOUT LIGHTNING, Martin A. Uman. Highly readable non-technical survey of nature and causes of lightning, thunderstorms, ball lightning, St. Elmo's Fire, much more. Illustrated. 192pp. 5⅜ × 8½. 25237-X Pa. $5.95

SAILING ALONE AROUND THE WORLD, Captain Joshua Slocum. First man to sail around the world, alone, in small boat. One of great feats of seamanship told in delightful manner. 67 illustrations. 294pp. 5⅜ × 8½. 20326-3 Pa. $4.95

LETTERS AND NOTES ON THE MANNERS, CUSTOMS AND CONDITIONS OF THE NORTH AMERICAN INDIANS, George Catlin. Classic account of life among Plains Indians: ceremonies, hunt, warfare, etc. 312 plates. 572pp. of text. 6⅛ × 9¼. 22118-0, 22119-9 Pa. Two-vol. set $15.90

ALASKA: The Harriman Expedition, 1899, John Burroughs, John Muir, et al. Informative, engrossing accounts of two-month, 9,000-mile expedition. Native peoples, wildlife, forests, geography, salmon industry, glaciers, more. Profusely illustrated. 240 black-and-white line drawings. 124 black-and-white photographs. 3 maps. Index. 576pp. 5⅜ × 8½. 25109-8 Pa. $11.95

THE BOOK OF BEASTS: Being a Translation from a Latin Bestiary of the Twelfth Century, T. H. White. Wonderful catalog real and fanciful beasts: manticore, griffin, phoenix, amphivius, jaculus, many more. White's witty erudite commentary on scientific, historical aspects. Fascinating glimpse of medieval mind. Illustrated. 296pp. 5⅝ × 8¼. (Available in U.S. only) 24609-4 Pa. $5.95

FRANK LLOYD WRIGHT: ARCHITECTURE AND NATURE With 160 Illustrations, Donald Hoffmann. Profusely illustrated study of influence of nature—especially prairie—on Wright's designs for Fallingwater, Robie House, Guggenheim Museum, other masterpieces. 96pp. 9¼ × 10¾. 25098-9 Pa. $7.95

FRANK LLOYD WRIGHT'S FALLINGWATER, Donald Hoffmann. Wright's famous waterfall house: planning and construction of organic idea. History of site, owners, Wright's personal involvement. Photographs of various stages of building. Preface by Edgar Kaufmann, Jr. 100 illustrations. 112pp. 9¼ × 10.
23671-4 Pa. $7.95

YEARS WITH FRANK LLOYD WRIGHT: Apprentice to Genius, Edgar Tafel. Insightful memoir by a former apprentice presents a revealing portrait of Wright the man, the inspired teacher, the greatest American architect. 372 black-and-white illustrations. Preface. Index. vi + 228pp. 8¼ × 11. 24801-1 Pa. $9.95

THE STORY OF KING ARTHUR AND HIS KNIGHTS, Howard Pyle. Enchanting version of King Arthur fable has delighted generations with imaginative narratives of exciting adventures and unforgettable illustrations by the author. 41 illustrations. xviii + 313pp. 6⅛ × 9¼. 21445-1 Pa. $5.95

THE GODS OF THE EGYPTIANS, E. A. Wallis Budge. Thorough coverage of numerous gods of ancient Egypt by foremost Egyptologist. Information on evolution of cults, rites and gods; the cult of Osiris; the Book of the Dead and its rites; the sacred animals and birds; Heaven and Hell; and more. 956pp. 6⅛ × 9¼.
22055-9, 22056-7 Pa., Two-vol. set $21.90

A THEOLOGICO-POLITICAL TREATISE, Benedict Spinoza. Also contains unfinished *Political Treatise*. Great classic on religious liberty, theory of government on common consent. R. Elwes translation. Total of 421pp. 5⅜ × 8½.
20249-6 Pa. $6.95

INCIDENTS OF TRAVEL IN CENTRAL AMERICA, CHIAPAS, AND YUCATAN, John L. Stephens. Almost single-handed discovery of Maya culture; exploration of ruined cities, monuments, temples; customs of Indians. 115 drawings. 892pp. 5⅜ × 8½. 22404-X, 22405-8 Pa., Two-vol. set $15.90

LOS CAPRICHOS, Francisco Goya. 80 plates of wild, grotesque monsters and caricatures. Prado manuscript included. 183pp. 6⅜ × 9⅜. 22384-1 Pa. $4.95

AUTOBIOGRAPHY: The Story of My Experiments with Truth, Mohandas K. Gandhi. Not hagiography, but Gandhi in his own words. Boyhood, legal studies, purification, the growth of the Satyagraha (nonviolent protest) movement. Critical, inspiring work of the man who freed India. 480pp. 5⅜ × 8½. (Available in U.S. only)
24593-4 Pa. $6.95

ILLUSTRATED DICTIONARY OF HISTORIC ARCHITECTURE, edited by Cyril M. Harris. Extraordinary compendium of clear, concise definitions for over 5,000 important architectural terms complemented by over 2,000 line drawings. Covers full spectrum of architecture from ancient ruins to 20th-century Modernism. Preface. 592pp. 7½ × 9⅜. 24444-X Pa. $14.95

THE NIGHT BEFORE CHRISTMAS, Clement Moore. Full text, and woodcuts from original 1848 book. Also critical, historical material. 19 illustrations. 40pp. 4⅝ × 6. 22797-9 Pa. $2.50

THE LESSON OF JAPANESE ARCHITECTURE: 165 Photographs, Jiro Harada. Memorable gallery of 165 photographs taken in the 1930's of exquisite Japanese homes of the well-to-do and historic buildings. 13 line diagrams. 192pp. 8⅜ × 11¼. 24778-3 Pa. $8.95

THE AUTOBIOGRAPHY OF CHARLES DARWIN AND SELECTED LET-TERS, edited by Francis Darwin. The fascinating life of eccentric genius composed of an intimate memoir by Darwin (intended for his children); commentary by his son, Francis; hundreds of fragments from notebooks, journals, papers; and letters to and from Lyell, Hooker, Huxley, Wallace and Henslow. xi + 365pp. 5⅜ × 8.
20479-0 Pa. $5.95

WONDERS OF THE SKY: Observing Rainbows, Comets, Eclipses, the Stars and Other Phenomena, Fred Schaaf. Charming, easy-to-read poetic guide to all manner of celestial events visible to the naked eye. Mock suns, glories, Belt of Venus, more. Illustrated. 299pp. 5¼ × 8¼. 24402-4 Pa. $7.95

BURNHAM'S CELESTIAL HANDBOOK, Robert Burnham, Jr. Thorough guide to the stars beyond our solar system. Exhaustive treatment. Alphabetical by constellation: Andromeda to Cetus in Vol. 1; Chamaeleon to Orion in Vol. 2; and Pavo to Vulpecula in Vol. 3. Hundreds of illustrations. Index in Vol. 3. 2,000pp. 6⅛ × 9¼. 23567-X, 23568-8, 23673-0 Pa., Three-vol. set $37.85

STAR NAMES: Their Lore and Meaning, Richard Hinckley Allen. Fascinating history of names various cultures have given to constellations and literary and folkloristic uses that have been made of stars. Indexes to subjects. Arabic and Greek names. Biblical references. Bibliography. 563pp. 5⅜ × 8½. 21079-0 Pa. $7.95

THIRTY YEARS THAT SHOOK PHYSICS: The Story of Quantum Theory, George Gamow. Lucid, accessible introduction to influential theory of energy and matter. Careful explanations of Dirac's anti-particles, Bohr's model of the atom, much more. 12 plates. Numerous drawings. 240pp. 5⅜ × 8½. 24895-X Pa. $4.95

CHINESE DOMESTIC FURNITURE IN PHOTOGRAPHS AND MEASURED DRAWINGS, Gustav Ecke. A rare volume, now affordably priced for antique collectors, furniture buffs and art historians. Detailed review of styles ranging from early Shang to late Ming. Unabridged republication. 161 black-and-white drawings, photos. Total of 224pp. 8⅜ × 11¼. (Available in U.S. only) 25171-3 Pa. $12.95

VINCENT VAN GOGH: A Biography, Julius Meier-Graefe. Dynamic, penetrating study of artist's life, relationship with brother, Theo, painting techniques, travels, more. Readable, engrossing. 160pp. 5⅜ × 8½. (Available in U.S. only)
25253-1 Pa. $3.95

HOW TO WRITE, Gertrude Stein. Gertrude Stein claimed anyone could understand her unconventional writing—here are clues to help. Fascinating improvisations, language experiments, explanations illuminate Stein's craft and the art of writing. Total of 414pp. 4⅝ × 6⅜. 23144-5 Pa. $5.95

ADVENTURES AT SEA IN THE GREAT AGE OF SAIL: Five Firsthand Narratives, edited by Elliot Snow. Rare true accounts of exploration, whaling, shipwreck, fierce natives, trade, shipboard life, more. 33 illustrations. Introduction. 353pp. 5⅜ × 8½. 25177-2 Pa. $7.95

THE HERBAL OR GENERAL HISTORY OF PLANTS, John Gerard. Classic descriptions of about 2,850 plants—with over 2,700 illustrations—includes Latin and English names, physical descriptions, varieties, time and place of growth, more. 2,706 illustrations. xlv + 1,678pp. 8½ × 12¼. 23147-X Cloth. $75.00

DOROTHY AND THE WIZARD IN OZ, L. Frank Baum. Dorothy and the Wizard visit the center of the Earth, where people are vegetables, glass houses grow and Oz characters reappear. Classic sequel to *Wizard of Oz*. 256pp. 5⅝ × 8. 24714-7 Pa. $4.95

SONGS OF EXPERIENCE: Facsimile Reproduction with 26 Plates in Full Color, William Blake. This facsimile of Blake's original "Illuminated Book" reproduces 26 full-color plates from a rare 1826 edition. Includes "The Tyger," "London," "Holy Thursday," and other immortal poems. 26 color plates. Printed text of poems. 48pp. 5¼ × 7. 24636-1 Pa. $3.50

SONGS OF INNOCENCE, William Blake. The first and most popular of Blake's famous "Illuminated Books," in a facsimile edition reproducing all 31 brightly colored plates. Additional printed text of each poem. 64pp. 5¼ × 7. 22764-2 Pa. $3.50

PRECIOUS STONES, Max Bauer. Classic, thorough study of diamonds, rubies, emeralds, garnets, etc.: physical character, occurrence, properties, use, similar topics. 20 plates, 8 in color. 94 figures. 659pp. 6⅛ × 9¼. 21910-0, 21911-9 Pa., Two-vol. set $15.90

ENCYCLOPEDIA OF VICTORIAN NEEDLEWORK, S. F. A. Caulfeild and Blanche Saward. Full, precise descriptions of stitches, techniques for dozens of needlecrafts—most exhaustive reference of its kind. Over 800 figures. Total of 679pp. 8½ × 11. Two volumes. Vol. 1 22800-2 Pa. $11.95 / Vol. 2 22801-0 Pa. $11.95

THE MARVELOUS LAND OF OZ, L. Frank Baum. Second Oz book, the Scarecrow and Tin Woodman are back with hero named Tip, Oz magic. 136 illustrations. 287pp. 5⅝ × 8½. 20692-0 Pa. $5.95

WILD FOWL DECOYS, Joel Barber. Basic book on the subject, by foremost authority and collector. Reveals history of decoy making and rigging, place in American culture, different kinds of decoys, how to make them, and how to use them. 140 plates. 156pp. 7⅞ × 10¾. 20011-6 Pa. $8.95

HISTORY OF LACE, Mrs. Bury Palliser. Definitive, profusely illustrated chronicle of lace from earliest times to late 19th century. Laces of Italy, Greece, England, France, Belgium, etc. Landmark of needlework scholarship. 266 illustrations. 672pp. 6⅛ × 9¼. 24742-2 Pa. $14.95

ILLUSTRATED GUIDE TO SHAKER FURNITURE, Robert Meader. All furniture and appurtenances, with much on unknown local styles. 235 photos. 146pp. 9 × 12. 22819-3 Pa. $7.95

WHALE SHIPS AND WHALING: A Pictorial Survey, George Francis Dow. Over 200 vintage engravings, drawings, photographs of barks, brigs, cutters, other vessels. Also harpoons, lances, whaling guns, many other artifacts. Comprehensive text by foremost authority. 207 black-and-white illustrations. 288pp. 6 × 9.
24808-9 Pa. $8.95

THE BERTRAMS, Anthony Trollope. Powerful portrayal of blind self-will and thwarted ambition includes one of Trollope's most heartrending love stories. 497pp. 5⅜ × 8½. 25119-5 Pa. $8.95

ADVENTURES WITH A HAND LENS, Richard Headstrom. Clearly written guide to observing and studying flowers and grasses, fish scales, moth and insect wings, egg cases, buds, feathers, seeds, leaf scars, moss, molds, ferns, common crystals, etc.—all with an ordinary, inexpensive magnifying glass. 209 exact line drawings aid in your discoveries. 220pp. 5⅜ × 8½. 23330-8 Pa. $4.50

RODIN ON ART AND ARTISTS, Auguste Rodin. Great sculptor's candid, wide-ranging comments on meaning of art; great artists; relation of sculpture to poetry, painting, music; philosophy of life, more. 76 superb black-and-white illustrations of Rodin's sculpture, drawings and prints. 119pp. 8⅜ × 11¼. 24487-3 Pa. $6.95

FIFTY CLASSIC FRENCH FILMS, 1912–1982: A Pictorial Record, Anthony Slide. Memorable stills from Grand Illusion, Beauty and the Beast, Hiroshima, Mon Amour, many more. Credits, plot synopses, reviews, etc. 160pp. 8¼ × 11.
25256-6 Pa. $11.95

THE PRINCIPLES OF PSYCHOLOGY, William James. Famous long course complete, unabridged. Stream of thought, time perception, memory, experimental methods; great work decades ahead of its time. 94 figures. 1,391pp. 5⅜ × 8½.
20381-6, 20382-4 Pa., Two-vol. set $19.90

BODIES IN A BOOKSHOP, R. T. Campbell. Challenging mystery of blackmail and murder with ingenious plot and superbly drawn characters. In the best tradition of British suspense fiction. 192pp. 5⅜ × 8½. 24720-1 Pa. $3.95

CALLAS: PORTRAIT OF A PRIMA DONNA, George Jellinek. Renowned commentator on the musical scene chronicles incredible career and life of the most controversial, fascinating, influential operatic personality of our time. 64 black-and-white photographs. 416pp. 5⅜ × 8¼. 25047-4 Pa. $7.95

GEOMETRY, RELATIVITY AND THE FOURTH DIMENSION, Rudolph Rucker. Exposition of fourth dimension, concepts of relativity as Flatland characters continue adventures. Popular, easily followed yet accurate, profound. 141 illustrations. 133pp. 5⅜ × 8½. 23400-2 Pa. $3.50

HOUSEHOLD STORIES BY THE BROTHERS GRIMM, with pictures by Walter Crane. 53 classic stories—Rumpelstiltskin, Rapunzel, Hansel and Gretel, the Fisherman and his Wife, Snow White, Tom Thumb, Sleeping Beauty, Cinderella, and so much more—lavishly illustrated with original 19th century drawings. 114 illustrations. x + 269pp. 5⅜ × 8½. 21080-4 Pa. $4.50

CATALOG OF DOVER BOOKS

SUNDIALS, Albert Waugh. Far and away the best, most thorough coverage of ideas, mathematics concerned, types, construction, adjusting anywhere. Over 100 illustrations. 230pp. 5⅜ × 8½. 22947-5 Pa. $4.50

PICTURE HISTORY OF THE NORMANDIE: With 190 Illustrations, Frank O. Braynard. Full story of legendary French ocean liner: Art Deco interiors, design innovations, furnishings, celebrities, maiden voyage, tragic fire, much more. Extensive text. 144pp. 8⅜ × 11¼. 25257-4 Pa. $9.95

THE FIRST AMERICAN COOKBOOK: A Facsimile of "American Cookery," 1796, Amelia Simmons. Facsimile of the first American-written cookbook published in the United States contains authentic recipes for colonial favorites—pumpkin pudding, winter squash pudding, spruce beer, Indian slapjacks, and more. Introductory Essay and Glossary of colonial cooking terms. 80pp. 5⅜ × 8½. 24710-4 Pa. $3.50

101 PUZZLES IN THOUGHT AND LOGIC, C. R. Wylie, Jr. Solve murders and robberies, find out which fishermen are liars, how a blind man could possibly identify a color—purely by your own reasoning! 107pp. 5⅜ × 8½. 20367-0 Pa. $2.50

THE BOOK OF WORLD-FAMOUS MUSIC—CLASSICAL, POPULAR AND FOLK, James J. Fuld. Revised and enlarged republication of landmark work in musico-bibliography. Full information about nearly 1,000 songs and compositions including first lines of music and lyrics. New supplement. Index. 800pp. 5⅜ × 8¼. 24857-7 Pa. $14.95

ANTHROPOLOGY AND MODERN LIFE, Franz Boas. Great anthropologist's classic treatise on race and culture. Introduction by Ruth Bunzel. Only inexpensive paperback edition. 255pp. 5⅜ × 8½. 25245-0 Pa. $5.95

THE TALE OF PETER RABBIT, Beatrix Potter. The inimitable Peter's terrifying adventure in Mr. McGregor's garden, with all 27 wonderful, full-color Potter illustrations. 55pp. 4¼ × 5½. (Available in U.S. only) 22827-4 Pa. $1.75

THREE PROPHETIC SCIENCE FICTION NOVELS, H. G. Wells. *When the Sleeper Wakes, A Story of the Days to Come* and *The Time Machine* (full version). 335pp. 5⅜ × 8½. (Available in U.S. only) 20605-X Pa. $5.95

APICIUS COOKERY AND DINING IN IMPERIAL ROME, edited and translated by Joseph Dommers Vehling. Oldest known cookbook in existence offers readers a clear picture of what foods Romans ate, how they prepared them, etc. 49 illustrations. 301pp. 6⅛ × 9¼. 23563-7 Pa. $6.50

SHAKESPEARE LEXICON AND QUOTATION DICTIONARY, Alexander Schmidt. Full definitions, locations, shades of meaning of every word in plays and poems. More than 50,000 exact quotations. 1,485pp. 6½ × 9¼. 22726-X, 22727-8 Pa., Two-vol. set $27.90

THE WORLD'S GREAT SPEECHES, edited by Lewis Copeland and Lawrence W. Lamm. Vast collection of 278 speeches from Greeks to 1970. Powerful and effective models; unique look at history. 842pp. 5⅜ × 8½. 20468-5 Pa. $11.95

THE BLUE FAIRY BOOK, Andrew Lang. The first, most famous collection, with many familiar tales: Little Red Riding Hood, Aladdin and the Wonderful Lamp, Puss in Boots, Sleeping Beauty, Hansel and Gretel, Rumpelstiltskin; 37 in all. 138 illustrations. 390pp. 5⅜ × 8½.　21437-0 Pa. $5.95

THE STORY OF THE CHAMPIONS OF THE ROUND TABLE, Howard Pyle. Sir Launcelot, Sir Tristram and Sir Percival in spirited adventures of love and triumph retold in Pyle's inimitable style. 50 drawings, 31 full-page. xviii + 329pp. 6½ × 9¼.　21883-X Pa. $6.95

AUDUBON AND HIS JOURNALS, Maria Audubon. Unmatched two-volume portrait of the great artist, naturalist and author contains his journals, an excellent biography by his granddaughter, expert annotations by the noted ornithologist, Dr. Elliott Coues, and 37 superb illustrations. Total of 1,200pp. 5⅜ × 8.

Vol. I 25143-8 Pa. $8.95
Vol. II 25144-6 Pa. $8.95

GREAT DINOSAUR HUNTERS AND THEIR DISCOVERIES, Edwin H. Colbert. Fascinating, lavishly illustrated chronicle of dinosaur research, 1820's to 1960. Achievements of Cope, Marsh, Brown, Buckland, Mantell, Huxley, many others. 384pp. 5¼ × 8¼.　24701-5 Pa. $6.95

THE TASTEMAKERS, Russell Lynes. Informal, illustrated social history of American taste 1850's-1950's. First popularized categories Highbrow, Lowbrow, Middlebrow. 129 illustrations. New (1979) afterword. 384pp. 6 × 9.

23993-4 Pa. $6.95

DOUBLE CROSS PURPOSES, Ronald A. Knox. A treasure hunt in the Scottish Highlands, an old map, unidentified corpse, surprise discoveries keep reader guessing in this cleverly intricate tale of financial skullduggery. 2 black-and-white maps. 320pp. 5⅜ × 8½. (Available in U.S. only)　25032-6 Pa. $5.95

AUTHENTIC VICTORIAN DECORATION AND ORNAMENTATION IN FULL COLOR: 46 Plates from "Studies in Design," Christopher Dresser. Superb full-color lithographs reproduced from rare original portfolio of a major Victorian designer. 48pp. 9¼ × 12¼.　25083-0 Pa. $7.95

PRIMITIVE ART, Franz Boas. Remains the best text ever prepared on subject, thoroughly discussing Indian, African, Asian, Australian, and, especially, Northern American primitive art. Over 950 illustrations show ceramics, masks, totem poles, weapons, textiles, paintings, much more. 376pp. 5⅜ × 8. 20025-6 Pa. $6.95

SIDELIGHTS ON RELATIVITY, Albert Einstein. Unabridged republication of two lectures delivered by the great physicist in 1920-21. *Ether and Relativity* and *Geometry and Experience*. Elegant ideas in non-mathematical form, accessible to intelligent layman. vi + 56pp. 5⅜ × 8½.　24511-X Pa. $2.95

THE WIT AND HUMOR OF OSCAR WILDE, edited by Alvin Redman. More than 1,000 ripostes, paradoxes, wisecracks: Work is the curse of the drinking classes, I can resist everything except temptation, etc. 258pp. 5⅜ × 8½.　20602-5 Pa. $4.50

ADVENTURES WITH A MICROSCOPE, Richard Headstrom. 59 adventures with clothing fibers, protozoa, ferns and lichens, roots and leaves, much more. 142 illustrations. 232pp. 5⅜ × 8½.　23471-1 Pa. $3.95

CATALOG OF DOVER BOOKS

PLANTS OF THE BIBLE, Harold N. Moldenke and Alma L. Moldenke. Standard reference to all 230 plants mentioned in Scriptures. Latin name, biblical reference, uses, modern identity, much more. Unsurpassed encyclopedic resource for scholars, botanists, nature lovers, students of Bible. Bibliography. Indexes. 123 black-and-white illustrations. 384pp. 6 × 9. 25069-5 Pa. $8.95

FAMOUS AMERICAN WOMEN: A Biographical Dictionary from Colonial Times to the Present, Robert McHenry, ed. From Pocahontas to Rosa Parks, 1,035 distinguished American women documented in separate biographical entries. Accurate, up-to-date data, numerous categories, spans 400 years. Indices. 493pp. 6½ × 9¼. 24523-3 Pa. $9.95

THE FABULOUS INTERIORS OF THE GREAT OCEAN LINERS IN HISTORIC PHOTOGRAPHS, William H. Miller, Jr. Some 200 superb photographs capture exquisite interiors of world's great "floating palaces"—1890's to 1980's: *Titanic, Ile de France, Queen Elizabeth, United States, Europa,* more. Approx. 200 black-and-white photographs. Captions. Text. Introduction. 160pp. 8⅜ × 11¼. 24756-2 Pa. $9.95

THE GREAT LUXURY LINERS, 1927-1954: A Photographic Record, William H. Miller, Jr. Nostalgic tribute to heyday of ocean liners. 186 photos of Ile de France, Normandie, Leviathan, Queen Elizabeth, United States, many others. Interior and exterior views. Introduction. Captions. 160pp. 9 × 12. 24056-8 Pa. $9.95

A NATURAL HISTORY OF THE DUCKS, John Charles Phillips. Great landmark of ornithology offers complete detailed coverage of nearly 200 species and subspecies of ducks: gadwall, sheldrake, merganser, pintail, many more. 74 full-color plates, 102 black-and-white. Bibliography. Total of 1,920pp. 8⅜ × 11¼. 25141-1, 25142-X Cloth. Two-vol. set $100.00

THE SEAWEED HANDBOOK: An Illustrated Guide to Seaweeds from North Carolina to Canada, Thomas F. Lee. Concise reference covers 78 species. Scientific and common names, habitat, distribution, more. Finding keys for easy identification. 224pp. 5⅜ × 8½. 25215-9 Pa. $5.95

THE TEN BOOKS OF ARCHITECTURE: The 1755 Leoni Edition, Leon Battista Alberti. Rare classic helped introduce the glories of ancient architecture to the Renaissance. 68 black-and-white plates. 336pp. 8⅜ × 11¼. 25239-6 Pa. $14.95

MISS MACKENZIE, Anthony Trollope. Minor masterpieces by Victorian master unmasks many truths about life in 19th-century England. First inexpensive edition in years. 392pp. 5⅜ × 8½. 25201-9 Pa. $7.95

THE RIME OF THE ANCIENT MARINER, Gustave Doré, Samuel Taylor Coleridge. Dramatic engravings considered by many to be his greatest work. The terrifying space of the open sea, the storms and whirlpools of an unknown ocean, the ice of Antarctica, more—all rendered in a powerful, chilling manner. Full text. 38 plates. 77pp. 9¼ × 12. 22305-1 Pa. $4.95

THE EXPEDITIONS OF ZEBULON MONTGOMERY PIKE, Zebulon Montgomery Pike. Fascinating first-hand accounts (1805-6) of exploration of Mississippi River, Indian wars, capture by Spanish dragoons, much more. 1,088pp. 5⅜ × 8½. 25254-X, 25255-8 Pa. Two-vol. set $23.90

A CONCISE HISTORY OF PHOTOGRAPHY: Third Revised Edition, Helmut Gernsheim. Best one-volume history—camera obscura, photochemistry, daguerreotypes, evolution of cameras, film, more. Also artistic aspects—landscape, portraits, fine art, etc. 281 black-and-white photographs. 26 in color. 176pp. 8¾ × 11¼. 25128-4 Pa. $12.95

THE DORÉ BIBLE ILLUSTRATIONS, Gustave Doré. 241 detailed plates from the Bible: the Creation scenes, Adam and Eve, Flood, Babylon, battle sequences, life of Jesus, etc. Each plate is accompanied by the verses from the King James version of the Bible. 241pp. 9 × 12. 23004-X Pa. $8.95

HUGGER-MUGGER IN THE LOUVRE, Elliot Paul. Second Homer Evans mystery-comedy. Theft at the Louvre involves sleuth in hilarious, madcap caper. "A knockout."—Books. 336pp. 5⅜ × 8½. 25185-3 Pa. $5.95

FLATLAND, E. A. Abbott. Intriguing and enormously popular science-fiction classic explores the complexities of trying to survive as a two-dimensional being in a three-dimensional world. Amusingly illustrated by the author. 16 illustrations. 103pp. 5⅜ × 8½. 20001-9 Pa. $2.25

THE HISTORY OF THE LEWIS AND CLARK EXPEDITION, Meriwether Lewis and William Clark, edited by Elliott Coues. Classic edition of Lewis and Clark's day-by-day journals that later became the basis for U.S. claims to Oregon and the West. Accurate and invaluable geographical, botanical, biological, meteorological and anthropological material. Total of 1,508pp. 5⅜ × 8½. 21268-8, 21269-6, 21270-X Pa. Three-vol. set $25.50

LANGUAGE, TRUTH AND LOGIC, Alfred J. Ayer. Famous, clear introduction to Vienna, Cambridge schools of Logical Positivism. Role of philosophy, elimination of metaphysics, nature of analysis, etc. 160pp. 5⅜ × 8½. (Available in U.S. and Canada only) 20010-8 Pa. $2.95

MATHEMATICS FOR THE NONMATHEMATICIAN, Morris Kline. Detailed, college-level treatment of mathematics in cultural and historical context, with numerous exercises. For liberal arts students. Preface. Recommended Reading Lists. Tables. Index. Numerous black-and-white figures. xvi + 641pp. 5⅜ × 8½. 24823-2 Pa. $11.95

28 SCIENCE FICTION STORIES, H. G. Wells. Novels, *Star Begotten* and *Men Like Gods*, plus 26 short stories: "Empire of the Ants," "A Story of the Stone Age," "The Stolen Bacillus," "In the Abyss," etc. 915pp. 5⅜ × 8½. (Available in U.S. only) 20265-8 Cloth. $10.95

HANDBOOK OF PICTORIAL SYMBOLS, Rudolph Modley. 3,250 signs and symbols, many systems in full; official or heavy commercial use. Arranged by subject. Most in Pictorial Archive series. 143pp. 8⅜ × 11. 23357-X Pa. $5.95

INCIDENTS OF TRAVEL IN YUCATAN, John L. Stephens. Classic (1843) exploration of jungles of Yucatan, looking for evidences of Maya civilization. Travel adventures, Mexican and Indian culture, etc. Total of 669pp. 5⅜ × 8½. 20926-1, 20927-X Pa., Two-vol. set $9.90

CATALOG OF DOVER BOOKS

DEGAS: An Intimate Portrait, Ambroise Vollard. Charming, anecdotal memoir by famous art dealer of one of the greatest 19th-century French painters. 14 black-and-white illustrations. Introduction by Harold L. Van Doren. 96pp. 5⅜ × 8½.
25131-4 Pa. $3.95

PERSONAL NARRATIVE OF A PILGRIMAGE TO ALMANDINAH AND MECCAH, Richard Burton. Great travel classic by remarkably colorful personality. Burton, disguised as a Moroccan, visited sacred shrines of Islam, narrowly escaping death. 47 illustrations. 959pp. 5⅜ × 8½. 21217-3, 21218-1 Pa., Two-vol. set $17.90

PHRASE AND WORD ORIGINS, A. H. Holt. Entertaining, reliable, modern study of more than 1,200 colorful words, phrases, origins and histories. Much unexpected information. 254pp. 5⅜ × 8½. 20758-7 Pa. $5.95

THE RED THUMB MARK, R. Austin Freeman. In this first Dr. Thorndyke case, the great scientific detective draws fascinating conclusions from the nature of a single fingerprint. Exciting story, authentic science. 320pp. 5⅜ × 8½. (Available in U.S. only) 25210-8 Pa. $5.95

AN EGYPTIAN HIEROGLYPHIC DICTIONARY, E. A. Wallis Budge. Monumental work containing about 25,000 words or terms that occur in texts ranging from 3000 B.C. to 600 A.D. Each entry consists of a transliteration of the word, the word in hieroglyphs, and the meaning in English. 1,314pp. 6⅜ × 10. 23615-3, 23616-1 Pa., Two-vol. set $27.90

THE COMPLEAT STRATEGYST: Being a Primer on the Theory of Games of Strategy, J. D. Williams. Highly entertaining classic describes, with many illustrated examples, how to select best strategies in conflict situations. Prefaces. Appendices. xvi + 268pp. 5⅜ × 8½. 25101-2 Pa. $5.95

THE ROAD TO OZ, L. Frank Baum. Dorothy meets the Shaggy Man, little Button-Bright and the Rainbow's beautiful daughter in this delightful trip to the magical Land of Oz. 272pp. 5⅜ × 8. 25208-6 Pa. $4.95

POINT AND LINE TO PLANE, Wassily Kandinsky. Seminal exposition of role of point, line, other elements in non-objective painting. Essential to understanding 20th-century art. 127 illustrations. 192pp. 6½ × 9¼. 23808-3 Pa. $4.50

LADY ANNA, Anthony Trollope. Moving chronicle of Countess Lovel's bitter struggle to win for herself and daughter Anna their rightful rank and fortune—perhaps at cost of sanity itself. 384pp. 5⅜ × 8½. 24669-8 Pa. $6.95

EGYPTIAN MAGIC, E. A. Wallis Budge. Sums up all that is known about magic in Ancient Egypt: the role of magic in controlling the gods, powerful amulets that warded off evil spirits, scarabs of immortality, use of wax images, formulas and spells, the secret name, much more. 253pp. 5⅜ × 8½. 22681-6 Pa. $4.50

THE DANCE OF SIVA, Ananda Coomaraswamy. Preeminent authority unfolds the vast metaphysic of India: the revelation of her art, conception of the universe, social organization, etc. 27 reproductions of art masterpieces. 192pp. 5⅜ × 8½.
24817-8 Pa. $5.95

CHRISTMAS CUSTOMS AND TRADITIONS, Clement A. Miles. Origin, evolution, significance of religious, secular practices. Caroling, gifts, yule logs, much more. Full, scholarly yet fascinating; non-sectarian. 400pp. 5⅜ × 8½.
23354-5 Pa. $6.50

THE HUMAN FIGURE IN MOTION, Eadweard Muybridge. More than 4,500 stopped-action photos, in action series, showing undraped men, women, children jumping, lying down, throwing, sitting, wrestling, carrying, etc. 390pp. 7⅞ × 10⅝.
20204-6 Cloth. $19.95

THE MAN WHO WAS THURSDAY, Gilbert Keith Chesterton. Witty, fast-paced novel about a club of anarchists in turn-of-the-century London. Brilliant social, religious, philosophical speculations. 128pp. 5⅜ × 8½.
25121-7 Pa. $3.95

A CEZANNE SKETCHBOOK: Figures, Portraits, Landscapes and Still Lifes, Paul Cezanne. Great artist experiments with tonal effects, light, mass, other qualities in over 100 drawings. A revealing view of developing master painter, precursor of Cubism. 102 black-and-white illustrations. 144pp. 8¾ × 6⅞.
24790-2 Pa. $5.95

AN ENCYCLOPEDIA OF BATTLES: Accounts of Over 1,560 Battles from 1479 B.C. to the Present, David Eggenberger. Presents essential details of every major battle in recorded history, from the first battle of Megiddo in 1479 B.C. to Grenada in 1984. List of Battle Maps. New Appendix covering the years 1967–1984. Index. 99 illustrations. 544pp. 6½ × 9¼.
24913-1 Pa. $14.95

AN ETYMOLOGICAL DICTIONARY OF MODERN ENGLISH, Ernest Weekley. Richest, fullest work, by foremost British lexicographer. Detailed word histories. Inexhaustible. Total of 856pp. 6½ × 9¼.
21873-2, 21874-0 Pa., Two-vol. set $17.00

WEBSTER'S AMERICAN MILITARY BIOGRAPHIES, edited by Robert McHenry. Over 1,000 figures who shaped 3 centuries of American military history. Detailed biographies of Nathan Hale, Douglas MacArthur, Mary Hallaren, others. Chronologies of engagements, more. Introduction. Addenda. 1,033 entries in alphabetical order. xi + 548pp. 6½ × 9¼. (Available in U.S. only)
24758-9 Pa. $11.95

LIFE IN ANCIENT EGYPT, Adolf Erman. Detailed older account, with much not in more recent books: domestic life, religion, magic, medicine, commerce, and whatever else needed for complete picture. Many illustrations. 597pp. 5⅜ × 8½.
22632-8 Pa. $8.95

HISTORIC COSTUME IN PICTURES, Braun & Schneider. Over 1,450 costumed figures shown, covering a wide variety of peoples: kings, emperors, nobles, priests, servants, soldiers, scholars, townsfolk, peasants, merchants, courtiers, cavaliers, and more. 256pp. 8⅜ × 11¼.
23150-X Pa. $7.95

THE NOTEBOOKS OF LEONARDO DA VINCI, edited by J. P. Richter. Extracts from manuscripts reveal great genius; on painting, sculpture, anatomy, sciences, geography, etc. Both Italian and English. 186 ms. pages reproduced, plus 500 additional drawings, including studies for *Last Supper*, *Sforza* monument, etc. 860pp. 7⅞ × 10¾. (Available in U.S. only) 22572-0, 22573-9 Pa., Two-vol. set $25.90

THE ART NOUVEAU STYLE BOOK OF ALPHONSE MUCHA: All 72 Plates from "Documents Decoratifs" in Original Color, Alphonse Mucha. Rare copyright-free design portfolio by high priest of Art Nouveau. Jewelry, wallpaper, stained glass, furniture, figure studies, plant and animal motifs, etc. Only complete one-volume edition. 80pp. 9⅜ × 12¼. 24044-4 Pa. $8.95

ANIMALS: 1,419 COPYRIGHT-FREE ILLUSTRATIONS OF MAMMALS, BIRDS, FISH, INSECTS, ETC., edited by Jim Harter. Clear wood engravings present, in extremely lifelike poses, over 1,000 species of animals. One of the most extensive pictorial sourcebooks of its kind. Captions. Index. 284pp. 9 × 12.
23766-4 Pa. $9.95

OBELISTS FLY HIGH, C. Daly King. Masterpiece of American detective fiction, long out of print, involves murder on a 1935 transcontinental flight—"a very thrilling story"—NY Times. Unabridged and unaltered republication of the edition published by William Collins Sons & Co. Ltd., London, 1935. 288pp. 5⅜ × 8½. (Available in U.S. only) 25036-9 Pa. $4.95

VICTORIAN AND EDWARDIAN FASHION: A Photographic Survey, Alison Gernsheim. First fashion history completely illustrated by contemporary photographs. Full text plus 235 photos, 1840–1914, in which many celebrities appear. 240pp. 6½ × 9¼. 24205-6 Pa. $6.00

THE ART OF THE FRENCH ILLUSTRATED BOOK, 1700–1914, Gordon N. Ray. Over 630 superb book illustrations by Fragonard, Delacroix, Daumier, Doré, Grandville, Manet, Mucha, Steinlen, Toulouse-Lautrec and many others. Preface. Introduction. 633 halftones. Indices of artists, authors & titles, binders and provenances. Appendices. Bibliography. 608pp. 8⅜ × 11¼. 25086-5 Pa. $24.95

THE WONDERFUL WIZARD OF OZ, L. Frank Baum. Facsimile in full color of America's finest children's classic. 143 illustrations by W. W. Denslow. 267pp. 5⅜ × 8½. 20691-2 Pa. $5.95

FRONTIERS OF MODERN PHYSICS: New Perspectives on Cosmology, Relativity, Black Holes and Extraterrestrial Intelligence, Tony Rothman, et al. For the intelligent layman. Subjects include: cosmological models of the universe; black holes; the neutrino; the search for extraterrestrial intelligence. Introduction. 46 black-and-white illustrations. 192pp. 5⅜ × 8½. 24587-X Pa. $6.95

THE FRIENDLY STARS, Martha Evans Martin & Donald Howard Menzel. Classic text marshalls the stars together in an engaging, non-technical survey, presenting them as sources of beauty in night sky. 23 illustrations. Foreword. 2 star charts. Index. 147pp. 5⅜ × 8½. 21099-5 Pa. $3.50

FADS AND FALLACIES IN THE NAME OF SCIENCE, Martin Gardner. Fair, witty appraisal of cranks, quacks, and quackeries of science and pseudoscience: hollow earth, Velikovsky, orgone energy, Dianetics, flying saucers, Bridey Murphy, food and medical fads, etc. Revised, expanded In the Name of Science. "A very able and even-tempered presentation."—The New Yorker. 363pp. 5⅜ × 8.
20394-8 Pa. $6.50

ANCIENT EGYPT: ITS CULTURE AND HISTORY, J. E Manchip White. From pre-dynastics through Ptolemies: society, history, political structure, religion, daily life, literature, cultural heritage. 48 plates. 217pp. 5⅜ × 8½. 22548-8 Pa. $4.95

SIR HARRY HOTSPUR OF HUMBLETHWAITE, Anthony Trollope. Incisive, unconventional psychological study of a conflict between a wealthy baronet, his idealistic daughter, and their scapegrace cousin. The 1870 novel in its first inexpensive edition in years. 250pp. 5⅜ × 8½. 24953-0 Pa. $5.95

LASERS AND HOLOGRAPHY, Winston E. Kock. Sound introduction to burgeoning field, expanded (1981) for second edition. Wave patterns, coherence, lasers, diffraction, zone plates, properties of holograms, recent advances. 84 illustrations. 160pp. 5⅜ × 8¼. (Except in United Kingdom) 24041-X Pa. $3.50

INTRODUCTION TO ARTIFICIAL INTELLIGENCE: SECOND, EN-LARGED EDITION, Philip C. Jackson, Jr. Comprehensive survey of artificial intelligence—the study of how machines (computers) can be made to act intelligently. Includes introductory and advanced material. Extensive notes updating the main text. 132 black-and-white illustrations. 512pp. 5⅜ × 8½. 24864-X Pa. $8.95

HISTORY OF INDIAN AND INDONESIAN ART, Ananda K. Coomaraswamy. Over 400 illustrations illuminate classic study of Indian art from earliest Harappa finds to early 20th century. Provides philosophical, religious and social insights. 304pp. 6⅜ × 9⅜. 25005-9 Pa. $8.95

THE GOLEM, Gustav Meyrink. Most famous supernatural novel in modern European literature, set in Ghetto of Old Prague around 1890. Compelling story of mystical experiences, strange transformations, profound terror. 13 black-and-white illustrations. 224pp. 5⅜ × 8½. (Available in U.S. only) 25025-3 Pa. $5.95

ARMADALE, Wilkie Collins. Third great mystery novel by the author of *The Woman in White* and *The Moonstone*. Original magazine version with 40 illustrations. 597pp. 5⅜ × 8½. 23429-0 Pa. $9.95

PICTORIAL ENCYCLOPEDIA OF HISTORIC ARCHITECTURAL PLANS, DETAILS AND ELEMENTS: With 1,880 Line Drawings of Arches, Domes, Doorways, Facades, Gables, Windows, etc., John Theodore Haneman. Sourcebook of inspiration for architects, designers, others. Bibliography. Captions. 141pp. 9 × 12. 24605-1 Pa. $6.95

BENCHLEY LOST AND FOUND, Robert Benchley. Finest humor from early 30's, about pet peeves, child psychologists, post office and others. Mostly unavailable elsewhere. 73 illustrations by Peter Arno and others. 183pp. 5⅜ × 8½.
 22410-4 Pa. $3.95

ERTÉ GRAPHICS, Erté. Collection of striking color graphics: *Seasons, Alphabet, Numerals, Aces* and *Precious Stones*. 50 plates, including 4 on covers. 48pp. 9⅜ × 12¼. 23580-7 Pa. $6.95

THE JOURNAL OF HENRY D. THOREAU, edited by Bradford Torrey, F. H. Allen. Complete reprinting of 14 volumes, 1837–61, over two million words; the sourcebooks for *Walden*, etc. Definitive. All original sketches, plus 75 photographs. 1,804pp. 8½ × 12¼. 20312-3, 20313-1 Cloth., Two-vol. set $80.00

CASTLES: THEIR CONSTRUCTION AND HISTORY, Sidney Toy. Traces castle development from ancient roots. Nearly 200 photographs and drawings illustrate moats, keeps, baileys, many other features. Caernarvon, Dover Castles, Hadrian's Wall, Tower of London, dozens more. 256pp. 5⅜ × 8¼.
 24898-4 Pa. $5.95

CATALOG OF DOVER BOOKS

AMERICAN CLIPPER SHIPS: 1833–1858, Octavius T. Howe & Frederick C. Matthews. Fully-illustrated, encyclopedic review of 352 clipper ships from the period of America's greatest maritime supremacy. Introduction. 109 halftones. 5 black-and-white line illustrations. Index. Total of 928pp. 5⅜ × 8½.
25115-2, 25116-0 Pa., Two-vol. set $17.90

TOWARDS A NEW ARCHITECTURE, Le Corbusier. Pioneering manifesto by great architect, near legendary founder of "International School." Technical and aesthetic theories, views on industry, economics, relation of form to function, "mass-production spirit," much more. Profusely illustrated. Unabridged translation of 13th French edition. Introduction by Frederick Etchells. 320pp. 6⅛ × 9¼. (Available in U.S. only)
25023-7 Pa. $8.95

THE BOOK OF KELLS, edited by Blanche Cirker. Inexpensive collection of 32 full-color, full-page plates from the greatest illuminated manuscript of the Middle Ages, painstakingly reproduced from rare facsimile edition. Publisher's Note. Captions. 32pp. 9⅜ × 12¼.
24345-1 Pa. $4.95

BEST SCIENCE FICTION STORIES OF H. G. WELLS, H. G. Wells. Full novel The Invisible Man, plus 17 short stories: "The Crystal Egg," "Aepyornis Island," "The Strange Orchid," etc. 303pp. 5⅜ × 8½. (Available in U.S. only)
21531-8 Pa. $4.95

AMERICAN SAILING SHIPS: Their Plans and History, Charles G. Davis. Photos, construction details of schooners, frigates, clippers, other sailcraft of 18th to early 20th centuries—plus entertaining discourse on design, rigging, nautical lore, much more. 137 black-and-white illustrations. 240pp. 6⅛ × 9¼.
24658-2 Pa. $5.95

ENTERTAINING MATHEMATICAL PUZZLES, Martin Gardner. Selection of author's favorite conundrums involving arithmetic, money, speed, etc., with lively commentary. Complete solutions. 112pp. 5⅜ × 8½.
25211-6 Pa. $2.95

THE WILL TO BELIEVE, HUMAN IMMORTALITY, William James. Two books bound together. Effect of irrational on logical, and arguments for human immortality. 402pp. 5⅜ × 8½.
20291-7 Pa. $7.50

THE HAUNTED MONASTERY and THE CHINESE MAZE MURDERS, Robert Van Gulik. 2 full novels by Van Gulik continue adventures of Judge Dee and his companions. An evil Taoist monastery, seemingly supernatural events; overgrown topiary maze that hides strange crimes. Set in 7th-century China. 27 illustrations. 328pp. 5⅜ × 8½.
23502-5 Pa. $5.95

CELEBRATED CASES OF JUDGE DEE (DEE GOONG AN), translated by Robert Van Gulik. Authentic 18th-century Chinese detective novel; Dee and associates solve three interlocked cases. Led to Van Gulik's own stories with same characters. Extensive introduction. 9 illustrations. 237pp. 5⅜ × 8½.
23337-5 Pa. $4.95

Prices subject to change without notice.
Available at your book dealer or write for free catalog to Dept. GI, Dover Publications, Inc., 31 East 2nd St., Mineola, N.Y. 11501. Dover publishes more than 175 books each year on science, elementary and advanced mathematics, biology, music, art, literary history, social sciences and other areas.